W9-BEE-084

From Rocky to Pataki

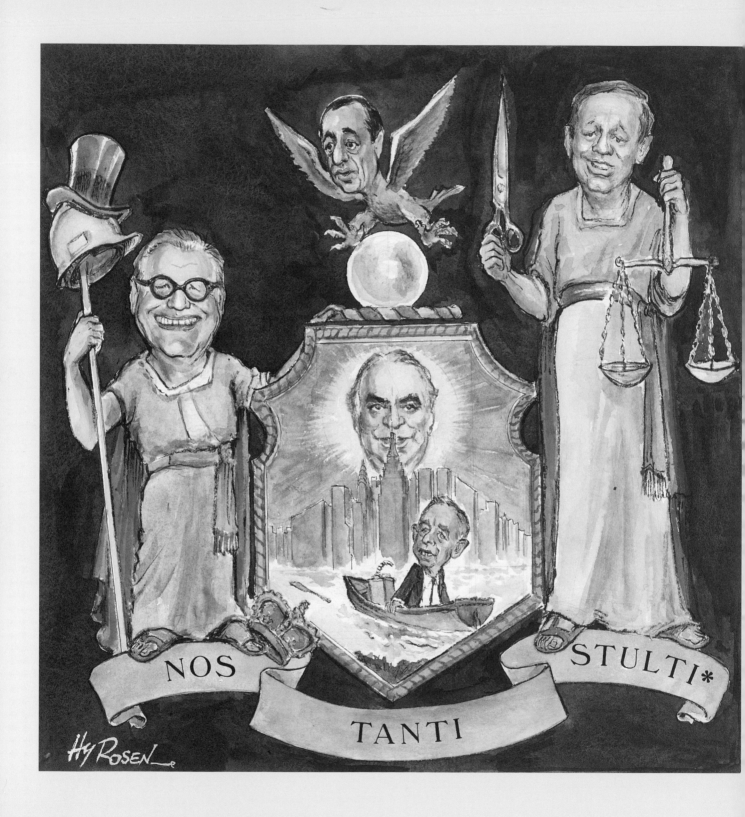

NOS TANTI STULTI*

From Rocky to Pataki

CHARACTER AND CARICATURES
IN NEW YORK POLITICS

Hy Rosen and Peter Slocum

With Forewords by

Senator Daniel P. Moynihan and

Senator Alfonse M. D'Amato

Syracuse University Press

98 99 00 01 02 03 6 5 4 3 2 1

The paper used in this publication meets the minimum requirements of American National Standard for Information Sciences—Permanence of Paper for Printed Library Materials, ANSI Z39.48-1984. ∞

Library of Congress Cataloging-in-Publication Data

Rosen, Hy.

 From Rocky to Pataki : character and caricatures in New York politics / Hy Rosen and Peter Slocum; with forewords by Daniel P. Moynihan and Alfonse M. D'Amato. — 1st ed.

 p. cm.

 Includes index.

 ISBN 0-8156-0543-9 (cloth : alk. paper)

 1. New York (State)—Politics and government—1951– —Caricatures and cartoons. 2. Governors—New York (State) —Caricatures and cartoons. 3. American wit and humor, Pictorial. I. Slocum, Peter.

II. Title.

F125.R64 1998

974.7'043—dc21 98–24245

Manufactured in the United States of America

To Elaine, and to Ann, Emily, and Molly

Contents

Foreword

Senator Daniel P. Moynihan

IT IS NOW well over forty years since I first came to Albany as a very junior member of Governor W. Averell Harriman's staff. I had served my nation in wartime, followed by a Fulbright scholarship to London, and survived the ideological struggles of City College and the streets of Hell's Kitchen. But there was one serious lacuna in my résumé. I had never lived north of Poughkeepsie and was hardly prepared for life in New York State's capital city.

To visit Albany today is to visit a city that has changed in vastly greater ways since I first came there in 1955 than it had in all the years since the Dutch first established their trading post over three centuries earlier. The Albany of 1955 was a remarkably insular city with the flavor of a small town, or rather several small towns. You could walk down State Street from the imposing Alfred E. Smith Building and lose yourself in the Little Italy of Madison Avenue, the Kosher butcher shops of South Pearl Street, or the vibrant Irishtown around Fourth Avenue. The Empire State Mall would change all that. The Teachers College on Western Avenue would become a renowned state university on the outskirts of town. Albany would reluctantly become evermore a part of the state over which it presided, while growing ever so much more interested in the rest of the nation and world as well.

This evolving ethos of Albany was best captured through the years in the pages of that city's two dynamic newspapers, the *Albany Times Union* and the *Knickerbocker News*. And there, among the learned commentary and spirited local reporting, was the indispensable commentary of Hy Rosen. I would read the newspapers to absorb information and then turn to Hy Rosen to see how this quintessential son of Albany would convey, in a crisp drawing, his powerful and important message.

Albany has changed. The state, nation, and world have changed. And yet Hy Rosen remains a remarkable constant. He has indeed been there from "Rocky to Pataki," providing his creative flavor and profound insight with undiminished skill—a standard of thoughtful consistency in a world rushing ever forward.

In 1980 I was privileged to write an introduction to an earlier collection of Hy's fine work and I asked what, in retrospect, is even a more appropriate observation eighteen hectic years later:

> Why has he stayed in Albany all these years? A reasonable question I suppose in an age when everyone moves about so, at least persons of distinctive genius are always being hired away from wherever they are by "better offers" elsewhere. But to ask this of Hy Rosen is to miss the artist in the thinker. He has a powerful sense of place and, Antaeus-like, has kept his feet on the ground that his mind might soar. Besides, where would an American political cartoonist find a greater resonance of place than in Albany, where in 1754 Benjamin Franklin created and published the historic cartoon "Unite or die?"

Foreword

Senator Alfonse M. D'Amato

IN A DISCIPLINE that requires not only wit and wisdom, but also the ability to tell a long story in a very few words, Hy Rosen has excelled. For four decades, he has chronicled the political happenings in Albany. He captures the essence of these years in *From Rocky to Pataki: Character and Caricatures in New York Politics.* In the following pages, Hy and Peter Slocum take us through New York political history, identify trends and changes, and give us a second look at some of Hy's finest artwork.

Albany has been a proving ground for a lot of national leaders and this book provides insight into a number of them. Hy and Peter look at some fascinating and very dissimilar individuals who have served as governors of our state and also at the legislative leaders they worked with and, I'm sure to a cartoonist's delight, against.

One thing they all have in common is being on the receiving end of Hy Rosen's keen observations. In fact, one of the ways you knew you had "arrived" in terms of the State Capitol was that first morning you woke up and found yourself in a Hy Rosen cartoon. Good editorial cartoons make a point, and great ones endure long after the players have left public life, and that's evident in these pages. Hy Rosen's cartoons are some of the best.

And while some of his cartoons depicting me are not among my favorites, others are. Hy has always drawn them like he sees them and is one of the finest, and fairest, practitioners of his craft. So sit back, you're about to be thoroughly entertained and also greatly informed about a fascinating period in New York State history.

Behind the Drawing Board

POLITICAL CARTOONISTS are a rare breed, a lucky breed. I always thought, "What a privilege to come to work each day and vent your spleen on any event in the world, and get paid for it."

For many years at the *Albany Times Union,* I enjoyed that privilege, in a town full of political action that fascinated me and made me eager to pick up my pen and put in my two cents. This book highlights some of the characters and controversies I drew over those years, from the late 1950s into the 1990s, literally, "from Rocky to Pataki." The capital of the Empire State gave me lots of material to work with.

The political cartoon is a piece of artwork to break up the lines of gray type on the editorial page. That's why I always believed that the cartoon should not only say something politically, but the drawing should be interesting, should strike the reader with a strong visual image. To hit it right, to grab the public's attention, a good cartoon must have three elements: a timely topic, a strong metaphor that connects with the reader, and a good drawing that attracts the eye.

How did I get my ideas? That's a question people ask me all the time. First, to have something to say, you have to stay on top of the news, read lots of papers and magazines, and follow television and radio. I used to drive my family nuts, telling the kids to "be quiet so Dad can hear the news."

I was always a news junkie. Growing up during the Depression and then watching the growth of Nazism, I was consumed by current events from an early age. The civil rights movement in this country affected me, too. The story of the regular guy, battling against injustice or forces beyond his control (sometimes the government), is what grabbed me. An editorial cartoonist isn't supposed to be objective.

When you know your topic and the point you want to make, you've got to find a metaphor to carry your message. It can be a current movie or play, a biblical story, a classic fable, a national symbol, a famous work of art—anything that is familiar and that works. I am not a member of the ravage-and-savage school of cartooning. That is not to say that when the occasion calls for it, you shouldn't "hit 'em hard." But a scalpel is better than a meat ax, and you have to be careful not to become a common scold.

Nearly always, I drew the principal actor (politician or public official) in the cartoon. I like to draw faces, believable faces, and I think the recognizable personality draws readers to the cartoon.

The massive photo file in the *Times Union* library was my gold mine. I'd study faces in those pictures, to get the details right. I've always depended on libraries, since my childhood in Albany's South End when the Howe branch library on Schuyler Street first opened my eyes to the world of art and drawing.

Finding that perfect metaphor is the hardest part. Sometimes you know the topic but doodle around with different ideas for hours. Then a word or phrase will trigger an image, and you've got it. Doing this five or six days a week, you come to realize that even Joe DiMaggio didn't get a hit every day, and he was one of a kind.

I'd usually talk over my cartoon idea with the editorial page editor before starting the final drawing. But editors didn't tell me what to draw. That's something a lot of people want to know, how much direction I got from above. The answer is, virtually none. I was a free agent, like a signed column carried on the editorial page, and I have always believed that this freedom of expression is a key ingredient for success. Otherwise, I would have just been illustrating someone else's ideas.

When I first started at the *Times Union* soon after World War II as an editorial artist and sports cartoonist, the Hearst newspaper chain had one set of opinions on national and world issues. The old man, William Randolph Hearst, sent out telegrams from the San Simeon castle in California, and papers all over the country were expected to follow his editorial policy. By the time I started doing editorial cartoons in the middle 1950s, there was much more autonomy. As the first real editorial page cartoonist at the *Times Union,* I was able to convince the editor that when readers saw a cartoon that sometimes differed from the paper's editorials, that gave the editorial page verity.

I had only a handful of cartoons killed over all my years, three or four out of 10,000 drawings. That's pretty good independence.

The cartoons collected in this book offer an entertaining way to reflect on these times, highlighting both funny moments and serious themes, and, I hope, reminding us of the flavor of the period. I asked three New York State colleagues to contribute their work on the Pataki period, because I retired from daily cartooning before he took office. I wanted cartoons that reflect the times when issues were hot, not my hindsight. And their work does that very well, in their own style.

You will see that their artistic style is different from mine, more "cartoonie," exaggerated and entertaining. The style in my day was more serious, focused on the message and on more realistic drawings. Times change, styles change, issues change, in cartooning as well as in politics.

This volume is not meant to be historical scholarship, but it does offer commentary on the passing scene, thanks mostly to the dozens of public officials who generously offered the personal reflections found throughout the book. They were frank and funny, and they had some great tales to tell. Their stories, along with the caricatures, illuminate the character of the people and the politics of the times.

Hugh Carey is here at his story-telling best, as is a dose of Mario Cuomo's marvelous imagery and passion. Nelson Rockefeller's endless creative energy is on view, along with a whiff of his hard, cold determination to win at all costs. There is a sense of George Pataki and his team, and their battle to win a Republican victory after being shut out for twenty years.

My coauthor, Peter Slocum, brings insights and knowledge of state government gained over twenty-five years, first as a reporter covering the capital and then as a public official working inside the government.

We hope that this book will help readers understand and appreciate the exciting times that kept us both so entertained.

Acknowledgments

DOZENS OF PEOPLE helped make this book possible, giving generously of their time and their insights into the political history of New York. New York has plenty of partisan infighting these days, but we found no reluctance from either party to talk with us for the book. Not all of these individuals appear in the book, because we simply did not have the room, but we learned something new from absolutely everyone we interviewed. Thanks to all.

All quotations in the book are drawn from interviews conducted specifically for this work, unless otherwise noted.

Thanks also to *Albany Times Union* librarians Margaret Williams and Kathy Fry, to Ellen Breslin and Joyce Cassidy and their colleagues at the New York Legislative Library, and to Jim Cassaro at the New York State Archives. All of these people graciously put up with endless requests for all sorts of esoteric research.

Lisa Herbst at the state Republican Committee headquarters and Beth Kemtter in the executive chamber were enormously helpful in setting up interviews and tracking down interviewees.

Thanks also to Dan Button, former senator Tarky Lombardi, and Professor Sarah Blacher Cohen of the University at Albany, who had the original idea for this book. Professor John McMahon of LeMoyne College did valuable Latin detective work.

Senator Martin Connor was understanding of the demands of the book on Peter Slocum's attentions, and many other current legislators were professional throughout. Inside Albany reporters David Hepp and Lisa Bang-Jensen, and their team, offered their vast video library, a wonderful historical collection.

Dick Zander was kind enough to review the manuscript and to share his own extensive historical knowledge. Other valuable commentary on the work in progress came from Michael Benedict, Paul Grondahl, and John Slocum, Peter Slocum's father, who devoted his professional life to public service.

Finally, most important, both authors are deeply indebted to their families for the faith and support they showed, and for the new reservoirs of patience that spouses Ann Sayers and Elaine Rosen drew upon.

1

Nelson A. Rockefeller, 1959–1973

*In those days the way you got to be president was based
on ideas; it was the period of exciting ideas. Rocky was spending
his time as governor, always wanting to be president, trying to
demonstrate that you could do new and exciting things.*

—Mario M. Cuomo

THE TIME WAS 1958, dawn of the Space Age and all the enthusiasm that suggests. The newly wealthy middle class was booming. Optimism was in the air. Possibilities were endless.

And New York, the Empire State, first among equals, had a new governor. He was Nelson A. Rockefeller, multimillionaire and optimist extraordinaire. No stranger to energy and power, he never met a challenge he didn't crave. This man would change the whole idea of governing a state in modern America. He never reached his ultimate goal, the White House, but he had a national impact beyond what many presidents achieve.

In 1958, New York was unquestionably number one, largest in population and wealth, center of business and culture and publishing and broadcasting, arguably the intellectual center of the country as well. The seat of power.

It was an illustrious post, the governorship of New York. Five of the men who held it had already won the presidential nomination in the first half of the century, and two of them, the Roosevelt cousins, made it all the way. Nelson Rockefeller was within his rights to think that it was a launching pad for him, too.

In the process, Rockefeller reshaped New York's entire state government, and re-defined the way people think about governing, about what government can and should do. He left New York with an investment in structures and systems that will live for generations. He also left a financial debt that will live a long time, and a pattern of government behavior that keeps creating debt. Governors to follow spent much of their time trying to beat down, or roll back, the financial engine he created, but also building upon the legacy he left behind. In pre-Rockefeller times, the state

played a minimalist role in higher education, in public transportation, in health care, in environmental policy. Post-Rockefeller, state government was the major player in each of those fields, and more. The laws and programs he generated affected not just the lives of 18 million New Yorkers; they became models and blueprints for action by states all around the country, and sometimes by the federal government, too.

He changed the public's expectations of government for a generation, if not permanently.

His own expectation was that the shortest route to the White House ran through Albany. No other ambition was worthy of his vision and his experience. His record as governor is full of original and dynamic problem solving. And if the problems he attacked seemed to have a national dimension, that wasn't surprising. New York had a lot of the same problems the rest of the country had, and solving problems in big, old, cantankerous New York would make an excellent platform for a presidential run.

He even launched his own national defense plan—backyard fall-out shelters for all homes—in his first term, right at the height of the cold war.

His performance as governor was an almost perfect blending of personality, ambition, and public will. He had a driving, impatient, go-go personality, eager to tackle new problems, bored by the status quo, and excited by challenge. Meeting those challenges, some of which he created, fed his ego and his national ambitions at the same time. He took office at a time of tremendous social change, when the state and nation were ready to move forward into a new era, on toward a new frontier (as President John F. Kennedy would soon say).

He told Congress much later: "I am simply a man who delights in tackling tough human problems. Nothing delights me so much as facing up to a complex issue, with all its confusion, turmoil, and intensity, and trying to pull together the human resources to deal with it."

How did Rockefeller arrive at this point in crusty old Albany, city of Dutch patroons, Democratic bosses, and desultory legislators?

The Road to Albany

Rockefeller actually moved down the stature ladder, from Washington to Albany, in order to climb back up to the very top. He had lots more experience in Washington than in Albany. But the national experience was as an advisor and commission member and "senior official," and he had learned, with difficulty at times, that real power lay elsewhere, in elective office.

Rockefeller worked for President Franklin D. Roosevelt in international affairs, primarily on Latin America, and then for President Dwight D. Eisenhower on both international and domestic affairs. He set up a new organization in competition with

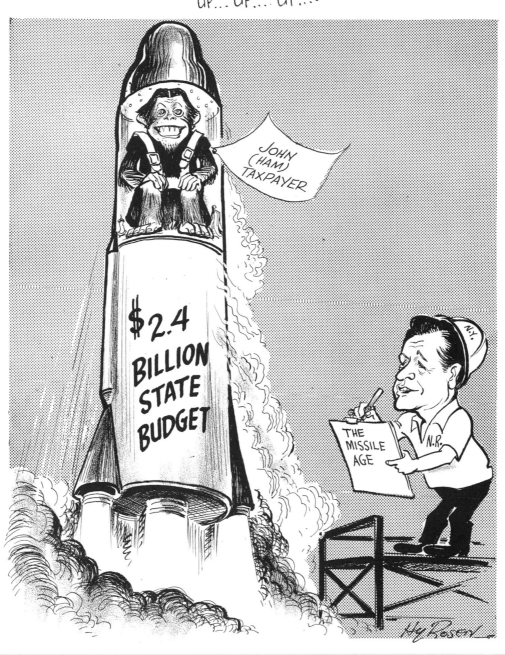

The U.S. space program was taking off, just like New York's governor, in the late 1950s and early 1960s. Rockefeller was elected in 1958, the year after the Russians launched Sputnik. Then President Kennedy promised to put a man on the moon. Rockefeller set the same kind of ambitious goals for New York and no problem was too big for his appetite.

the State Department that helped advance his ideas during and after World War II, but ultimately ran out of allies, and successes.

For Eisenhower, Rockefeller filled a series of roles, eventually becoming deputy secretary of the Department of Health, Education, and Welfare. He is credited by some with the idea of creating that cumbersome agency in the first place, pulling the human services together under one mammoth bureaucratic roof. He hoped to become Secretary of Defense but lost out. Once again he left, vexed by his inability to get done the things he believed needed to be done. When he had to depend on the good will of his bureaucratic or political superiors, frustration was easy to come by. Satisfaction was not.

Elective office was the answer. That's where the power lay. He knew all about the exercise of power in the private sector. As the son of one of America's wealthiest and most powerful families, he was well acquainted with the use of power and influence in midcentury America.

The story of the United Nations is instructive. Rockefeller had worked on the formation of the United Nations under Roosevelt and Truman, and had attended the first gathering in San Francisco.

In 1946, the world body was searching for a permanent home, and Nelson was on the committee looking for a location in New York City. He was determined that the UN should be in New York and even persuaded his brothers and father to offer up a large part of the family estate at Pocantico Hills, near Tarrytown, if nothing could be found in the city itself, but that was too far away for the delegates.

Just back from Mexico the night before the deadline, Rockefeller had a new idea put to him—the Turtle Bay area along the East River, just north of Forty-second Street. A large project was planned there by real estate developer William Zeckendorf. Perhaps Zeckendorf could be bought out and the land turned over to the United Nations. But how to make that happen, as time was running out?

Nelson called his father with the idea, got a commitment for $8 million, and made the deal that very night. The family bought the land from Zeckendorf and donated it for UN headquarters.

When you can make things on that scale happen, when you can make deals on that level, is there any reason to expect you'll be happy as deputy secretary of HEW?

The 1958 Campaign

Rockefeller had a convenient perch for looking over the 1958 prospects. Governor William Averell Harriman had made him chair of the special state Commission on the Constitutional Convention, charged with examining what issues a convention

needed to address. The state constitution declares that every twenty years the citizens must vote on whether to hold a constitutional convention. In this case, in 1957, the voters said "No thanks," but by then Rockefeller had used the commission to hold public hearings around the state on pressing public issues and to generate a series of studies on state government: problems to solve, challenges. The governor had let Rockefeller build a platform for someone to run statewide, of all things, against himself in 1958. Harriman, a Democrat, was thought to be a strong candidate for reelection to a second term in New York. But the national recession wasn't helping him any, and Rockefeller was ready to move.

He announced his candidacy in June 1958, joining a crowded field that was dominated by Leonard W. Hall, former national GOP chairman and a wealthy, influential Long Island attorney. But Rockefeller had a strategy, crafted in part by Malcolm Wilson, the respected Westchester state legislator and Albany insider with strong Catholic ties. Wilson recalled the day of the announcement:

> The other candidates were working on the county leaders. I thought the way to get the nomination was to go right underneath the leaders to those who were going to be the delegates to the convention. And so the day he made his announcement, down at 30 Rockefeller Plaza, after he made the announcement, we came downstairs, and my brand new Buick was parked in front of 30 Rockefeller Plaza.
>
> And so, with Nelson Rockefeller at my side, I started to drive up toward Columbia County, that had only five delegates to the convention.... As we were driving up the Taconic Parkway, we overtook a Rolls Royce, with a very stately woman driving, and at her side, slumped down in the front seat, was a very aged gentleman. And as we passed, Nelson Rockefeller said to me, "That's my father." I said, "Fine." And I pulled over to the side of the road, and Nelson got out, and flagged him down, and he had a brief visit with his father, and then we continued on our way to Columbia County.
>
> That evening, Mertie Tinklepaugh [county GOP chairman] introduced Nelson to all of those who were present, including those who would be the delegates to the convention. And as usual, Nelson during the course of the dinner went out to the kitchen and thanked the chef, and the soup chef and the salad chef, and the waiters. That was his custom. And that was not a put-on. He just was very grateful for the kind of service he received. In all events, that night the delegates had a separate meeting, all five of them, and they voted unanimously to support Nelson Rockefeller. As a consequence the next morning, when the *Herald Tribune* and the *Times* published the news of the announcement of Nelson Rockefeller's intention to seek the nomination, the last paragraph in each of those stories said, "And last night, up in Columbia County, the five delegates decided that they would support Nelson Rockefeller."

Wilson was a veteran assemblyman at the time, with a reputation as a conservative. He had recently gambled on a run for leadership, and had lost. So he had spare political time. But how did he square up with Rockefeller, who had a reputation as a liberal? Wilson remembered:

> The first afternoon Nelson Rockefeller came up to my office in the Bar building, in downtown White Plains, we discussed philosophy. And I told him that one of the things that concerned me was the general perception of Nelson Rockefeller, that he was a liberal. And he said, well, he couldn't really be categorized in any way. He tried to look at all issues on their merits, regardless of the position of other candidates or the position of editorial writers. And that was really what sold me on Nelson Rockefeller.

Rockefeller certainly knew the power of money, and how to use it. His family fortune could be put to good use finding a permanent home for the United Nations. It could also be used to serve his political and governmental needs, as in the generous gifts and loans to key staff members that caused so much controversy when they became public during his vice presidential confirmation hearings. One aide got more than $550,000.

Malcolm Wilson described how Rockefeller offered to use his money in 1958, at an early meeting they had to talk about Wilson managing the campaign:

> He said, "I look around here, I know you're a partner in this law firm. You'll take a lot of time doing this, so I'd like to work out some way whereby the firm could represent our family on some matters."
>
> I said, "There's no way that that could be done, because that would make my efforts on your behalf appear to have been purchased by the Rockefeller money."
>
> And that's the last thing that I wanted to have happen. And that was the basis, really, of the relationship between Nelson Rockefeller and me.

This story seems charmingly innocent by the standards of the 1990s, when financial arrangements between candidates and supporters became the subject of embarrassing court battles and grand jury investigations.

Wilson also financed part of the Rockefeller tour of the state out of his own pocket, periodically getting reimbursed by the Westchester County Republican Committee for the dinners that he arranged in many upstate areas. But ultimately, of course, the Rockefeller family underwrote the costs of that campaign and others to come.

The nomination was won, and so was the general election. Harriman, a patrician statesman who had a serious hearing loss and was not a candidate of the new age, seemed overwhelmed by the eager, driving Rockefeller. The challenger was full of energy and ideas and activism. The incumbent was older, stiff and defensive, the status quo.

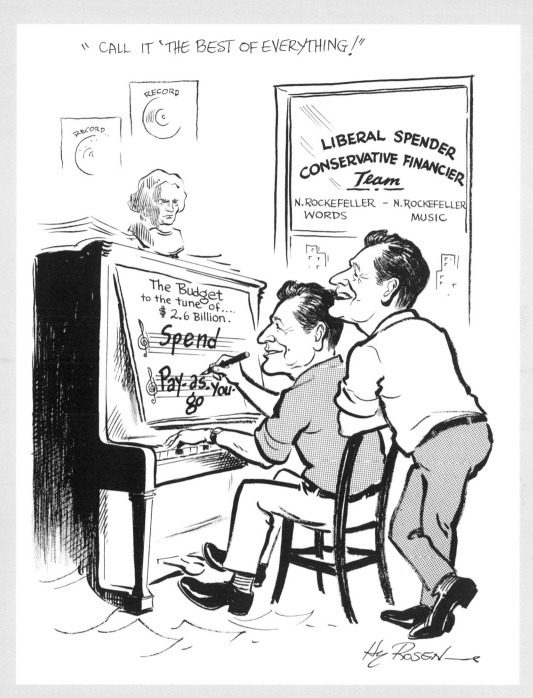

"Pay as You Go" was the sheet music for Rockefeller's 1958 campaign, and later ones, too. But the demands of his vision kept growing and he raised taxes again and again. Then when he needed more money, he became the champion borrower. By the time he was through, nobody would be calling him a "conservative financier." "Creative financier" was more like it.

Landing in Albany

At age forty-nine, Rockefeller was governor, and anxious for action. He pounced onto the Albany scene with gusto, bursting with enthusiasm for the great tasks that lay ahead.

He was ready to move in another sense, too, setting up a small team in New York City to explore running for president in 1960. Even his first inaugural address talked about the needs of Americans as much as it referred to New Yorkers. He spoke about national challenges, and national problems.

Rockefeller's initial gubernatorial rhetoric stuck to his campaign themes of fiscal conservatism. In a warning that drips with irony when viewed from the other side of the New York City fiscal crisis of the 1970s, Rockefeller's first inaugural address cautioned that "we must put the state's fiscal house in order" if New York was to avoid fiscal disaster. It immediately brings up the label question: liberal or conservative? As always, but especially with a public figure who had as broad a sweep as did Nelson Rockefeller, and as long a career, it is too simplistic a question. A simple definition is misleading.

Joseph E. Persico, a Rockefeller speech writer and author of *The Imperial Rockefeller*, said,

> The key to Nelson Rockefeller's personality is not whether he was liberal or a conservative, right or left. He was an activist. You've got a problem, you attack it. So he did that in the state, that made him sound liberal.
>
> You've got a mass transit problem? You enact a program. You pump money into mass transit.
>
> You've got a water pollution problem, you create a Pure Water Authority.

His family background had imbued him with a sense of the importance and value of service. The Rockefellers mixed their money-making with service. Their contributions are spread all over the globe: Rockefeller University in New York, the University of Chicago, the first western medical school in Beijing, the Museum of Modern Art, and more. These institutions are the ones that the family created whole. They supported and nourished many, many more.

Nelson Rockefeller maintained that he turned away from architecture, his first career choice, because he (and the family) felt that it did not offer opportunity for a great enough contribution. It was short on service. Nelson Rockefeller did not go into government to be a caretaker.

The first thing he did as governor was create a whole bunch of task forces (more than forty of them) to consider new state programs. He used this tactic again and again as governor, but not to shelve problems, as other politicians often did. He brought together top people to study a situation and recommend action, not to delay.

The first state aid to private colleges came out of such a task force, and so did the landmark Adirondack Park law, which protected a huge area of wilderness land, private as well as public, against development. These famous programs came later. In his first year, he used the task forces to gain control of the Albany agenda.

Right away, in his first budget, he proposed tax increases. They were nothing compared to what was coming, but they were there: a cigarette tax, a gas tax, and an "adjustment in the personal income tax." In fact, that adjustment in the personal income tax took the top bracket above 7 percent for the first time. (Thirty-five years later, the next Republican to be elected governor would make it point of pride to roll that tax rate back down below 7 percent. This was George Pataki, who as a young man worked on one of Rockefeller's campaigns. But that's getting ahead of the story.)

The late 1950s and early 1960s were a time of extraordinary optimism. The population was growing, the economy kept expanding, and all things seems possible, not just in New York, but throughout the country. The United States and its allies had won the greatest war in history; it was the American Century.

Commissioner John Egan, a career public servant who started out shoveling coal in the prison at Dannemora and would later help supervise construction of the Governor Nelson A. Rockefeller Empire State Plaza, remembered:

> Rockefeller was a lot like John Kennedy in many ways. There's nothing that was too big, and we threw a lot of money at things. One assignment I had was building courtrooms in New York City as part of the dangerous drugs program. We spent about $10 million overnight. It was a failure. We failed. The point was it was a noble failure.
>
> Kennedy said, "We're going to the moon."
>
> With Rockefeller, it was "We're going to clean up the earth. We're going to clean up the air, clean up the water."
>
> We succeeded, in many ways.

Perry Duryea, former Speaker of the Assembly and the Republican leader who fought bitterly with Rockefeller over the size of the budget, remembered the spirit of those times:

> For his time and place, he was the right man.
>
> Take Long Island. The Long Island Expressway, which now of course is described as the longest parking lot in the world, had not reached the Queens border. Now it extends to Riverhead, and incidentally would have gone further if the money and the times had dictated.
>
> The park system. We were all talking about fiscal responsibility, yet we were shilling for a 1960 bond issue to buy park land. It was approved by the voters and we did buy park land. [Rockefeller built fifty-five new parks.]
>
> So people were thinking about economy and balanced budgets, and pay-as-you-go, but they were really giving it lip service.

There were highways (and lots more) to build, and a growing, changing population that was bursting out of the old social strata. It was a time of dramatic social change.

The new wealth of the immediate postwar decade was flowing to the middle and lower middle classes as never before, creating new demands and expectations for education, for housing, for civil rights, and for travel.

SUNY

Perhaps Rockefeller's most enduring legacy is the State University of New York, the largest public university system in the United States and in the western world. New York was the last state to charter a state university, mainly because of the preeminence and political muscle of the state's many private colleges and universities. When SUNY was founded in 1948, the law was written to say that it should not get too big, or too strong: it was supposed to "supplement, not supplant," the proud privates.

For its first ten years, then, the SUNY system was making slow progress toward independent standing and growth. Funding rose from $29 million to $44 million in that first, pre-Rockefeller decade and student enrollment climbed from 26,000 to 39,000. However, the seeds of change had definitely been planted. A first-ever SUNY bond issue was approved by the voters in 1957, and in the post-Sputnik uproar about education, SUNY leaders had convinced Harriman to approve a major new science-centered campus on Long Island, which became the university at Stony Brook.

Under Rockefeller, there poured forth a river of money generous enough to make the whole state bloom with campuses of higher learning.

The degree of the revolution that Rockefeller funded shows in the numbers from his time. In 1958, total New York college enrollment was 380,000, with 63 percent in private colleges. By 1972, the college population was up to 842,000, but the private college share dropped to 38 percent. These numbers represent a profound social change. Attending college, mainly a privilege of the rich, had now evolved into an opportunity for all.

Alton G. Marshall, a senior Rockefeller budget and policy man who became secretary to the governor (chief of staff), recalled that the state needed to build new university capacity, and fast:

> Here we had just a little group of normal schools in SUNY, because a lot of the state's attitude on higher education had to do with letting the big private universities, the Columbias, the Syracuses, the NYUs, the Cornells, run things.
>
> But we were in this crisis situation. There was this essential crisis for higher education, which really was thrust on us by the fact of the GI bill, and the returning veterans [from WW II or Korea] and the shutdown of the flow of New York students

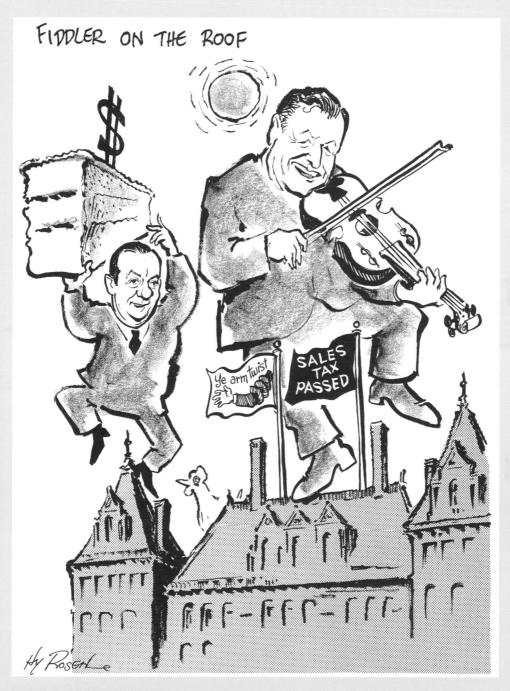

FIDDLER ON THE ROOF

In Rockefeller's heyday, he called the tune and the whole Capitol danced.
This cartoon dates from 1965, when Rockefeller got the Legislature to enact a
state sales tax to help pay for his ambitious spending plans. New York City mayor
Robert Wagner, here taking home a big slice for his home town, helped Rocky
win Democratic votes in the Legislature. "Fiddler" was a Broadway hit at the time.

to other states, which were so goddam full, that they weren't about to take any more New York students. Plus an additional social phenomenon was developing that suggested that more people should have the opportunity to attend higher education than had been the case before then.

It was almost as if, I mean, if you were lucky enough to be in a family that could afford you a higher education, you got one. Other people, "to hell with 'em." It was just tough luck.

You were born to a mason's family? "Well, learn to be a mason, and don't go on to college."

A rapidly expanding SUNY fostered this major social change. The governor's moneyed upbringing did not blind him to the aspirations of others.

A politically astute feature of SUNY's expansion under Rockefeller was its statewide dimension. Formed originally from a loose federation of normal schools dotted around the state, the SUNY geographic sprawl started naturally enough. But what emerged was a complex regionalized and integrated system. Community colleges grew up in every few counties, with each region sharing the costs and enrollment rights for its own citizens. Next came nineteen four-year colleges, which specialized in a variety of subject areas as well as the training of teachers, and several specialty schools. Finally, four major university centers were built, in Buffalo, Albany, Binghamton, and Stony Brook. Ultimately, four medical schools joined the SUNY constellation, in part because of discrimination against Jewish students from New York City by the state's private medical schools.

It is an exaggeration to say that every state legislator had a SUNY unit in his or her district, but many of them did. All of them had lots of constituents sending their sons and daughters to SUNY units, and almost every lawmaker's home district was economically affected by one part or another of the SUNY system. The number of community colleges nearly tripled, from thirteen to thirty-eight.

This geographic spread helped assure that adequate funding would be forthcoming to support the huge system that Rockefeller was constructing. It also made the system harder to manage, and much harder to shrink, when enrollments dropped and money dried up later on. But Rockefeller didn't tend to think about money drying up.

Larry Murray, a key administrator at SUNY headquarters and acting chancellor for a time, remembered using the geo-patronage technique once to get more money for Stony Brook. He went to then–Speaker of the Assembly Joseph Carlino, who was from Long Island, and pointed out that Senate leader Walter Mahoney of Buffalo had slipped a fresh $1 million into the state budget for a science program at the University of Buffalo. Didn't Carlino want the same for Stony Brook as his powerful fellow Republican had nabbed for Buffalo? Murray said that Carlino confirmed the report with

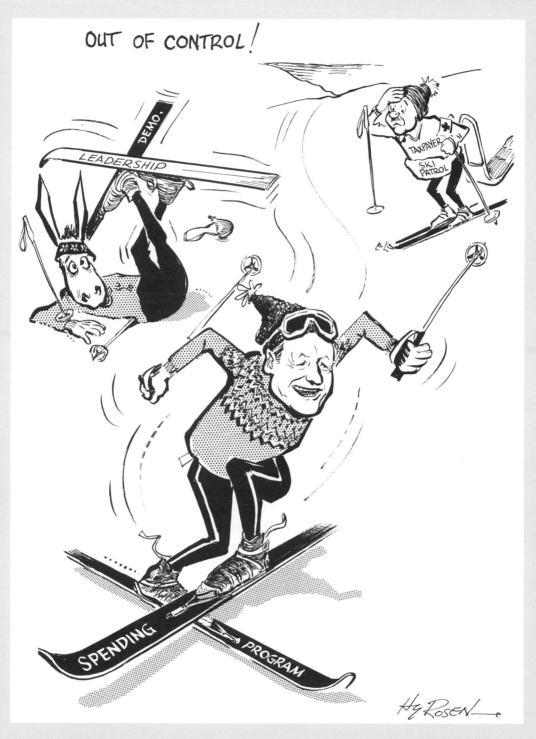

Rockefeller's spending habits were legendary, and he didn't let obstacles stand in his way, for long. Here is a January cartoon dating from the mid-1960s, when Hy Rosen was taking up skiing for the first time. Cartoonists get some of their ideas from their own experience. Little did Rosen know that he'd still be skiing with the O.C. (Out of Control) Ski Club in the late nineties!

his own budget people and gave the word to put in the money for his local science university. Then, Murray recalled, Carlino paused and said, "Make that $2 million. Let's not be pikers here."

The need for physical expansion was so great, the building needs so immense, and the costs so vast that when it came time to attack the SUNY problem, the Rockefeller administration invented an entirely new way to pay for it: moral obligation bonding.

What they did was get the Housing Finance Agency, a quasi-independent government agency, to sell bonds to raise money to build new buildings for SUNY. Student tuition payments were diverted to pay off the bonds, and the Legislature was persuaded to add a little clause saying that if there was any problem, the Legislature would try to make good on the debt. But neither the Legislature nor the public was legally committed, because there had been no vote by the public, as the state constitution requires before borrowing by the state. It was simply a "moral obligation."

This creative solution to Rockefeller's problem was the inspiration of a creative, portly, Wall Street lawyer named John Mitchell, who was virtually unknown outside the world of municipal finance. Mitchell later became more notorious than famous; as President Richard Nixon's attorney general, he had a leading role in the Watergate scandal that brought down the Nixon presidency. But in the early 1960s, Mitchell was quietly helping to open up a whole new way of government spending, called back-door borrowing.

Arthur Levitt, the legendary Democratic state comptroller, who withstood the Republican landslides of the era, saw danger ahead but never had the political strength or will to stop Rockefeller's expansionist activities. The idea that an independent official from another party was counting the money made convenient political mythology. The truth is that Levitt was close enough to the governor to use one of the guest rooms upstairs at the Governor's Mansion occasionally, and Rockefeller just about endorsed Levitt for reelection a number of times.

As Al Marshall saw it, the cause was too urgent for a gradualist approach:

Now a purist in government—I'm not one of them—would have said "Well, hell, that's a dishonest way." My friend Arthur Levitt—he and I were very close—he was just sick. He thought, "You should go to the people, and have them vote the bond issue."

Well, despite the fact that it was a crisis, an identifiable and real crisis, there was no way you were going to get to the citizens and have 'em vote an eight-billion-dollar bond issue to create a state university. No, the answer is you couldn't have got them to. The citizens would not have voted that. So to anyone who said, "you went around the citizenry," the answer is, yes, we did, because we did not believe we could persuade the citizens to vote that size of a bond.

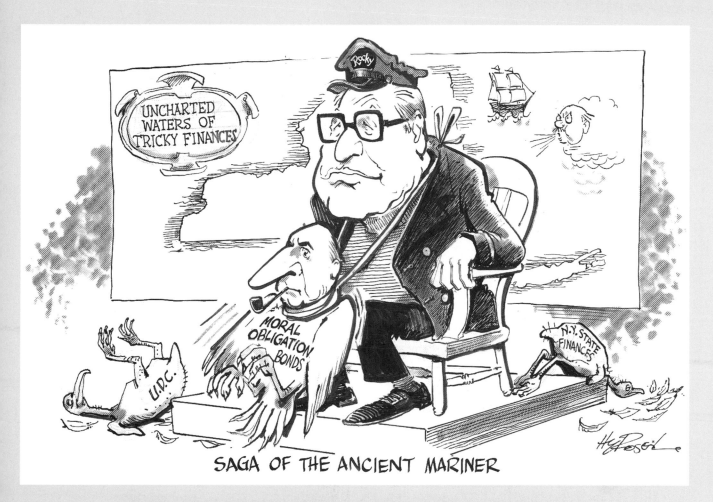

SAGA OF THE ANCIENT MARINER

John Mitchell was the crafty, pipe-smoking Wall Street attorney who helped Rockefeller's men come up with the moral obligation, back-door borrowing that neatly avoided the state constitution's requirement for voter approval of public borrowing. This made great things possible, like the building of the state university, and it gave great power to quasi-independent authorities largely outside the Legislature's control. But it also helped set New York up for a fall when the economy turned sour. Mitchell, later U.S. attorney general under President Nixon, had a great fall of his own, as a key player in the Watergate scandal. He went to jail and lost his license to practice law.

Interviewed in 1996 in a sitting room of the Fort Orange Club, Albany's most exclusive city club, Marshall reflected on the old battles with the leaders of private colleges:

> Here they were in education, and they should have known what the situation was as well as anybody. But you know very well how selfish people can be: "Damn it, we want it, we'll control the education system in the state." But they were in no position to do that. . . . But you couldn't be comfortable that you could come into this place right here and talk with the people here and that they would see it. Nor that you could persuade them.

Public university growth was astounding. It leapt from forty-six campuses and 41,000 students in 1960 to sixty-four campuses and 357,600 students in 1975. The City University of New York (CUNY), which got massive new state aid under Rockefeller, also ballooned in this time. It went from seven campuses and 85,000 students to twenty campuses and 250,000 students.

By 1985, New York had *both* the largest (SUNY) and the third largest (CUNY) public university systems in the world. At the same time, however, New York became the first state to provide direct aid to private colleges. Politically, giving the privates state aid helped reduce opposition to the public growth. And it made sure there were enough classroom seats for a growing population.

The Building Was Great, the Borrowing Was Greater

So there was a deliberate decision to end-run the constitutional provisions requiring voter approval for borrowing. Did the Legislature have a problem with that? Marshall said:

> Oh God, yes. Because this was a Rube Goldberg thing, I mean. I daresay it was one of the largest expenditures up to that time, in that short a period of time, in the history of the state, and to do it through a rinky-dink Housing Finance Agency that was never created to finance a state university. Well, the idea that such a mammoth undertaking would be done without the vote of the public—that was never conceived of when the state constitution was written.

The purposes were valued, the goals were politically popular, but the costs were enormous. From 1958 to the end of Rockefeller's terms in 1973, state payments for debt service increased by 1,633 percent.

Full faith and credit debt grew significantly—hugely, by any reasonable standard—from just under $900 million in 1959 to almost $3.5 billion in 1973. That seems large, and it is. But the growth in so-called back-door borrowing, the kind done without voter approval, made those numbers look small. In fact, state debt *not* approved by

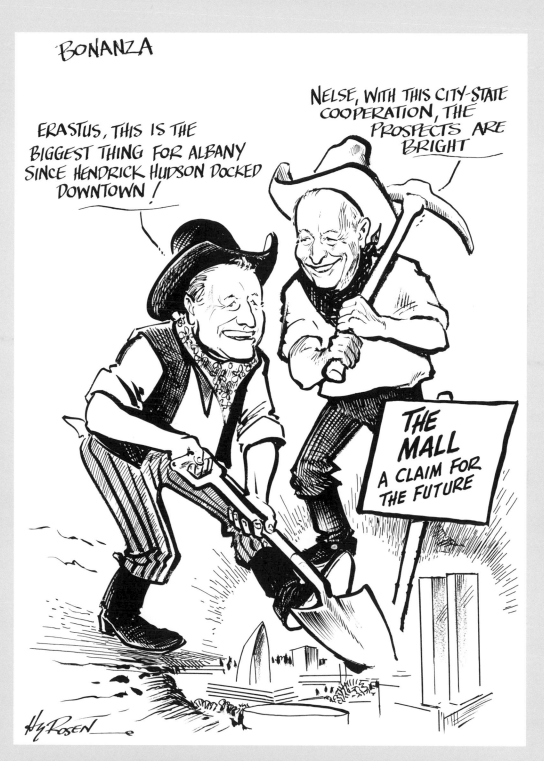

Construction of the Empire State Plaza government complex in Albany made allies of Rockefeller and Democratic Mayor Erastus Corning. This boosterish drawing reflects local enthusiasm for the project, despite cost overruns and long delays. The plaza was later named for Rockefeller. It was Rocky's architectural memorial.

voters shot from $129 million to $5.6 billion between 1962, when the creative financing ideas of John Mitchell, Rockefeller, and friends took flower, and 1972, the year before Rockefeller left office.

As Governor Pataki's first budget director, Patricia Woodworth, remarked twenty-five years later, having the ability to tap the brains of Wall Street was a double-edged sword:

> New York State government and its finances benefit and suffer—we have both the best and the worst—as a result of being in New York. We have the best of the creative financing, which is wonderful, to have the benefit of creative minds that think like that. But it can also be the worst thing because it gives policy makers, decision makers, the ability to avoid making hard decisions.

Actually, it wasn't a matter of avoiding a decision, but rather putting off the day of reckoning, the day when the bill comes due. The politicians and the people both love projects that they don't have to pay for.

The South Mall

If Rockefeller and his men were doubtful about the voters approving massive spending for the state university, even with thousands of their children likely to get a first-class education out of the deal, they had to be even more skeptical about their chances of getting public support for a massive makeover of the state capital complex. This was to be a marble-lined, five-tower remake of downtown Albany, bringing to the staid old capital some of the zest and esthetic excitement that Rockefeller Center brought to midtown Manhattan.

The governor took an intense personal interest in the South Mall project. Wallace Harrison, one of his closer advisor/friends, was the chief overall architect, but Rockefeller himself got involved in details. (Harrison was associated with the governor for decades; he reportedly suggested the site for the United Nations headquarters and later was involved with the Battery Park city plans for lower Manhattan.) What marble would cover the buildings? Check with the governor. Which way should the towers face? Rockefeller would play with the scale model and judge the options.

This project transformed the capital dramatically, giving it a grander skyline than any city its size in America, and it was hard to imagine that anyone would ever build something of these dimensions in a state capital again.

But how to pay for this grand vision, for a capital he'd be proud to show visiting royalty? (One story is that he decided to remake Albany when he had to escort a Dutch princess through the capital's slums on the way to his residence.) A highway or bridge

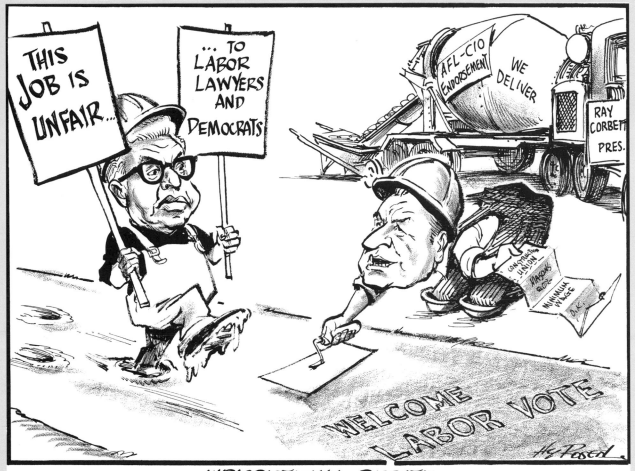

JURISDICTIONAL DISPUTE

Rockefeller's appetite for new construction—some called it his "edifice complex"—extended to the State University, sewage treatment plants, and Albany's South Mall. And the Republican governor's building habits won the affection of traditionally Democratic organized labor. The union leaders loved all those construction jobs, along with other prolabor policies. This 1970 cartoon shows Democratic gubernatorial candidate Arthur Goldberg trying to disrupt Rocky's smooth relationship with New York labor bigwigs. No such luck. Goldberg, a former labor lawyer, U.S. Secretary of Labor, and Supreme Court justice, didn't have a chance against the free-spending governor.

in every county, a sewage plant in every city—those are easy to sell politically. But a cluster of state office buildings in Albany? Why should the voters of Painted Post or Forest Hills want to pay for that? No, this did not seem like good bond issue material.

The answer to Rockefeller's financing problem was found right under his nose, down the street at Albany's City Hall, with the resourceful Erastus Corning II, mayor since 1941. He was the latest (and ultimately the last) of the patrician mayors brought to power by Albany's Irish O'Connell Democratic machine, and the mayor knew his way around money. Corning also knew his way around municipal finance, and as he had all the levers of power one could ask for, he was able to offer Rockefeller the answer to his problems. Albany County, which was not required to get voter approval before undertaking big borrowing, would sell the bonds for the South Mall project, and lease the buildings and property back to the state. The state's lease-back payments would cover the county's costs of paying the bonds, and not a single voter need be troubled by the boring details.

Originally the price tag was $175 million, and the ninety-eight acres just south of the Capitol Building itself would be cleared and rebuilt in five years. Ultimately, the project cost around $2 billion (counting interest), took more than ten years, and several components had to be jettisoned. Replacement housing for the hundreds of families pushed out of their homes was never built, and the highway links through downtown Albany were only partly completed.

Nevertheless, the project succeeded in transforming the face of Albany. A significant part of the city's white ethnic population was rooted out to make room for the Mall, and that helped speed the suburbanization of the region.

Particularly during the earlier stages of its construction, the South Mall was the most controversial issue in the Albany region. The media feasted on cost overruns, construction delays, allegations of large-scale theft, and the periodic denunciations of the back-door financing technique being used to build the whole complex. Rockefeller withstood it all, with his determined grin and jutting jaw, and prevailed, as usual. The labor unions, particularly the building trades, loved him for it, and the South Mall project never became the sort of statewide issue that could hurt him politically. He built the Legislature a huge new building and opened that structure first; that didn't hurt his ability to maintain political support for the overall project.

The tallest structure was named for Mayor Corning shortly before he died in 1983, the whole complex was renamed the Nelson A. Rockefeller Empire State Plaza in 1978, and the taxpayers of the state pay approximately $435,000 per year to Albany County, through 2004.

Rockefeller also exercised his devotion to modern art and his desire to bring art closer to the public by lining the public hallways and gathering places of the plaza with an extraordinary collection of modern art—paintings and sculpture—purchased with

money donated by Rockefeller family friends. The collection is worth millions but often goes unnoticed by the thousands of state workers who pass by every day.

The Empire State Plaza episode is another example of that happy marriage between Rockefeller's political needs and his personality, his ego needs. This was certainly the would-be architect at work, but also the master builder, the political leader with a love of visible legacies built of concrete and steel. He understood that the public can easily appreciate accomplishments that are set in concrete and faced with glass and marble. Physical structures like university and office buildings, housing complexes and sewage treatment plants, highways and parks not only provide the public with necessary functional space, they also directly and powerfully demonstrate the commitment of the government to the people, with evidence of what the leaders accomplish for the people they represent.

Nor did it hurt the Republican governor's feelings that the state's traditionally Democratic building trades unions felt beholden to him throughout his career.

The Environment Governor

Building and construction: they are part of the reason Rockefeller became such an environmental leader. He was not a traditional environmentalist by any means. He was no Teddy Roosevelt nature lover, no bird watcher or outdoorsman. "The Improbable Tree-Hugger" is what Henry Diamond, the man Rockefeller picked to create the first full-blown environmental agency in the country, called him in a paper he wrote about the governor's record.

Nelson's brother Laurance, for whom Diamond worked, had an abiding interest in the outdoors and was vice chairman of the State Parks Council before Nelson became governor. They were the closest of the five Rockefeller brothers.

The environment was a new field politically when Rockefeller came to it: it offered him the opportunity to make his mark. For raw boldness and creativity in public policy, it is hard to match the Rockefeller record on the environment. The policy initiatives themselves were way ahead of their time and had New York out in front of the other states. When it came to paying for these innovations, New York was way out front again, which had both good and bad consequences.

Diamond credited the governor's ability to see ahead, practically and politically:

I remember when Rockefeller went to California in the early sixties, and he was impressed by the fact that at that time, California was spending about $2 billion a year to move water from north to south, from the Sacramento area to Los Angeles. He said, "Our problem [in New York] is not that we have too little water, but that it is dirty." One reason he liked water and sewage treatment was that it helped the environment, and it also meant building things, which he loved to do, and it created jobs. Nelson

liked sewage treatment plants, they are very labor intensive operations, basically a big plumbing operation.

In New York, Rockefeller proposed a bond issue for the voters' approval, for an incredible $1 billion worth of spending on environmental projects. The 1965 Pure Waters Bond issue was designed to build sewage treatment plants all over New York, and to give labor unions and construction companies another reason to support the administration, even if they didn't love "tree huggers."

Al Marshall remembered running a television campaign to "scare the s—— out of the public" about the state of their drinking water. A serious drought that summer didn't hurt the campaign. New York actually had begun a survey of all water sources and pollution points back in the late 1940s, and the health professionals had a comprehensive catalog of problems that needed solving all ready for Rockefeller.

Always ready to lend his own energy to his favored causes, Rockefeller flew around the state promoting the bond (the campaign plane diet was Oreo cookies and sips of Dubonnet), and the voters bought it. New York had a billion-dollar Pure Waters program that was four times the size of the federal government's program. Four times the national commitment, in one state.

Rockefeller even had the gall, or courage, to sell the public the idea that the bond issue was going to "pre-finance" projects that would later get federal aid. On top of all the other fiscal schemes that his administration advanced, this one is remarkable. Here were the voters being asked to approve a first-ever environmental bond issue, with the idea that up to half of it might be repaid by the federal government.

In fact, Rockefeller was right. The federal government *did* significantly increase its spending on water pollution, and New York's well-advanced programs were at the head of the line when Washington got around to handing out the dollars. It was a state/federal bet that Rockefeller won. The fact that he won demonstrated his political savvy and his knowledge of Congress. The same was true for the more celebrated revenue-sharing gambit several years in the future, for Medicaid, and more.

The environmental bond issue is also an example of the way in which Rockefeller's state government was set up to take fullest possible advantage of federal spending programs. "Drawing down" federal dollars became an Albany art form that continued into the 1990s. It wasn't just politics. Under Rockefeller, the state Budget Division assigned smart technicians to figure out how to set up state programs to maximize the federal share. Of course the downside is that when the federal government turns off the money spigot, it sometimes is hard, politically, to turn off the programs.

Rockefeller also pushed New York out front when it came to using government muscle to protect and clean up the environment. The State Department of Environmental Conservation (DEC) was created by a governor's proposal that Rockefeller signed into law on the first Earth Day, 1970. It beat the U.S. Environmental Protection

Agency into being by several months, and was a prototype used by other states as they responded to the evolving politics that Rockefeller had earlier detected.

James Biggane, Diamond's deputy at the DEC and later commissioner himself, said, "In 1970, when Henry took over, you were riding a white horse. You were exactly in tune with the electorate. You know, Henry could do no wrong."

Diamond, with Rockefeller's blessing, took a hard line with corporate polluters and jumped ahead on pesticide regulation—banning DDT before the U.S. did, for instance.

"We were so far out front, it was almost ridiculous, when you think about it," according to Biggane, whose own experience as commissioner for one year, and then as a senior legislative advisor, led him to believe that New York's environmental enthusiasm resulted in such an anti-business stance that the state's economy suffered from it.

At the time, though, Rockefeller was riding the popular wave. He even put out a book called *Our Environment Can Be Saved,* and New York State was a model for other states. The man loved solving problems. Identifying the issues, bringing together the best people to fashion solutions, and then hammering the right pegs into the right holes—that was what made Rockefeller tick.

The dream of becoming president was another powerful motive for action. If a good record as governor could recommend a man for the White House, then building the absolutely best, number one, off-the-charts record of all should make him a sure thing. Of course, it never turned out that way, but not for lack of trying.

New York City and Unions

Nowhere did Rockefeller try harder than in New York City, that only partly governable metropolis that is the nation's first city in so many ways. And in no arena was he so frustrated. Whatever the combination of reasons and motives—certainly a record of failing in the nation's first city would not bode well for a national candidate—Rockefeller seemed to tackle the New York City problems with extra zeal. The stakes were highest there.

He left his mark in many ways: housing, transportation, education, health, and parks. He put state parks in the city for the first time. He spent famously on housing projects and economic development in the minority communities, like the Harlem State Office Building on 125th Street in Harlem. The City University system got major state aid. New hospitals and nursing homes were built with state-backed bonds. Mass transit advanced toward the modern age.

There seems no doubt that, from the mid-1960s on, he was motivated in part by a determination not to get beat out—in the public's mind—by New York City's dy-

namic young mayor, John Lindsay. A Republican congressman from the Silk Stocking district of Manhattan, Lindsay was first elected in 1965, with a healthy dose of Rockefeller money. With his tall good looks and zest for the challenges ahead, he quickly became a media darling. His first day in office he was hit with a transit strike, and his tough, no-compromise response to that immediate crisis earned him enormous political capital.

In an interview, a much older John Lindsay said that the rivalry was overstated by the press, and that if they were not "intimate buddies," they "were not enemies, either. . . . We got on a lot better than people thought. . . . Of course, Nelson tended to want things his own way."

Some of the governor's most difficult interactions with the city came over labor issues. The sanitationmen's strike of 1968 is a prime example. Lindsay-Rockefeller friction was part of that episode.

After the garbagemen struck, illegally, Lindsay demanded that the state call out the National Guard to pick up the garbage. Rockefeller refused. Instead, he got the Sanitationmen's Union leader, John DeLury, out of jail, and negotiated a settlement of the strike with him. Needless to say, this enraged Lindsay, who felt that Rockefeller gave away too much to get a settlement, and that he had been one-upped. The governor got hammered in the press, which by and large took Lindsay's side in the whole affair. The political damage to Rockefeller was so heavy that some people think it hurt his chances for the Republican presidential nomination that year. It is not so clear that Rockefeller could have beat Nixon in their second go-round anyway, but the reputation of being "soft" on a public employees strike didn't help.

Ironically, in that same year Rockefeller was vilified by public sector unions for passing what they called, at one Madison Square Garden rally, "The Slave Labor Act." The new law, named the Taylor Law for the chairman of the advisory panel that recommended it to the governor and Legislature, maintained the existing legal prohibition against public employee strikes. But it also enshrined a right to collective bargaining for public employees, which turned out to be far more significant. The law gave to all public employees—school teachers, bus drivers, nurses' aides—at all levels of government the right to be represented by unions and to be treated fairly in negotiations over the terms and conditions of their employment. This was an enormous breakthrough, which became a model in many other parts of the country. It allowed even lower-level public employees to share in the society's growing middle-class wealth.

Interestingly, the governor's father, John D., Jr., made a progressive name for himself by creating a model labor-management agreement after the 1913 Colorado Fuel and Iron strike and murderous disaster in Ludlow that so tarred the family name. The Taylor Law actually grew out of a smaller-scale disaster, the 1966 New York City sub-

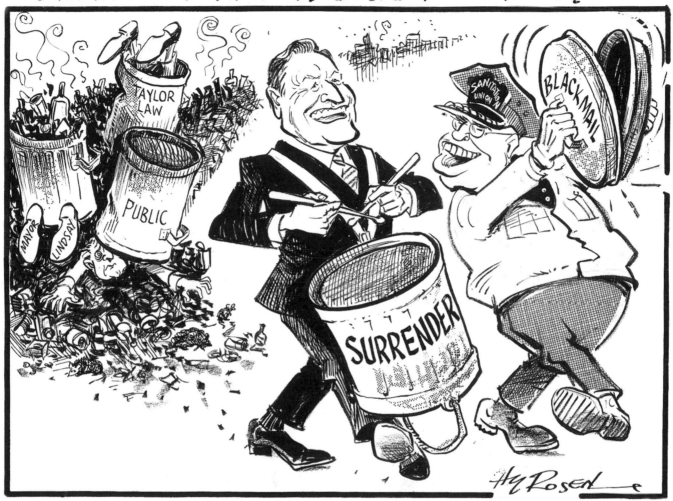

The 1968 Sanitationmen's strike in NYC was a civic and political mess. Rocky was crucified in the press when he got union leader John DeLury out of jail and negotiated a settlement without Mayor John Lindsay. It may have finished off any hopes he had of winning that year's GOP presidential nomination.

way strike. Rockefeller was distressed at the chaotic state of labor relations, what with the Legislature stepping in to grant the Transit Workers Union amnesty from the no-strike law. As a manager, he found it a poor way to run things.

The battle for mass transit money to pay the workers, to run the trains and buses, and to upgrade the physical system, was constant.

Again predating federal action, Rockefeller in the mid-1960s became one of the first prominent advocates for the idea of using "rubber to pay for rail," in other words, using tolls on automobiles to help finance mass transit. This idea later became a major tenet of national urban transportation policy, but it was not the case when Rockefeller first started maneuvering in this arena.

Lindsay's staff first came up with the idea of using automobile tolls collected by the Triborough Bridge and Tunnel Authority (TBTA) to help pay for subways. Rockefeller grabbed hold of the idea and embellished it. Ultimately, he was able to capture the TBTA toll dollars, after working around a lawsuit brought by his brother David's Chase Manhattan Bank. A new umbrella authority called the Metropolitan Transportation Authority (MTA) was created to run the whole region's mass transit, urban and suburban, and to receive those extra toll revenues. It also gave the state unified authority in an arena that had been fractured and confused. (Of course it also deposited responsibility—for the system's failures, for fare increases—squarely on the governor's plate. This would bedevil the two Democratic governors who followed, with dramatic late December legislative sessions called to postpone, or reduce the size of, fare hikes, as the tabloids' front pages kept watch in "End of the World"–size type.)

Rockefeller was so determined on this issue that immediately after his 1966 reelection, he proposed and won passage of a massive $2.5 billion transportation bond issue to get the new MTA some working room. He also let William Ronan, who had been with him from the beginning on the Commission on the Constitutional Convention and had become his secretary and closest advisor, leave Albany to head the MTA.

The TBTA money helped hold the fare increases down, because that money was used for operating expenses. It worked. The basic subway fare was seventy-five cents when the MTA was created, and it was only ninety cents when Rockefeller left office. One official involved in those financing arrangements estimated later that the fare would have been three dollars by the early 1980s without Rockefeller's interventions.

The bond issue was for capital spending, to rebuild and improve the system. That worked, too. Rockefeller made a celebrated pledge to turn the creaky, incompetent Long Island Railroad into the "best railroad in the world in sixty days." The *New York Daily News* ran a box score every day, as if it were following a baseball pennant race,

and at the end even the toughest critics admitted that the improvements were vast. The railroad might not be the "best in the world," but it was markedly better, as Rockefeller had poured in money and management expertise in a war crisis–type operation.

The railroad was a state responsibility because New York bought the private company from the failing Pennsylvania Railroad. Those were the days when government was taking over services and responsibilities, to expand or perform them better. Thirty years later, government was contracting out its jobs to the private sector, in the name of more efficient and cost-effective service for the public. Times do change.

Absolutist

It was typical of Rockefeller to set such absolutist goals of perfection: "Best in the world." He didn't aim for "lots better," or "major improvements." He went all the way.

Joe Persico, the speech writer, believed that Rockefeller "hated to ever qualify what he wanted to do." Persico remembers being upbraided for trying to tone down a 1970 campaign crime speech: "'Why are you sliding off of it?' the governor asked. 'We're going to *eliminate* crime.'" Persico had tried for some phrasing about "reducing," rather than "eliminating" crime.

The 1970 State of the State Message contains similar absolutist phrasing. Among other things, Rockefeller announced plans "to eliminate poverty and injustice and to make the opportunity for good education and good health a universal right." No chief executive who followed Rockefeller would ever dare to say such a thing.

Crime: Drugs and Attica

Arguably, Rockefeller's two biggest failures were in the same field—criminal justice. One was an obvious disaster at the time, the Attica prison riot of September 1971, which claimed forty-three lives. Rockefeller was widely thought to have mishandled that crisis, not exercising enough direct command and control. The police assault that recaptured the prison after four days of unsuccessful negotiations claimed forty of the lives lost in the entire episode, and the Special State Commission on Attica found that the state police who conducted the assault ran amok, killing inmates needlessly and shooting a number of the guards who had been taken hostage in the confusion. "With the exception of Indian massacres in the late nineteenth century, the State Police assault which ended the four-day prison uprising was the bloodiest one-day encounter between Americans since the Civil War," the commission's 1972 report concluded.

Rockefeller didn't go to the prison and was widely criticized for that. He seemed to hold himself a little apart. Budget director Richard Dunham remembered the fateful climactic day, when he was in the room alone with the governor:

In every other crisis, he was always in the middle of it. He loved big problems to solve. He'd wade right into them. And I never understood why this was different. Now, I'm not a practicing psychologist, but somebody was telling me the reason why was that if you look back to the Ludlow strike in 1913, when the Rockefellers sent in the National Guard and women and children were killed, that really affected the family. And all I can think of is that Nelson remembered that.

I'm sure people told him "don't go." But my point is, it was so atypical, uncharacteristic. To my knowledge, and I was the only one there in the room with him, he wasn't on the phone directly. I'm not saying he didn't get reports some other time, earlier. But I had the feeling that he just wasn't that involved. So it wasn't just a matter of not going there. But it was not a hands-on thing.

The tragic episode had powerful racial overtones because the rioting inmates were mainly black and embraced some of the Black Power rhetoric of the day. It soured Rockefeller's excellent relationship with a segment of the black community and civil rights movement, which he had long supported politically and with his own personal fortune. He gave generously to Martin Luther King's Southern Christian Leadership Conference, although he had no sympathy for the more radical activists who followed King, or for the antiwar protesters of the time.

If Rockefeller's engagement was a question at Attica, there was no such doubt when it came to the tough drug laws that he rammed through the Legislature in 1973, and that from the perspective of a quarter-century's experience are widely viewed as a failure. He campaigned around the state and nation for the "life without parole for pushers" proposal, even testifying at a legislative hearing and browbeating opponents into submission. All this came after years of expensive struggle. His so-called drug wars—he may have started the first drug wars in America—were failures. He spent billions on treatment; he tried more courts and more cops. In final frustration, he turned to long prison terms, absolute mandatory jail time, as the answer.

State Senator Dale Volker, a Republican from the Buffalo area, was a young assemblyman back in 1973, and he was among those who thought Rockefeller's plan was too "Draconian." He remembered the political warfare:

Of course this was the same time I had my phone line tapped. So did a number of other guys. Rocky was a very tough guy. One night we were walking down State Street and we saw his limo coming down. He had his driver pull right across the sidewalk in front of us. He said nothing to me, but looked straight at my father [a retired assemblyman] and said, "Have you convinced your son?"

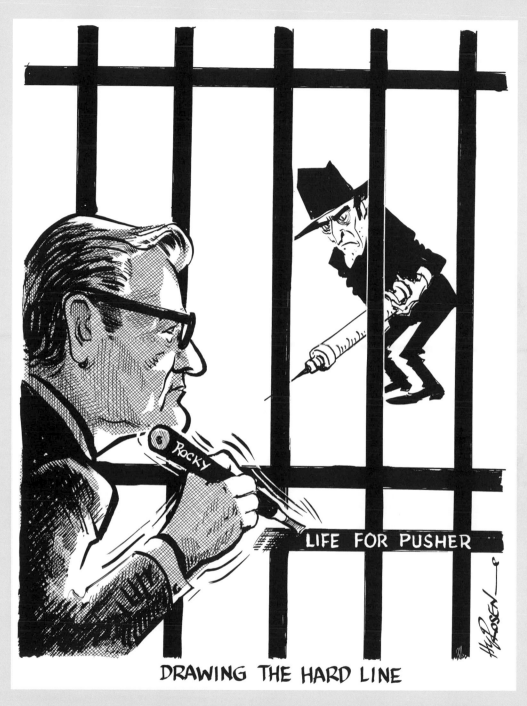

DRAWING THE HARD LINE

The tough "life without parole" Rockefeller drug laws came from his frustration at not being able to solve the drug problem any other way. He tried many times, at great expense. Many legislators believed a personal friend's experience spurred Rocky. Others thought that he was trying to counter his liberal image, both nationally and in New York. The laws didn't do anything to solve the problem.

We went on down to Jack's [a local restaurant] and when I got upstairs, the first thing was I saw the governor and he came and stuck his finger in my chest and pushed me right across the room against the wall. He said, "You'll be making a big mistake."

When asked if he was sure the phones were tapped, and that the tapping was related to the drug law, Volker responded, "Oh yes. There is no question. I know they were tapping the phones. We detected it at the time. Later, I had a friend who worked for Rockefeller call me up and say how he really felt bad about tapping my phone above all, because we had been friends, and on the police force together. But hey, what are you going to do?" Secret tapping in high places was not unique to Albany in those days; 1973 was the year that President Richard Nixon's own secret White House tapes helped drive him from office. Presidents Kennedy and Johnson also taped conversations.

Rockefeller's drug proposal was modified somewhat, largely because a conservative Republican assemblyman and former federal prosecutor named Dominick Di-Carlo from Brooklyn refused to let the original bill out of the Codes Committee that he chaired. The governor answered complaints about courtroom overload by proposing to create one hundred new judgeships (patronage to spread around in exchange for votes). There were some significant changes, but the basic plan passed, and became a national model for a society fed up with its inability to stop the drug epidemic with treatment programs. Volker voted for the amended bill and still supports it as modified in the years since.

Many others involved think that the law was misguided; it locked up young kids being used as drug couriers by big-time dealers, and allowed judges no discretion. Even Governor Pataki, tough on crime as he was, proposed to amend the law for nonviolent offenders in his first year. Retired Senate Leader Warren Anderson said:

> One of the issues that I had some problem with him on was the drug law. He was concentrating on the penalizing, I mean everyone thinks it's the worst problem, and it is. If you were going to ask me what has changed government more than anything else in the last forty years, I'd say drugs. You know, what it's done to our criminal justice system, what it's done to our society generally. And Rockefeller saw that and felt that more severe penalties might solve it. And it's a bigger problem than that.

Anderson did not think the law really solved the problem. He said,

> Actually, if you ask me what is the solution, I'd have to say I don't know. As long as there is a demand, and people are stupid enough to get themselves hooked, I don't know. Rockefeller saw that through an individual instance, as I recall. It was some friend of his family's who had become addicted. You know, some bastard was selling it. I know it was not a fictitious illustration that got him really going on this subject.

Other legislators recalled the same thing, though some thought Rockefeller's motives were more purely political; he quit Albany at the end of 1973 to position himself for one last presidential attempt as a more conservative candidate than he once was. Richard Dunham, budget director at the time, recalled: "We were all panicked. And we all thought that it could be stopped in a heartthrob by putting 'em all in jail. Well, that's part of your jail problem today. They found ways around it, of course, the big guys get out of it and you get the little guys who are selling drugs, and they're all in our prisons."

The drug law certainly didn't prevent the crack cocaine epidemic from destroying vast neighborhoods in the 1980s. It did help fill up New York's prisons, and it forced Governor Cuomo to build more and more of them; by the late 1990s only 29 percent of New York's prisoners were behind bars for violent offenses, while 47 percent were sent away for nonviolent drug crimes.

Medicaid

Patience was not one of Rockefeller's virtues. He didn't like it when people opposed him, he didn't like it when problems resisted him, and he didn't like to dicker over small details when there was a job to get done.

When the federal government's War on Poverty offered states money to help finance health care insurance for the poor, New York jumped to expand its existing program. There was a great debate in Albany as to what the income eligibility level should be. Robert F. Kennedy, a U.S. senator at the time, was leaning on Anthony Travia, Democratic Speaker of the Assembly, to make the level as generous as possible. And what would it cost the state? Nobody seemed to know. Al Marshall, negotiating for Rockefeller, recalls being up on the Speaker's podium in the Assembly Chamber with Travia, because Travis wouldn't take Marshall's calls from downstairs anymore. Marshall was estimating a $600 million price tag, but he later admitted that the governor and his staff didn't really know what it would cost.

Only one member of the Republican-controlled State Senate voted against the plan, though. That was a farmer from Big Flats named W. T. Smith, nicknamed Cadillac Smith because one year he bought a brand new Cadillac with the money that the federal government paid him not to grow crops. Given that background, it's not surprising he was skeptical of the assurances that Rockefeller's men gave him about Medicaid: "I could never figure out what it was going to cost. . . . I went to three or four different offices."

Right away, the costs skyrocketed. Soon the $600 million figure was left way behind. "God, the first year was $1.3 billion My estimate was way off," said Marshall. It

turned out that nearly one-third of New York's families were eligible, and New York was drawing down as much money as Washington had allocated for all the states put together.

Cuts had to be made, with great difficulty. Taking away a benefit or a program from constituents is always an extremely painful political process, lots harder than bestowing one in the first place. Experience teaches that the savings from cutbacks are never as great as promised. Not only poor families had benefited from Medicaid; major hospitals and nursing homes and clinics had gotten hooked, and the political combination of all those forces, including the union workers employed at those facilities, made it extraordinarily difficult to roll back the program. Ever since those days in the late 1960s, the state Division of the Budget has engaged in a ritual dance with the Legislature over Medicaid cost control, trying to chip away at the program here and there to save money.

The Medicaid cost explosion eventually led to a tax revolt by some upstate counties and contributed to the New York City fiscal crisis (because New York makes counties and New York City pay half of the half of Medicaid that Washington doesn't pay). And nearly thirty years later, George Pataki made massive Medicaid cuts a centerpiece of his budget-cutting strategy.

Revenue Sharing

Rockefeller was compelled to help local governments, in part because of Medicaid, and he wanted to regularize the system of state aid to insulate himself from the continual political pressure of Mayor Lindsay's demands for more aid for New York City. It was also a way to boost his case for a federal revenue-sharing program, which became a great cause for Rockefeller and is a program for which he is in many ways responsible.

Gearing up to run for a fourth term in 1970, Rockefeller unveiled his own state revenue-sharing plan, pledging 21 percent of the state's income tax receipts to local governments. The plan passed, and he went around the state touting this "no strings" $598 million assistance to localities. At the same time, he went around the country pressing for a federal revenue-sharing plan.

Governor Carey was drafted to Rocky's cause back then, when he was a congressman from Brooklyn. Rockefeller was having trouble with his own budget, and he wanted to use the promise of federal revenue sharing to balance it. Republican Speaker Perry Duryea needed convincing. Carey was a member of the House Ways and Means Committee and close to its chairman, Wilbur Mills of Arkansas, who was not a fan of revenue sharing.

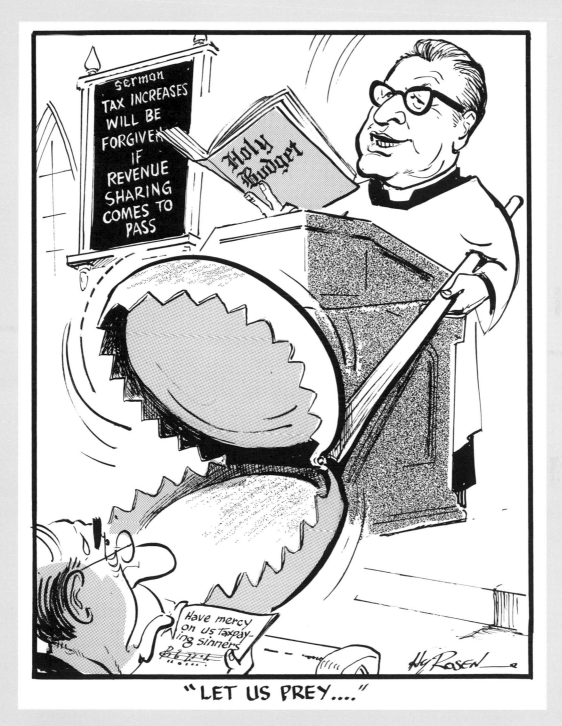

"LET US PREY...."

By 1971, New Yorkers were running out of ways to pay for Rockefeller's ambitious programs, and he campaigned to have Washington share more money with the states, via "revenue sharing." He succeeded, and used the promised federal money to balance his budget. This cartoon is skeptical, to say the least.

As Carey remembered the story, he was in New York Christmas shopping for his large brood of children when he got word that the governor wanted to see him. Carey arrived at the governor's apartment and found a gathering of political figures: Brooklyn Democratic chairman Meade Esposito, last of the old-time city bosses; Stanley Steingut, the Assembly Democratic chief; Rockefeller fund-raiser Jerry Finklestein; and others. They were all sitting around cracking nuts and throwing the shells in the fireplace.

Rockefeller asked Carey, "You know Wilbur Mills? We want you to get him to back revenue sharing."

"Oh my God," retorted Carey, "He thinks revenue sharing is the worst idea that's ever come along."

After some further discussion, apparently including some mention of the political calendar, which would soon include the redrawing of all congressional and legislative districts, Carey was persuaded to put through a call to Mills in Arkansas.

Carey said, "I'm here with the governor, and reapportionment is coming up."

Mills's response was, "What does he want?"

"A letter from you saying you'll consider revenue sharing," Carey answered.

Mills agreed, Carey said, and instructed the New Yorkers to bring him a letter to sign, since he had no office help at hand. James Cannon, a Rockefeller aide, flew down to Arkansas to get the prized signature, and brought it back to the governor.

"Nelson put it under Duryea's nose and that was it," said Carey. "Can you imagine balancing the budget of the state with a letter—for $300 million?"

Rockefeller had an ability to assemble all political weapons at his disposal and create a few new ones. He had great influence in the Legislature and an ability to affect the reapportionment decisions rather significantly. Therefore, it was important to Carey and Mills to please Rockefeller in order to help maintain a Democratic Congress. Carey's recollection of that Christmas meeting is of a roomful of Democrats, at a time when the Republicans controlled both houses of the Legislature. A frequent Carey quip: "My predecessor as governor owned one political party and leased the other one."

Farewell

The national economy went up and down during Rockefeller's time, and ultimately the state's revenue base began to suffer. In the late 1960s, the predictions were that New York would grow to more than 20 million people. It didn't happen. Jobs and people left, and the Empire State's stature waned. The carpet factories of the Mohawk Valley and the steel mills of Buffalo were among the many manufacturing plants that left for sunnier climates, lower-cost labor, and lower taxes.

"I WOULD LIKE TO THANK MY PRODUCER, MY DIRECTOR, MY CAMERA MAN, MY WRITER, WITHOUT WHOSE....."

Rockefeller dominated the Republican party with absolute authority, controlling the selection of statewide candidates and providing most of the money for campaigns. This domination hurt the Republicans after he left, because the party had lost its ability to stand up without him. But meantime, it was his show, and his candidates in 1970 were Wilson for lieutenant governor, Lefkowitz for attorney general, Regan for comptroller, and Goodell for U.S. Senate. This cartoon appeared at Academy Awards time.

To suggest that Rockefeller's big-spending ways are to blame for it all is silly. Other northeastern and older industrial states suffered the same troubles. Massachusetts, New Jersey, Michigan, Ohio, and Pennsylvania became known collectively as the "Rust Belt," which couldn't compete with the fresher, newer, cheaper "Sun Belt." Business leaders made bad decisions that hastened this regional disaster, declining to rebuild aging plants and failing to invest in technological change, which left them vulnerable to competition from abroad. The St. Lawrence Seaway, completed in the 1960s, wiped out the economic importance of the Erie Canal, and the cities strung along that corridor suffered as a result. Succeeding governors have had to deal with the fall-out.

Rockefeller did show signs that his earlier, unbounded faith in the state's ability to attack, if not solve, all problems was waning. It was hard for him to slow down and admit that a state, his state, the Empire State, might not be able to do everything that needed doing.

Al Marshall remembered getting into a fight about this:

> I wrote part of the first draft of the State of the State message in 1970, and I started off the first sentence or first paragraph: "We have made New York State noncompetitive." And he called me and raised hell. We had quite a long discussion. I said, "The fact is, we have undertaken a lot of programs other states have not undertaken and we've undertaken them in rather massive proportions, and we've increased our tax load to the point where, from the tax burden standpoint, we are noncompetitive with other states."
>
> He was impatient with the federal government, even before the Great Society. He'd say, "God damn it, that's a problem. Let's do something about it."
>
> You might say, "Yeah, but that's a federal problem, of a magnitude or a nature that the state can't take that on."
>
> That was not a very compelling argument to him.

That 1970 State of the State message does contain a passage about New York's non-competitiveness, noting that New York's state and local "taxes combined now represent the highest tax effort of any competitor state." The governor used that as an argument for federal revenue sharing.

Rockefeller's ambitious extension of state activities produced an incredible array of investments. That so many of them turned out so well is a testament to the vision of the governor and the amazingly able staff that he worked so hard to assemble and keep by his side. The impatience and flat-out determination of the leader got things done that would ordinarily take a generation. On the other hand, some of those projects should have gone a little slower.

In what would be his last campaign, in the fall of 1970, Rockefeller explained his approach to an audience of newspaper publishers in Albany. He also admitted some mistakes:

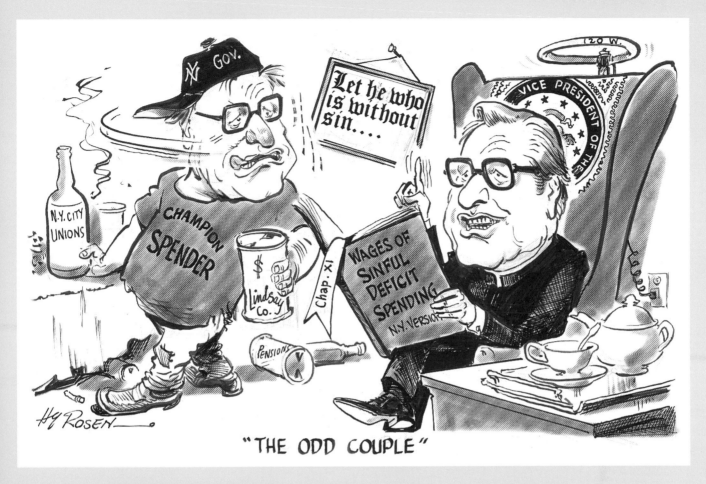

"THE ODD COUPLE"

This drawing was published in 1975, when Rockefeller was vice president and New York was teetering on the edge of financial ruin. Rockefeller's spending as governor was part of the reason. This "doubles" cartooning technique was a useful device for showing the two sides of one man's character or record, as Rosen did earlier in Rocky's career (see "Best of Everything").

I'm running this time for the same basic reasons I ran the first time: because I like to do things for people; because I want to see state government continue to be creative in this period of change; because I like to think of myself as an optimist, an idealist, an activist, and a doer—an activist in that when I see a problem my immediate reaction is to start work on a its solution. . . . I recognized that this country has been very good to me and my family. In return, I wanted to do something for people.

And so I went into government and then politics. I believed I could best translate my intentions into constructive action in government—where the real action is. . . . I have not solved every problem or righted every wrong. If I had, I would have no reason to run again.

And I've made mistakes.

But most of them were the result of trying to move too fast or do too much. I suggest that these mistakes are preferable to those resulting from timidity or inertia.

2

Nelson Rockefeller's National Dreams

I thought of Rockefeller as a New Deal Republican.
　　　—Barry Goldwater

STRANGE AS IT SEEMS, this most successful governor of the Empire State—the only governor ever to win four four-year terms—couldn't ever get his party's presidential nomination. He strove and he struggled. He dreamed, he schemed, and he tried again and again. But he came up empty.

In 1960, the prize went to Richard Nixon, the sitting vice president. In 1964, it went to Barry Goldwater, symbol of the Western and conservative tilt of the national Republican party. They both lost. In 1968, Nixon got the nomination again and that time won the White House. In 1972 Nixon ran for his second term, won, and then had to resign in 1974 because of the Watergate scandals. Gerald Ford took his place, and appointed Nelson Rockefeller as his vice president. Finally he was close to the throne. But then Ford felt compelled to dump Rockefeller from the ticket in 1976 to placate the conservative wing of the GOP and hold off Ronald Reagan's challenge in the presidential primaries.

Ultimately, Ford did beat back Reagan. But there was a brief moment, when things looked shaky for Ford, even after dumping Rockefeller, when the New Yorker thought he might have one final shot. Rockefeller's last state Republican chairman, Richard Rosenbaum, recalled the story:

> I was sitting in my Albany office going over the numbers, and saw that with the Super Tuesday primaries coming up in the South, Reagan might be able to stop Ford. I had this idea if New York came out for Ford before that, we could slow down the momentum.
>
> I called Rockefeller and said. "I would like you to call George Hinman, Bobby Douglas, and Hughie [Hugh Morrow] together to talk about something important." [These were Rockefeller's primary advisors and his national campaign people.] I flew down and we had dinner and talked this over. It was my theory that if the New York

delegation would come out for Ford before the Super Tuesday primaries, it would slow Reagan's momentum and Ford would have enough delegates so Reagan could not win. There was a delay by Rockefeller. I realized what he was thinking—Rockefeller really thought that Ford and Reagan could deadlock and he could come up the middle and get the nomination.

We stayed up 'til four in the morning. There was no decision. I told him, if Ford loses the nomination, you are going to get blamed.

Well, he called me about ten, later that morning, and said, "go." Get the delegation together for Ford.

So that was it, farewell to the very last chance. It must have been hard to give it up, eighteen years after first getting elected governor, running up victory margins that other people could only dream about. He won reelection to the unprecedented fourth term in 1970 by a margin of 730,000 votes. That was the margin of *victory*. Gerry Ford, a congressman, had never even had 730,000 people vote *for* him.

Rosenbaum called the New York delegation together in Albany and greased the nomination for Ford. When it came to Republican politics in New York, Rockefeller made the rules. More than that, he decided on the games. He was the absolute master. On the national scene, however, he was anything but masterful. He was a failure. Some of it was bad luck; some of it was bad timing, bad judgment, and bad campaigning.

If his New York record shows a man who landed in the right place at the right time, the national experience was just the opposite. He was the wrong man in the wrong place at the wrong time—every time.

The 1960 Race, Nixon's Turn

In 1960, Nixon was Eisenhower's heir apparent, the legitimate successor after eight years of service as vice president. The fact that Nixon was not personally very popular, nor much beloved by Eisenhower himself, meant there was an opening.

Rockefeller was eager and willing to take advantage. His first election in New York in 1958 brought him huge national publicity as a fresh, vigorous new Republican. The Rockefeller name and money gave him the chance to capitalize. So at the same time he was learning how to be governor, Rockefeller hired a separate staff just for the nomination and traveled the country in late 1959 looking for support. He found it in the press coverage and in public gatherings. But some Republicans did not respond well. Courted by Nixon and his partisans for years, they were loyal to the vice president. The party regulars in the Midwest and West were cool to the incredibly wealthy activist governor from the East.

Would the rank and file have reacted differently if "Rocky, the Great Campaigner"

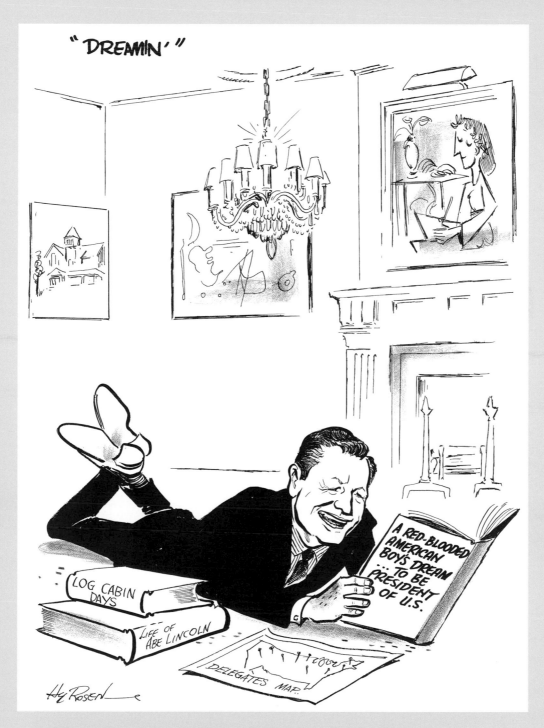

The governor's mansion in Albany was decorated with Rocky's magnificent modern art collection, including Picasso tapestries. But he was dreaming of hanging that art in the White House and plotted for years to follow in Abe Lincoln's footsteps.

had shown his stuff in primary battles against Nixon? They loved him in Watertown and in Elmira, why not in Peoria and Portland? The issue never came to a test. Rockefeller was discouraged by his poor showing with the party, and he pulled out of the race the day after Christmas 1959, before the primaries began. Looking back, maybe 1960 was his best shot to make the White House. He was fresh, free of the political baggage that he acquired as time went along. And the country hadn't yet turned sour on the activist government approach that he typified.

In the general election, Nixon lost to Kennedy by the smallest margin in American history, and he would have won with a shift of a few thousand votes in Illinois and Texas. Was a Rockefeller win plausible? With his strong support of civil rights, he might well have won those few extra votes in Illinois. And why not New York? New York's forty-five electoral votes and only five more would have been enough.

The "what ifs" pile up. But that was the general election, and Rockefeller couldn't get the nomination.

An underlying reason was that the Republican Party was moving away from him just as he arrived on the national scene. It was shifting its geographical power center from the establishment East to the new Republicans in the South and West. The national party was already more conservative than were the easterners. The power elites who helped put Eisenhower in office in 1952 by blocking U.S. Senator Robert A. Taft of Ohio, the heartland's favorite, were losing out to a new generation of leaders. These new folks didn't particularly like the New York establishment crowd either.

1964: Barry and the New Baby

The bruising battle of 1964 within the Republican Party dramatized and even solidified this shift of power, and Rockefeller carried the banner for the losing side. When the political season opened, Rockefeller and Goldwater were the two leading candidates. President Kennedy expected to face Rockefeller for his reelection run.

By the time voters actually started casting ballots, the political world was very different. Lyndon Johnson was in the White House because of Kennedy's assassination, and Rockefeller had created a huge stir, perhaps inflicting a fatal political wound, by getting remarried only a year after his 1962 divorce. Perhaps Rockefeller just never understood how much that would hurt him nationally; he survived the divorce and got reelected in New York by more than half a million votes, didn't he? But a national election was different, and getting remarried so soon was also different.

Maybe he thought he could get away with it; maybe he didn't care. Either way, he paid a price right away. He took a dive from 43 percent to 29 percent in the national polls after the wedding, while Goldwater went the other way. In the New Hampshire primary, he and Goldwater both got beaten by a late write-in campaign for Henry

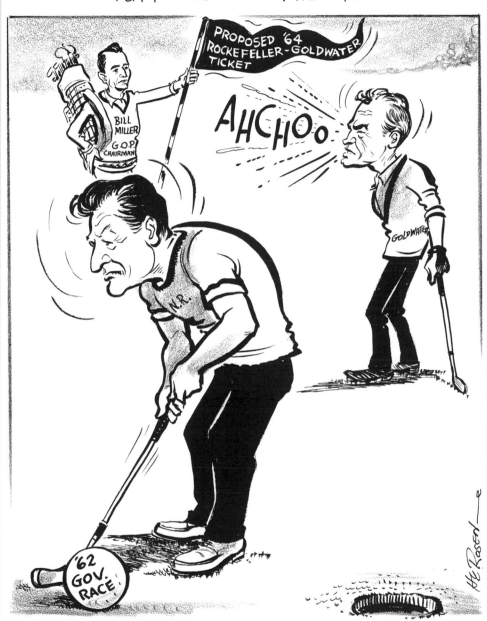

Rockefeller and Barry Goldwater of Arizona were never a happy twosome, as this 1962 cartoon predicts. There was talk about them pairing up, but they went head-to-head instead, battling over the future of the national GOP. Goldwater won the battle, and the 1964 presidential nomination, as the party turned away from the liberal easterners. In Goldwater's eyes, Rocky was a "a New Deal Republican." Ironically, national GOP chairman Bill Miller, a western New York congressman, ended up as Goldwater's vice presidential running mate.

Cabot Lodge of neighboring Massachusetts. Goldwater, who wasn't likely to win there anyway, finished second. Rockefeller had expected to win and was crippled by his third-place finish, but he soldiered on, and actually won the next primary, in Oregon.

Then came the ultimate test, California, the state about to become the most populous in the union, and the site of that year's GOP convention. California was also becoming the next power center of the Republican Party, with Ronald Reagan as governor and all those votes. Even if Rockefeller didn't have a realistic chance of winning the nomination (Goldwater had so many committed delegates and many others disliked Rockefeller on principle), he was by then engaged in a holy war against Goldwater's brand of extremism. He meant to "save" the party from the right wing. The problem was, that's where the party was, but without Rockefeller.

Rockefeller put up a valiant fight and was actually leading going into the last weekend before the California vote. Then he flew home to his wife, Happy, who gave birth that Saturday night to Nelson Junior. The blessings of the event did not extend to politics. This reminder of Rockefeller's divorce and quick remarriage killed him in California, where overnight his lead evaporated. Two million Californians voted that day, and Goldwater won the primary—and sewed up the nomination—by just 60,000 votes, 3 percent.

The ensuing convention at San Francisco was Barry Goldwater's show, where he launched the conservative crusade that led to the worst presidential defeat in American history. The slaughter was so great that the Democrats even won control of the New York State Senate, which even Watergate couldn't do for them again. It was at that convention that Rockefeller faced down an angry crowd of Goldwater partisans, enduring ten minutes of venomous booing as he tried to argue for moderating amendments to the platform. Some say it was his finest, most courageous public hour.

Rockefeller pretty much sat out the general election, earning himself more enemies within the GOP. He declined even to say whether he would vote for Goldwater.

In a 1996 interview, an eighty-seven-year-old Goldwater was mellow on the subject of his old opponent from the East. Goldwater sat in his hilltop home outside Phoenix and succinctly summed up Rockefeller's problem:

> I thought of Rockefeller as a New Deal Republican. The idea of spending money to get the economy going came from Roosevelt. The economists told Roosevelt to spend money to jump start out of the Depression.
>
> One-on-one we were OK. The media blew the feud out of proportion. I went to Rockefeller's funeral and sat in the back of the cathedral. Jack Javits [U.S. senator from New York and stalwart of the eastern liberal establishment] saw me and asked me to come up front. I didn't want to attract attention.

In 1968, Rockefeller's stand against Goldwater cost him again. He still wanted the nomination, but knew the party did not forgive him for helping to brand Goldwa-

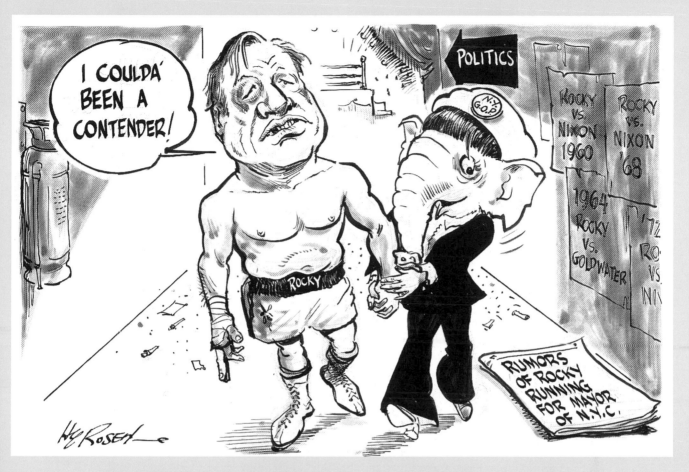

Like a prize fighter who doesn't know when to quit, Rockefeller kept running for president again and again. After his last shot, there were brief rumors about him running for mayor of New York City. The bandaged finger refers to that famous gesture he flashed at a heckler during the 1976 campaign. The first of Sylvester Stallone's *Rocky* movies was playing.

ter an irresponsible extremist. So he had to sit out the early rounds, using his own resources to sponsor George Romney of Michigan as the moderate-liberal alternative to Nixon. When Romney's candidacy fell apart by March, the governor got ready to move. That put two New Yorkers-come-lately in the race, Rockefeller and U.S. Senator Robert F. Kennedy, who jumped in when President Johnson flopped in the New Hampshire Democratic primary.

Things happened fast that spring: Eugene McCarthy nearly beat Johnson in New Hampshire because of the Vietnam War; Kennedy jumped in; Johnson bowed out; Rockefeller jumped in; Martin Luther King, Jr., was assassinated; Kennedy was assassinated; Rockefeller appealed to the Kennedy vote; Hubert Humphrey rose up. Two things stayed steady: Nixon kept on course, and the Republican party leaders had no use for Rockefeller. In the fall of 1967, a Gallup Poll showed Rockefeller ahead of President Johnson 52 percent to 35 percent among the public at large. But polling of GOP county chairmen around the country showed those influential Republicans favoring Nixon over Rockefeller five to one.

The ferocious last-minute campaigning came to naught. Nixon won the nomination on the first ballot in Miami Beach.

In Sum: Failure

The same start-stop, stop-start pattern emerges in all three of these races. Determination, hesitation, plunge. He ended up hurting his own party's candidate most of the time, and that helped earn him the reputation as the spoiled rich kid who wouldn't play on the team unless he could be captain.

And yet when Humphrey suggested that Rockefeller run for vice president on the Democratic ticket in 1968, his loyalty to the Republicans wouldn't let him.

There are any number of people who think that Rockefeller could have been president but he'd picked the wrong party. Certainly his brand of activist government was at odds with where the Republicans were going nationally. The GOP road led from Goldwater to Reagan to the Newt Gingrich Congress of 1994. There's not much room for the Rockefeller brand of Republicanism on that continuum. (In reality, the Nixon presidency demonstrated an appetite for the some of the same type of pragmatic and ambitious social programs for which Rockefeller was known: health care reform, social welfare experiments, forcing colleges to fund women's athletics, and more. Nixon perfected the skill of winning the nomination from the right and then moving to the center. Rockefeller was stuck trying to win the nomination from the left.) Ironically, for all his liberal reputation on domestic policy, Rockefeller was a staunch anti-Communist and a hawk on foreign policy.

Looking back at the presidents of his time, Rockefeller has more in common with

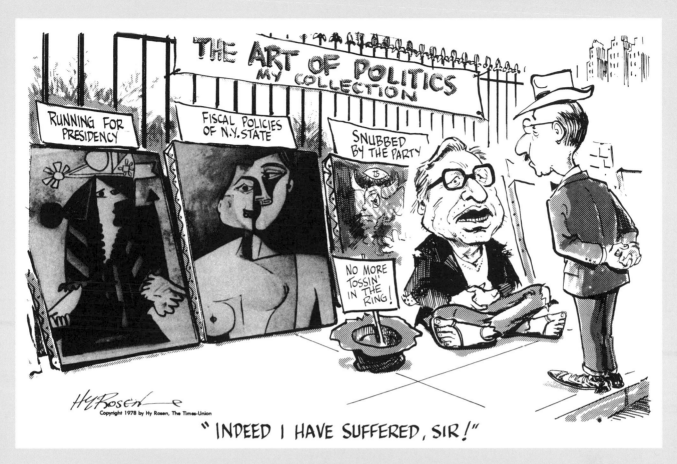

"INDEED I HAVE SUFFERED, SIR!"

The hat that Rocky tossed into so many rings was now retired. He has taken his lumps. Hy Rosen complained about the governor's spending policies, but he appreciated Rockefeller's love of art. Rockefeller created the first state level agency to finance artistic work in the United States.

Lyndon Johnson than anyone else. They shared a big-muscle enthusiasm for governing, for bringing together the political forces necessary to move ideas and events forward. Two creative, irresistible wheeler-dealers, with a common flaw: they were both so eager to use government to do good things that they ignored the down side, the long-term consequences of their actions. They almost had the same route to the presidency. Johnson signed on as Kennedy's vice president at the 1960 convention, and then ascended when Kennedy was killed. Rockefeller signed on as Ford's vice president, appointed after Nixon's Watergate disaster, and fate teased him when a strange young woman named Squeaky Fromm and her revolver got within five feet of President Ford at a rally in California. But Squeaky Fromm didn't get off a shot, and history veered away from Nelson Rockefeller once again.

A year later, Rocky got dumped by Ford, and then Ford himself lost the election, missing out on New York's electoral votes in the process. A bitter-sounding Richard Rosenbaum reflected: "Ford dropped Rockefeller from the ticket and it cost him. I believe he could have been president again. He lost New York, and it was a close election. I just think Ford was a weak-kneed guy. What's the use of being president if you can't tell people to f—— off?"

In the same spirit, one of the enduring images of that 1976 campaign is of Rockefeller, spurned and cast aside in favor of U.S. Senator Bob Dole of Kansas, touring the country with all the enthusiasm of that first energetic race almost twenty years before, gleefully flashing the middle-finger salute to a heckler in Binghamton. Malcolm Wilson told *Newsday* reporter Richard Zander that Rockefeller had "just got his fingers mixed up." But more likely he was letting out a little of the monstrous frustration that had built up over all those years.

After all those triumphant years as governor, and the lists of accomplishments, the ending seemed rather sad. Rockefeller endured the humiliation of drawn out congressional hearings on his vice presidential nomination in 1974, and endless prying into his family's financial doings, only to be dumped in less that two years. And finally his death in 1979, in the company of a young woman assistant, further tarnished his reputation, at least for a time.

3

Malcolm Wilson, 1973–1974

It's never the man; it's the year.

—Hugh L. Carey

ALAS POOR MALCOLM, the loyal soldier. For fifteen years he gave his service to Nelson Rockefeller, the expansionist governor. Finally, the lieutenant governor got his chance; Rockefeller resigned in December 1973 with one year left in his fourth term, and handed the scepter to Wilson.

And then the political roof fell in: The OPEC gas crisis left millions of people trapped in lengthening gas lines; Watergate hit, Nixon resigned and got pardoned by Ford, and Republicans took a bath everywhere; the New York fiscal crisis began to crawl out from under the Rockefeller security blanket.

None of this was remotely attributable to Wilson. And yet he was the one going before the voters in 1974. It was decidedly not a "felicitous concatenation of circumstance."

Wilson was a courtly type, given to complex sentence structure, Latin references, and three-dollar words. He often used that phrase, "felicitous concatenation of circumstance," to describe the lucky happenstance of beneficial politics. How ironic it was that his brief moment in the center of the ring was marked by exactly the opposite kind of luck.

Gas Line Blues

To be fair, he goofed in his early handling of the gas line crisis of early 1974. As he saw it, looking back after more than twenty years: "I had made the wrong judgment. I had said there is no need for rationing. I said I felt the American people were sane enough to be self-sacrificing, but I was wrong. And that was one of the things that was responsible for my defeat." Indeed, his decision in early February *not* to impose mandatory rationing of gasoline immediately cost Wilson dearly. Many states jumped

quickly to an odd-even rationing system, allowing motorists to buy gas only every other day. The final digit on everyone's license plate was the key, either odd or even.

The gas crisis was a time of enormous frustration for Americans, unaccustomed as members of the post–World War II middle class were to any restraints on their love affair with the automobile. Sitting in gas lines for hours in the middle of winter, paying more and more for each gallon to a bunch of unknown foreigners, seemed totally outrageous. And if those angry Americans couldn't get hold of the OPEC sultans themselves, well, there were other targets for their wrath. Any politician who did not come up with quick answers, or at least pretend to do so, got whacked.

Wilson, by temperament and politics, was not inclined to be a quick-answer kind of leader, and he certainly did not tend toward "save the world" type responses. Unlike his predecessor, Wilson was not given to reaching for the sledgehammer when a little screwdriver might do. In their political partnership, he was the one who worked behind the scenes, tinkering with the politics here and there, to help clear the way for Rockefeller's grand plans. He was a specialist in damage control and in working with the Republicans in the Legislature, especially the more conservative upstaters.

But this gas crisis demanded a different kind of out-front leadership, and Wilson was staggered early in his term by the appearance of inaction. People were waiting, fuming in their gas lines, impatient for somebody to DO SOMETHING!

Looking back, it is remarkable that Wilson got penalized, tagged with the indecisive label, so quickly. On February 12, the governor issued a call for voluntary rationing, and for the sanity of "self-sacrifice." It did not work. And Wilson didn't tarry long. Just a week later, the governor issued an executive order imposing an odd-even rationing scheme for all gas stations in the state. But the damage was done. His reputation was cast.

Wilson might well have made a fine governor, but he never had the chance to develop. Raymond T. Schuler, transportation commissioner under Rockefeller, Wilson, and Carey, said, "Probably he was the right person to be governor for the next four years. He would have put in place structures to deal with the Rockefeller excesses." Richard Dunham, budget director under Rockefeller and Wilson, recalled, "Malcolm had the capacity for making the tough decisions. Circumstances were ripe for him. We had to scale back. We had overdone it."

Whiff of Disaster

Overdone it. What did that mean? This next period was going to be about coming to grips with the downside of Rockefeller's era, trying to bring the state back to an even keel. In other words, the Rockefeller expansionist years were too much, were beyond the state's ability to handle. The 1981 in-house Budget Division history, *The Ex-*

THE GRADUATE

Malcolm Wilson served Rockefeller as lieutenant governor for fifteen years, after first helping him get elected in 1958. Now it was his turn, when Rocky stepped down in 1973 to set up a Commission on Critical Choices in Washington, and Wilson graduated to the top spot. He was extraordinarily well-liked and highly regarded in the insider political-governmental world around the Capitol. But despite the strength of his wife, Katharine, as a political asset, he didn't have that necessary magic with the public.

ecutive Budget in New York State, argued that the lingering fallout from the national recession of 1969 "was to raise serious questions . . . about the limits of capacity, about the extent to which a single state could take the lead in developing and sustaining the enormous investment required to bring about significant social change."

An element of bad luck weighed in here, too. What if there had been no 1969 recession? But there was, brought on in part by President Johnson's effort to spend on domestic programs and on the Vietnam War at the same time, and those were the politics of the time, in Washington and in Albany.

One behind-the-scenes expression of the problem, which was to become very public and have far-reaching national repercussions in just a couple of years, had Wilson and his men scrambling, quietly but urgently, in that star-crossed year of 1974. The massive borrowing of the Rockefeller era—for higher education, for the environment, for transportation, for housing—traditionally enjoyed Wall Street's hearty cooperation. Wall Street made millions off the borrowing, in interest payments, and in the fees that go to the banks and lawyers involved. Remember, it was a Wall Street bond counsel, John Mitchell, who invented the so-called back-door borrowing technique that permitted vast new loans.

One day in the summer of 1974, budget director Richard Dunham got an urgent call from New York City. The banks were refusing to market a multimillion dollar bond offering by the Urban Development Corporation, the public authority set up to finance and build everything from low- and moderate-income housing to economic development projects. Dunham hustled down the Hudson River to see the key players, at the imposing headquarters of Morgan Guarantee Trust on Wall Street: "Have you ever been to that building? You know the phrase about the hair standing up on the back of your neck. I'd never dealt directly with the bankers, certainly not at this level. Of course Morgan, this great place, High Jerusalem. I just went in there, and said to the guard, 'I want to see Elmore Patterson,' and I saw him. Delightful guy."

Morgan was balking at putting its name on the official offering statement—nicknamed the "red herring"—as the lead bank for the bond sale. This statement was the document that attested to basic facts about the bonds and the likelihood of repayment. Since Morgan was the lead bank on all the other deals, its absence here would send a terrible signal about New York finances. According to Dunham:

> What it finally came down to was the bankers required modification of the program. This was low-income housing. They were making business decisions. They wanted the program scaled down. In essence it was a bargaining process.
>
> The banks had an awful tough time with UDC, no question. It was a very liberal type of idea, bringing low-income housing into the suburbs. It was experimental, let's put it that way. And in the bankers' eyes, some of that was extreme. Maybe the opposition wasn't just on financial grounds.

"YEA, AND I'M NELSON ROCKEFELLER; TODAY IT'S EVEN NUMBERS ONLY!"

When the gas shortage hit in the winter of 1973–74, and Wilson didn't jump in right away with an activist rationing program, the new governor took a public pounding. He did eventually impose an odd-even system at gas stations, but was accused of waiting too long. Wilson said, "I felt the American people were sane enough to be self-sacrificing, but I was wrong." The timing was terrible for an incumbent.

Rockefeller had pushed the UDC law through the Legislature on the weekend of Martin Luther King's funeral. It had the power to override local zoning laws, and one of its main goals was to help open up new housing opportunities for blacks trapped in the inner cities. Wilson appointed a special task force, chaired by Dunham, to recommend ways to ensure UDC's future solvency. The task force reported after Wilson had lost the election, but here was a whiff of the chaos to come.

Dunham and others maintain that all the heavy borrowing never directly endangered the state's financial solvency. The moral obligation projects like state university construction and UDC housing were all self-liquidating. Yes, they were launched without voter approval, hence the name "back door." But the cash was always there to pay off the bonds. For instance, the state university bonds were covered by student tuition payments, and the UDC bonds were paid by the tenant rents in the new apartment buildings.

Not so for New York City, which was using some of the same financial back doors. In the city's case, when the door got pried rudely open, the money was not there. Dunham reflected:

> Under Lindsay, they had done some extraordinary financial things. Property taxes. Nobody since the days of Ancient Rome has ever collected 100 percent of their real property taxes. But they [city officials] would borrow against those taxes, and then roll over the notes when the collections came up short. They kept rolling over the notes. Finally it all came to a head.
>
> I remember when Abe Beame came to see me after he was elected mayor [in 1973] with Jimmy Cavanagh [budget director]. I said, "Now's the time to end this. You're the new mayor. Correct the situation. This shouldn't be going on, these types of things. End it now and blame your predecessor. The time-honored practice."
>
> Well, Abe couldn't do it. Jimmy Cavanagh says to me, "Well, Dick, something'll always happen [to save things]. You balanced the budget one year with $120 million in revenue sharing and there wasn't even a bill in Congress."
>
> "Yeah, Jimmy," I told him, "but Nelson went down and got the money with revenue sharing."
>
> I don't blame Beame and Lindsay alone. The banks didn't do their due diligence. They wouldn't allow a private business to do what they let the government do.

The state's free-spending and borrowing ways eroded its ability to enforce fiscal responsibility on the city. It was hard for Albany to crack the whip when it was on a spending bender itself. And Albany's legal authority to impose a change in behavior was limited.

Could Rockefeller have held off the deluge? Was the banks' behavior inevitable? It is impossible to know for sure. Certainly Rockefeller had extraordinary connections with Wall Street, and an ability to call in favors. On the other hand, the national and

"MAYBE I SHOULD HAVE SAID 'THE SQUEAKING WHEEL GETS THE MOST OIL!'"

Governor Wilson had a great fondness for quoting famous Latin phrases to make his point, but most New Yorkers hadn't studied that much of the language. They *were* very familiar with the long gas lines that the energy crisis produced. Wilson spent a lot of time trying to get more oil and gas from Washington. This cartoon typified the political characterization that did him in—highbrow and scholarly, but ineffectual and a little out of touch.

regional economic slump was changing the environment dramatically; the revenue just wasn't there any more. At any rate, the fiscal crisis did not hit in 1974. It held off, while Wilson tried for election in his own right.

Election '74: Watergate and Railroads

What did poison the well for Wilson was the national Republican debacle, the catastrophe of Watergate and its aftermath.

Consider this time line: in May 1973, Watergate hearings begin in Congress. In October, Vice President Spiro Agnew resigns in disgrace. In December, Rockefeller resigns as governor and Wilson takes over. In August 1974, Nixon resigns, and Ford becomes president and taps Rockefeller as vice president. In September, Ford pardons Nixon. In November, Wilson faces the voters.

Nineteen seventy-four was the Watergate watershed year. The Democrats seized control of the New York Assembly and have held it ever since. A whole new class of young Democrats came into government that year, men mostly, who would influence government and policy for decades to come.

Around the country, it was wholesale slaughter. Republicans were washed out by the boatload. Wilson was no different. He had to carry the disgraced Republican president around his neck, as well as the man who had pardoned him. "Everywhere he went, it was 'What about the pardon?' Pardon. Pardon. Pardon," remembered Gerald McLaughlin, Wilson's press secretary.

It was a curious legislative year for a man who spent thirty years in Albany, first in the Assembly, then as lieutenant governor, seen largely as a conservative. He put through the first direct state operating aid for New York City subways, and he expanded college tuition grants to cover middle-class students.

Wilson also reinstated the New York City rent controls that were lifted by Rockefeller only three years earlier. Long-time assemblyman Herman "Denny" Farrell, Jr., a Harlem Democrat and chairman of the reform-minded Manhattan Democrats, looked back on those days from the vantage point of 1997, when there was another big battle over rent controls: "Wilson was able to see the error that had been made by deregulating and then re-regulated rent control in New York City [and its suburbs]. For me, that was instructive for 1997. The Urstadt Law in 1971 deregulated rents. And we started getting one-month leases, so tenants could be thrown out for complaining. Also, we started getting horrendous increases in rent. We experienced all of the sins that we warned about this year [1997], that we said could happen."

Whether Wilson believed this was a real problem or not, he was looking for ways to appeal to New York City voters, and he came to the Democrats for recommendations on rent control. Democratic senators drew up a wish list, and were stunned

when the governor accepted all their demands. Ultimately, the Assembly Republicans balked at the deal and forced Wilson into a compromise. That infuriated the Democrats, who felt betrayed, so the bill reinstating rent control passed with all Republican votes. Farrell recalled:

> He recontrolled and stabilized New York City. . . . Didn't help him at all in the election. Carey [running against Wilson that year] had to be in favor. No Democrat can run and oppose rent control. You run and oppose rent control, forget New York City. Look at Pataki's position. Pataki lost New York City by 650,000 votes to Cuomo. If he had said he was opposed to rent control at the time he was running, we could have run that figure up to 750,000, 850,000. That could have been the difference in the election.

Back in 1974, while Wilson was running, there was another campaign going on around New York State—sponsored by that same Wilson administration—that was proving much more successful than the governor's own effort. This was the Railroad Bond Act campaign, to persuade voters to let the state borrow $250 million to prop up freight and passenger railroads. The idea was to make an infrastructure investment that would provide long-term help for the state's economy.

The problem was, Malcolm Wilson wasn't that enthusiastic about the big government borrowing program. Former transportation commissioner Schuler told the story:

> I was working very strongly for Malcolm, in the public policy area. Malcolm wasn't very keen about a bond issue on the ballot with him running for governor. There was a reluctance. We had to move him. He had the vision for it, but was reluctant. But the Penn Central, the New York Central, the Lehigh Valley, Erie Lackawanna, had all gone bankrupt. Here we were about to lose major rail service in the Northeast. So we came up with this plan of a railroad bond issue that would be used to rehabilitate railroad lines and thereby induce the Western railroads to come East, as well as doing subway work in New York. In order to get a bond issue passed you have to have New York City votes.
>
> I started running a campaign. It was my job to get it passed. He [Malcolm] had a [gubernatorial]campaign running. They didn't have the time, the wherewithal to run two campaigns. So I was on the road, editorial boards all across the state, you know, all that kind of stuff.
>
> And running trains. We reopened the service to Montreal, big ribbon-cutting ceremonies. I kept trying to get Malcolm to come out and join this. Because wherever we went we had bands and banners and parades.
>
> A *New York Times* guy caught on to me once. We did a trip across the state with the *Niagara Rainbow*. I forget the *Times* guy's name. At every station he was interviewing people. After we got out to about Rome, maybe Utica, he said, "You know, a lot of these people look familiar." What we were doing, we were moving people. We

had 16,000 employees, we were moving 'em around. We couldn't take a chance that we weren't going to have crowds. Of course we were emptying all the state offices. We get to Rochester, and this guy says, "Most of these people work for you!"

So I kept trying to get Malcolm to come out. He wouldn't do it. . . .

Then Carey endorsed the bond issue. He took it on as though it was his program. He got more out of that bond issue than Malcolm did.

Of course the bond issue passed overwhelmingly. And Malcolm, unfortunately, with Watergate and everything working against him, went down.

A True Conservative?

Wilson was at heart a conservative man, intrinsically uncomfortable with big government programs. And yet he was a man of his times, part of an era that accepted government intervention in a way that later fell out of fashion. In a campaign speech at the state's big business lobby convention in October 1974, just before the election, he bragged about doing things that the next Republican administration, Pataki's twenty years down the road, would find unacceptable, as would the business lobbyists of the future.

Here is some of what Wilson said at that Associated Industries convention in Lake Placid:

> To protect those workers who for whatever reason cannot find jobs or who are disabled, we have enacted increases in unemployment insurance, Workers Compensation, and sickness disability benefits. And to ease the dreadful pressures of inflation on the lowest paid workers, we have increased the state's minimum wage to $2.00 per hour.
>
> We also moved to inject new mortgage dollars into our housing market. We have issued $100 million in State Mortgage Agency bonds and we have taken steps to issue a second $100 million to help people find mortgage loans. . . .
>
> We have put up $200 million in state and local transportation funds to hold down fares. . . . It is because we have taken decisive actions like these over the past sixteen years—in good times and in uncertain times alike—that we have been able to build a sound climate for growth in New York.

As it turned out, that growth did not materialize the way it had in the past, notwithstanding those investments in infrastructure.

And in George Pataki's first term, he made points with the business community by cutting back on Worker's Compensation and resisting efforts to raise the minimum wage. He also cut back state subsidies to mass transit, insuring that fares would rise. He pushed through a long-term capital investment plan for the NYC transportation network that reversed the trend toward greater statewide support for the city.

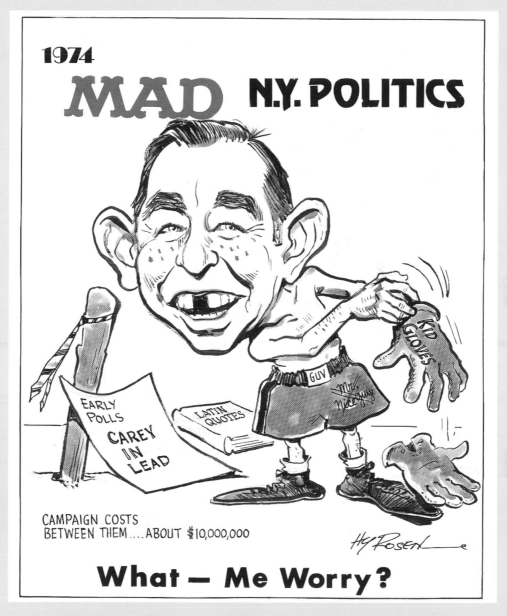

A cartoonist is always looking for striking physical features to emphasize and thereby help define a public figure. Malcolm Wilson had the large ears and lean face that—with some exaggeration—could look like *Mad* magazine cover boy Alfred E. Neuman, the "What, Me Worry?" kid. By October in the gubernatorial campaign of 1974, there was plenty for Wilson to worry about. He was trailing Hugh Carey in the polls, President Ford had pardoned Richard Nixon, and Republicans were feeling pretty glum everywhere. Wilson was throwing away the Latin phrase book and kid gloves and preparing to do battle. And we thought campaigns were expensive then!

But that's another chapter, and a long swing of the political pendulum away from the Rockefeller/Wilson epoch that closed with the election of November 1974.

Wilson, the vanquished loyal soldier, left Albany after nearly thirty years of service, returning to his Westchester home. He became chairman of the Manhattan Savings Bank and had little to do with active politics after 1974. It was a quiet retirement for someone who had spent most of his public life working behind the scenes, while the great events of an incredibly activist era were played out upon the stage.

4

Hugh L. Carey, 1975–1982

*Poor Hugh, I drank the champagne and Hugh Carey
got the hangover.*

—Nelson A. Rockefeller

TWO SONS are killed in an automobile crash at the ages of eighteen and nineteen.
Their mother is diagnosed with cancer the very next year. She seems to recover but
ultimately does not. And she dies just before the beginning of her husband's campaign
for governor.

That was the spring of 1974; seven-term Brooklyn congressman Hugh L. Carey and
his wife, Helen, had planned this run for governor together. He had promised they
would finally come back to New York from Washington. He soldiered on without her,
teeth gritted, plunging into an underdog campaign. Against great odds, personal and
political, he won the Democratic primary and then the governorship.

It is hard to escape the notion that Carey was a man whose life prepared him to
deal with adversity and taught him to persevere under the hammer blows of fate. He
had one type of preparation for adversity in World War II. Joining the army as a pri-
vate, he won a battlefield promotion to the rank of colonel in the Timberwolf Divi-
sion and learned how to lead men in the life-and-death crucible of battle. He and
his unit had the searing experience of liberating Nazi death camps.

The preparation of Hugh Carey was not wasted. This was a governor who got hit
with an entire truckload of bricks, with no warning, no time. "I had no idea how bad
it was," Carey recalled. "Nobody knew that the city was virtually bankrupt."

In the post-election weeks, after he beat Howard Samuels in the Democratic pri-
mary and then Malcolm Wilson by 808,000 votes in the general election, the party-
going congressman from Brooklyn set up shop in New York City and began to put his
administration together. Budget specialists came down from Albany, to brief him on
what he'd won.

"Oh my God, we had no idea."

Nor did people have any idea about Carey, either. A lawyer-businessman before going into politics, he had a reputation as a bright but unremarkable politician who enjoyed hoisting a glass at the local pub and made friends regardless of party label and ideology. The death of his wife, Helen, in March 1974 left the new governor with sole responsibility for twelve children—six at home. A reporter arriving at the family's home in Brooklyn the morning after Carey's primary victory said it looked like a dormitory, with kids' underwear and pajamas strewn all around.

But there was an inner strength in Carey that proved to be a godsend for New York in the years to come. The state's budget troubles, and the city's pending bankruptcy, were an extraordinary testing time.

David Burke, Carey's first secretary, or chief of staff, reflected on the governor's character at an anniversary conference in 1995:

> There were times when I thought perhaps he wasn't smart enough to know how much trouble he was in. You go into the next door and you say that you just got a call from the city manager of Yonkers, and Yonkers is going down too. And he treats you to an entire rendition of "Who Cares." "Who cares if the banks fail in Yonkers, as long as we have a love that conquers?" And I'd walk back into my office and I'd say, "How did I get into this? How did I get into this situation? Who is this man?"
>
> This man is a unique man. I think it is fair to say that when he was a congressman representing Brooklyn, his district in Brooklyn, for those fourteen years, I don't think that there was anyone who would say, "You know that Congressman Hugh Carey, he could be a historic character. He could really be a savior of an entire state and set a standard that people would look to in years later across the nation." The fact of the matter is, because of events Hugh Carey became that very person. And that to me is the definition of greatness, a person who can rise from nowhere, when the events of the moment call for it. So many of us fail at that. He didn't. He saved us.

At the beginning it was like setting up a government in occupied territory, because the whole place and all the people had grown up under Rockefeller. Burke continued:

> We felt alone. Then when the bottom began to fall out, I was petrified. The governor of the state was not petrified, but he was afraid. Hugh Carey is a courageous man, as a soldier is courageous. A soldier is a person who is afraid and moves forward anyway. And we all know that Hugh Carey had that part of his life as well. But in government Hugh Carey was courageous because he knew full well our inadequacies.

This is how Carey framed the issues in his first State of the State message, even before he knew the full extent of the crisis ahead:

> The extraordinary creativity and labor of our people skimmed the cream from a lush national economy; the government of the state in turn skimmed the cream from their rewards, and every interest and group and advocate came to think of the state budget

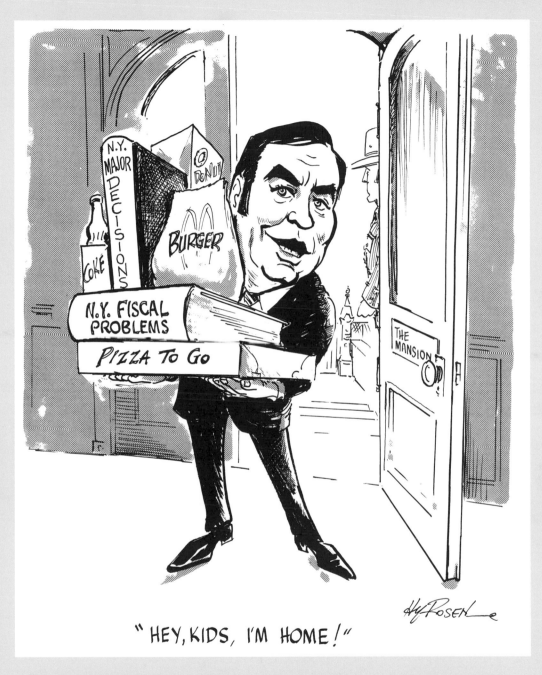

"HEY, KIDS, I'M HOME!"

The new governor moved into the old Victorian mansion on Eagle Street in Albany with a family of bouncy young kids, left motherless by Helen Carey's death less than a year earlier. They livened up the mansion and the town, as did their father, who was a free spirit with an impish sense of humor. Meantime, he was getting hit with a host of unhappy surprises about state and city fiscal problems.

and of state subsidy of local budgets, as a cornucopia, a never-ending horn of plenty that could pay for more and more each year.

Now the times of plenty, the days of wine and roses, are over. We were in the lead car of the roller coaster going up, and we are in the lead car coming down.

Just holding on for that ride was going to be quite a feat.

Crisis Looms

First came UDC, the Urban Development Corporation, the creative, super-powered agency created by Rockefeller to build low- and moderate-income housing, with the powers to override local zoning in the process. Governor Wilson dealt with the beginning of the UDC debt spiral in his lone year of stewardship. But the problem wasn't solved.

According to Carey:

> I started getting these tear sheets, and visits from Bob Morgado and Howard Miller [budget officials]. They said "You can't print money."
>
> "What?"
>
> "It's not like the federal government, you can't print money."
>
> They said the "UDC has a payment to make in February and you have no money. . . . That's what you're up against."

Carey began what would turn out to be an intense year's involvement with some of the nation's biggest bankers and business leaders, as he struggled to save UDC, then New York City, and ultimately New York State, from bankruptcy. It was a high-wire act, and Carey hung by his fingernails for a good part of it. He used every trick and every contact available.

His first sessions with the bankers, about UDC, were not so pleasant:

> "Gentlemen, what I need is time. I will try to restructure the UDC, but I need time." We went around the table. McGillicuddy was very accommodating [John McGillicuddy, president of Manufacturer's Hanover]. Sweat was coming down his face like a river. His bank owned a lot of UDC debt.
>
> Wriston's turn came [Walter Wriston, president of Citibank]. He said, "I have a suggestion, or advice."
>
> "What is it?"
>
> "Pay your debts!"

But the governor could not pay, not right away. He bought time by getting the Legislature to create a special shell agency to manage the UDC debt, and to enact special taxes to prop up UDC temporarily ("swallowing a political hand grenade," he called it at the time). The plan was put together by private developer Richard Ravitch, budget director Peter Goldmark, and Carey himself. They created the model that

would be used to pull New York City back from the brink. Ravitch, a square-shouldered, gutsy, can-do sort of fellow, was the first of Carey's many recruits from the private sector. He became chairman of the UDC, played a major role in rescuing the city, and later ran the Metropolitan Transportation Authority for Carey.

Big Apple Busted

Essentially, the technical problem was that New York City's budget was way out of balance, and with the economy turning sour, there was no more hiding, rolling over, or papering over this inconvenient fact. The city had lived beyond its means for years, hiring workers it couldn't afford, paying them wages it couldn't handle. It boasted an expensive city hospital system, the largest in the nation by far, and one of the largest public university systems in the world. Not just the nation, the world, and it was *free;* it charged no tuition.

Many responsible people in government and on Wall Street knew that the New York City government was in chronic debt, and was rolling over debts to avoid facing the bad news. But everyone looked the other way while things were going well. Now the banks were not going to lend any more money to this high-risk borrower (even though they had helped the process go bad), because they couldn't afford to do so any more in the 1975 economy. And without more loans, the city could not pay its bills, period.

Senator Warren Anderson, Republican of Binghamton, who was the leader of the state Senate in the crisis days, was a crucial figure. He brought upstaters around to vote for save-the-city measures, even though their constituents weren't always supportive. Reflecting back on the city budget mess, Anderson said: "Temporary loans that you take are one thing. But when you start to do it [borrow] for day-to-day operations, you can get in trouble pretty quick."

So how to get emergency money to the city was the problem. Carey likens his efforts to FDR's in the Great Depression, scrambling and trying one thing after another, playing for time. He harkened back to a law Roosevelt got passed that said that "if you paid the interest, you couldn't be thrown out of your house." What New York State did was create a new state agency called the Municipal Assistance Corporation (MAC), which sold bonds to raise money to buy up the city's short term debts. Then Carey got a moratorium passed that said that as long as the state paid the interest, it did not have to pay off the principal on the so-called Big MAC Bonds.

The legality of this move—simply having the Legislature declare that a debt was not a debt, according to the original terms—was obviously questionable. But Carey needed to buy (or borrow) time, and he took a gamble:

> We were sitting around the office eating a pastrami sandwich on a Sunday afternoon with Sy Rifkind. I said, "Don't I have emergency powers?"

"Yes, for floods, hurricanes, natural disasters. But not for finance."

"How long will it take them to knock us out in court?"

"A year."

"Good, that's all we need."

Rifkind was the retired federal judge who played an enormous role in helping the state handle the crisis. He pointed out to Carey that no law is unconstitutional until a court says it is. As Carey said, "We really printed our own money. The MAC bonds were our own money."

Getting this much done involved monumental struggles with the Legislature, and that spring season was loaded with tough negotiations and tough votes. Still, there was a remarkable degree of bipartisan cooperation. Some of the negotiations took place on a front porch in Forest Hills, Queens, home of Jack Haggerty, chief counsel to the Senate Republicans. The Big MAC bonds were a bridge loan to get the city through the summer and fall, but they were not a permanent solution: the Legislature could not extend its own credit to cover all the city's debt without drowning the state in the process. Ultimately, the New Yorkers realized, the federal government would have to come to the rescue in one form or another.

It was a crazy time in Albany, when the Legislature never seemed to go home. There would be a recess here and there for a week or so. But before long, the legislators would rush back for some new emergency legislation.

Warren Anderson recalled the ongoing tension and endless maneuvering to recapture the state's fiscal honor. When asked if he ever felt that the government had spent too much in the past, he replied:

> You have to live with the cards you've been dealt. You might wish you had a couple more trumps sometimes.
>
> I think the problem we faced in 1975 was the only time in all the years that I was in Albany that scared the hell out of me, because it looked for a while, with the divergence between the city and the state and federal government, as if that maybe government wasn't going to work. And that scared me.

Trumps or no, the pressure on the state government was enormous. There were all-night meetings at the Capitol and in the Executive Mansion down the street. Late one night, the Capitol was even locked to prevent lawmakers from leaving and troopers rushed out onto the Thruway to find legislators who had escaped and bring them back for a crucial vote.

Anderson, with a conference dominated by upstaters, had a very tough time. He was convinced that the state needed to come to the city's rescue, but his fellow upstate Republicans were not so eager to put their constituents on the line. That old upstate-downstate tension is powerful. Said Anderson:

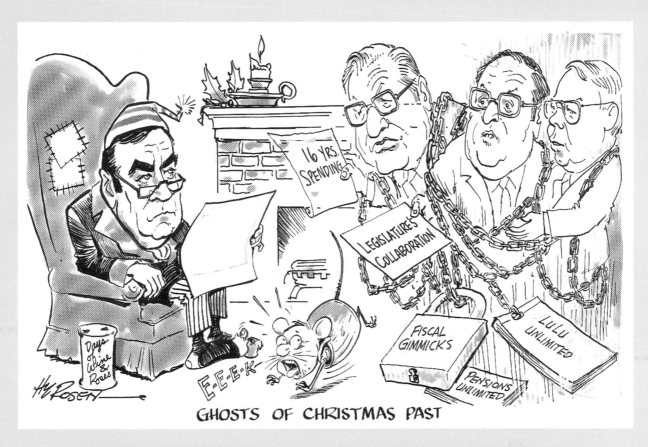

GHOSTS OF CHRISTMAS PAST

Carey's first Christmas as governor found him confronting a hole in his budget, if not his stocking. He played the role of Scrooge, cutting spending to bring the budget into balance. The Ghosts, representing big spending sinners of the past, are Governor Rockefeller, Assembly Speaker Stanley Steingut, and Senate Majority Leader Warren Anderson. The "Lulu Unlimited" reference is to the payments "in lieu of expenses" that the Legislature used to boost compensation for those with leadership positions and committee chairmanships.

I've got to tell you it wasn't all eleemosynary on my part. I had five members of my conference from the City of New York, one from each borough. They made the difference between my being a majority leader and the minority leader.

I felt that most of the upstate senators wanted to cooperate, but they were afraid. So I never asked for a vote in conference and fortunately nobody ever challenged me and said, "why don't you find out how many people want this bill to go?"

This was statesmanship on Anderson's part, leadership of a high order. If he had followed the usual rules, and let the Republican majority conference decide whether some measure should come to the floor, he risked losing the vote. So he put his leadership on the line and told his fellow Republicans what had to be done, and he did it. He also pressed Carey to demand more control over city spending.

Getting the nation's entire financial industry behind the city was also crucial. Carey had involved major figures in New York, including the bankers. He also brought in investment banker Felix Rohatyn, Richard Shinn of Metropolitan Life, Albert Casey, head of American Airlines, and William Ellinghaus of New York Telephone, to name a few.

"The smartest thing I did was get people with brains around me," said Carey.

Carey remembered one time he needed to go to the West Coast to persuade bankers out there to help, and Al Casey offered him a ride.

We got to the airport and I saw a cargo plane. They were loading up horses on the damn thing. They were taking horses out to Santa Anita Park. Casey said I could sleep upstairs, he'd sleep down with the grooms.

We were met by friends, and they asked us, "where have you gentlemen been? Would you like to take a shower before you go downtown?"

The pungent smell of airborne horse stalls was hardly the only handicap Carey bore during his New York City rescue ride. In the spring and summer of 1975, New York's appeal for federal assistance was rejected. Washington was not comfortable extending major financial help to the city, for a variety of reasons.

For one, a Republican administration was not eager to help a Democrat-dominated city and state, even though Rockefeller was vice president. For another, Congress, though controlled by Democrats, was reluctant to extend the federal treasury very far in the direction of one state and city, for fear of the precedent. Also, Washington reflected the rest of the country's political and cultural antagonism toward the big, swaggering, bravado of the nation's number one city, which was notoriously fond of looking down its nose at every place that had the misfortune to not be New York.

A famous *New Yorker* cover cartoon of the era showed the United States dwindling to insignificance west of the Hudson River.

Well, now the tables were turned, and New York was on the receiving end.

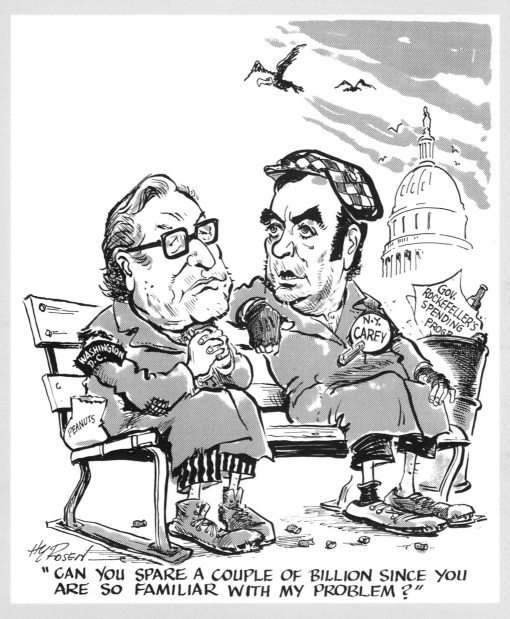

"CAN YOU SPARE A COUPLE OF BILLION SINCE YOU ARE SO FAMILIAR WITH MY PROBLEM?"

Carey spent a lot of time in Washington trying to get the federal government to help New York State pull New York City back from the brink of bankruptcy. Rockefeller, then vice president, was accused of being part of the problem, but not enough of the solution. Carey studiously avoided blaming Rockefeller, and said that Rockefeller was very helpful behind the scenes in Washington.

NBC's *Tonight Show with Johnny Carson* was still produced in New York City in those days, and the city's problems were constant fodder for the most watched comic in America. Not only did Carson joke about crime and dirty subways and rude New Yorkers, he had great sport with the financial mess.

In other words, it wasn't easy.

Doesn't Anybody Love Us?

A major effort was needed to convince Congress. New York emissaries went out around the country to speak at luncheons and dinners of business and community leaders, to try and persuade these opinion leaders that giving the profligate city another chance was in the country's interest.

With the help of Carey's contacts in Congress, and the major concessions unions were making—seeing their own long-term self-interest served by short-term self-sacrifice—a proposal for federal loan guarantees began to make some headway. Not everyone was optimistic, however. Carey says he was surprised by one pessimist:

> We were at a hearing in the Hubert Humphrey Office Building, and Jack Javits pulled Abe Beame and me aside.
>
> Javits told us, "You know, Jerry Ford's not going to give you any help. But my law firm will draw up a good bankruptcy agreement. We won't charge too much."

President Ford was not ready to come around. And a Democratic Congress was not going to "give in" to New York without an agreement with the White House.

The Headline

It is probably the most famous New York tabloid headline since REMEMBER THE MAINE. And it helped sink Ford's reelection chances a year later, when the Jimmy Carter campaign plastered a reproduction of that fateful *Daily News* front page all over New York City. In the elaborate stage play that resulted in the city's rescue, it was a key scene.

On October 30, 1975, the president said he would not support federal aid for the city and he didn't find a lot good to say about the place, either. The *New York Times* front page headline used the word "castigating," but the *Daily News* put it more bluntly. After toying with five or six different ways to express Ford's brusque rejection, an editor walked into the busy newsroom on Forty-second Street just before deadline and laid down the winner: FORD TO CITY: "DROP DEAD!"

Only in the shorthand rules of tabloid headline writing could you call that headline correct, or fair. Ford had not ruled out, for all time, any aid for the city. Nor was this the over-the-cliff end point in the drama. But the headline did capture the truth of the moment: Ford was not ready to buy into the "Save the City" game.

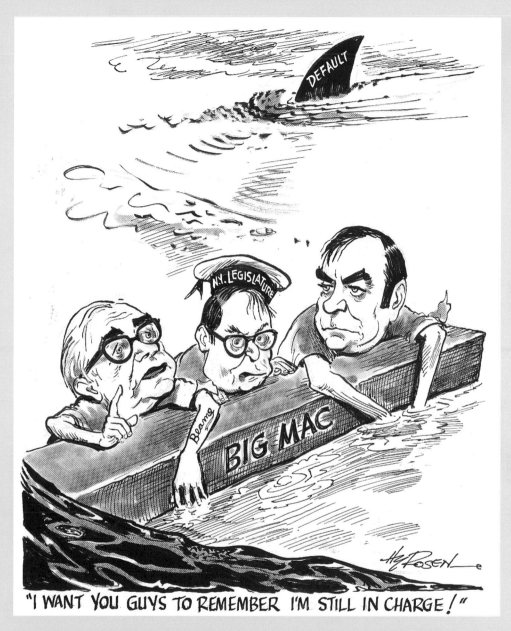

"I WANT YOU GUYS TO REMEMBER I'M STILL IN CHARGE!"

Governor Carey got the state started on a rescue plan for New York City, and the Municipal Assistance Corp. (Big MAC) was a key component. But it was only temporary, as the circling shark in this September 1975 cartoon suggests. Mayor Beame tried to preserve his city's independence—and his own political standing—by maintaining that he was really in charge. The cartoon was prophetic: Carey and the Legislature later did force the city to surrender ultimate budget authority to a state control board. The Legislature is represented here by Assembly Speaker Stanley Steingut.

Felix Rohatyn, a partner in the investment banking firm Lazard Freres and a deal-maker who was Carey's best-known private sector recruit (he chaired the Municipal Assistance Corporation and always had a snappy line for the press) told a 1995 anniversary conference about that headline and that day:

> We watched President Ford make that speech and we were pretty depressed about it. And at that time Hugh Carey and I were single, and we were bachelors-about-town and we used to frequent a saloon called Elaine's up on Eighty-eighth Street and Second Avenue. And we went up there for dinner that night, very depressed. And at ten o'clock in the evening this kid comes in selling the *Daily News*. And Hugh Carey looked at the headline of the *Daily News,* which said, "Ford to City: Drop Dead!" and said, "We're going to win this thing."

In the long run, this may actually have been the best thing, because it was after Ford's rejection that the next level of controls was imposed upon the city budget process, with a new entity called the Emergency Financial Control Board. This board, with the governor as chairman, virtually took away the city's independent budget authority. Now the mayor had to come to this board asking permission to spend money. It was a humiliating concession on the part of the nation's number one metropolis, indicating that it could not be trusted to manage its own finances. Of course by this time, most everyone in Albany, Washington, Los Angeles, San Francisco, and anyplace else that was paying attention believed this was the case.

Politically, it was probably impossible for the city's own elected leaders to make the kind of cuts that had to be made, without the Control Board looming in the background. A series of further concessions from municipal unions and others also flowed from this point.

Twenty years later, Florida was setting up a Control Board for Miami, Congress put one into Washington, D.C. (where it summarily dismissed the school superintendent), and other, smaller communities got the same treatment. But it all began in New York City in 1975. Felix Rohatyn's own son was involved in the U.S.-directed bailout of the South Korean economy in 1998, which employed the same sort of separate agency to roll over debt that was pioneered in the New York.

Golf on the Edge

Back in 1975, the problem was getting Ford's ear. Carey said it took a golf game:

> I was almost moribund. I didn't know why I couldn't get anywhere, because I had been a long-time friend of Jerry Ford's, who was president. I had figured out how it could be done without a big cost to the federal government, but I couldn't get

through. Mel Laird had been a friend of mine in Congress, we had served together for fourteen years. I knew of Mel's acumen and his cleverness. So in desperation I called.

And he said, "Well, have you got an airplane?"

I said, "Yeah, I can get the state plane."

"Make believe you're going to New York City but head south, and I'll pick you up at Dulles Airport."

Which he did, in one of those big, big limousines, those wedding cars. He says to me, "This is how I live now." [The former Republican congressman from Wisconsin had retired and was living well.]

"Well, I'm down here trying to figure out what to do." [Carey said.]

"Here's what you have to do. Did you bring your sticks?" He'd told me to bring my golf sticks.

"Yeah."

"Okay, we're headed for the golf course."

"What am I doing that for?"

"Well, until I beat you in golf, and you pay me, you're not going to get any information out of me."

So he wanted the satisfaction of having me lose, which I did, and there was a big picture window at the clubhouse, and he wanted a picture of me paying him off. When that was all done, he said, "Okay, you paid your dues. Now I'll tell you what the problem is."

He said somebody's got Jerry thinking through Rummy, Donald Rumsfeld [Ford's Illinois-born chief of staff], that if New York goes down, Chicago will become the financial capital of the world.

"What? That's not going to happen," I said. "It might be London, it might be Paris. It wouldn't be Chicago."

"Even Daley is convinced."

"Oh my God!" That gave me a tip. I got in touch with old Mayor Daley, and talked with him about how he was hurting his friend Beame. And sure enough, even Senator Stevenson, the son of Adlai, was going to vote against it. So I told him this was all hatched up by Rumsfeld. He saw this as a way of hurting New York and Rockefeller. So Rummy was the bad boy of the plot. Once he was out of the way, we straightened it out. Jerry [Ford] then actually helped me find the votes to get the bill through.

New York did make some major government changes at this time. Did Carey see that as enforced discipline, a price for national help?

We had to. They made us impose tuition [at CUNY] and a subway fare increase. They made us do any number of things, which were disciplinary.

Helmut Schmitt was on the Readers Digest Foundation with Laird, and helped, too. He told Jerry, "If you let New York City go down, the American dollar's worth s———."

In retrospect, this was Carey's finest hour. No other challenge he faced was so monumental, so dramatic. This was his moment in the sun, his time to defend the Alamo, to beat back the British at Saratoga. The international spotlight was on, and he triumphed. What he faced in the aftermath was the long, slow process of trying to rebuild the state's fiscal and economic health. That was not a one-year drama with rising tension, the looming crisis followed by a successful climax. What followed was less glamorous, though perhaps no less important.

Carey's determination and courage, his political acumen, his contacts and negotiating skills, were a major factor in saving the city. He met the challenges head on, and he hung on—for dear life, sometimes—but never quit. In that instance, his style proved a winning virtue. A more calculating type might not have pulled it off. In other events, these same character traits did not serve him so well. When things are going badly, *determined* translates as *stubborn* and *courageous* becomes *politically distant.*

Never again was Carey able to mobilize popular opinion to his cause as he did during the fiscal crisis. In part this was because his opponents in other battles had more call upon the sympathies of his constituents than did his opponents in the fiscal crisis battle. The famous "Ford to City: Drop Dead!" headline in the *Daily News* symbolized the kind of support Carey enjoyed. Editorial pages all around the state kept up a drumbeat of demands for the Legislature to impose concessions on New York City, for the city's power structure to accept them (Mayor Beame had run for office on a pledge to preserve the City University's free tuition policy at all costs), and for Congress and the president to help New York. The opposite position was to advocate bankruptcy, and hardly anybody had the stomach for that strong medicine, especially because Carey and others made a strong case that taxpayers from Soho to Saranac Lake would suffer the side effects of New York City's "cure."

Budget Battles with Legislature

For a career legislator, Governor Carey had astoundingly poor relations with the Legislature. He was the first governor in modern times to see the Legislature override his veto, and the running dogfights in Albany were so bad that his first term popularity plummeted after the heady days of the fiscal crisis.

Certainly a lot of this friction was because Carey was trying to do difficult things, such as slow down state spending on Medicaid, which was going up by 25 percent a year, and on school aid, which climbed from $2 billion in 1970 to $3.4 billion a decade later. But part of the problem was attitude—on both sides.

Carey came to Albany after fourteen years in Congress, where he rose to enjoy some influence and made many valuable connections on both sides of the aisle, as his own story about Mel Laird makes clear. He knew the legislative culture. Over eight years of struggle with the Albany legislators, however, he developed a contempt, some-

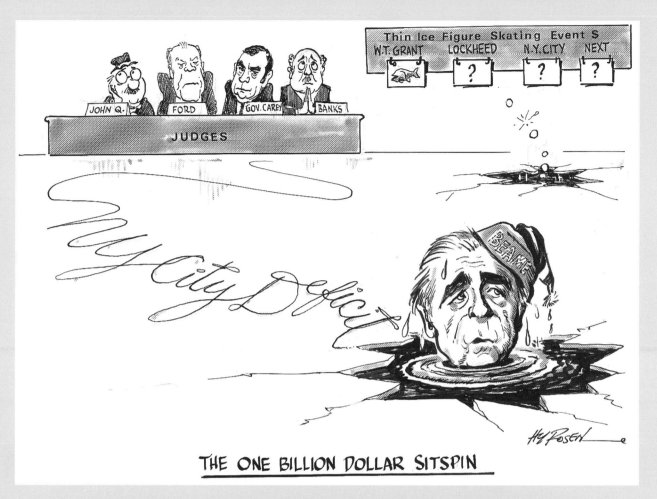

THE ONE BILLION DOLLAR SITSPIN

With the rescue plan in place, Mayor Beame had to perform his budgetary tricks before a bigger, and more demanding, audience than usual. The federal (President Ford) and state (Governor Carey) governments were watching closely, as were the banks, which had a lot of money involved. John Q. Public has an almost bemused look in this cartoon. The 1976 Winter Olympics were in progress at the time, and belly-up bankruptcies were definitely on the scoreboard in those days.

times not so thinly veiled, or veiled at all. "Small boys" was the term he used for them at the 1982 news conference called to announce his decision not to run for a third term. With an attitude like that, it is no wonder that brinkmanship battles were a standard feature of Albany life during his tenure. Carey's personality—a tendency to erect a wall (of principle, in his mind) on the political battlefield and fight to the death behind it—was not one designed to bring about cozy compromise.

To be fair, Carey arrived in Albany at a time of major institutional shifting, independent of any one individual. The Legislature was reasserting itself after what seemed like eons of Rockefeller's benevolent dictatorship. (Dewey was no pushover, either.) It was adding the staff capacity that allowed more effective challenges to the governor. Some of these challenges came as a shock to the new governor.

Preparing for Albany, Carey says he thought he could count on the Democrats who had won control of the Assembly in the same election. Stanley Steingut, another Brooklyn Democrat, was the new Speaker. "I thought I'd have at least one house that would be helpful. I thought we'd have a pretty good relationship. I talked with Steingut and he said, 'It's very simple. If I don't like what you're doing, I'll just say, 'f—— you.'" Steingut, whose own father had been Speaker years earlier, was determined to assert independence from the executive. The fact that a fellow Democrat now sat downstairs on the Capitol's second floor didn't count for much in this institutional power struggle. Steingut was followed by Stanley Fink, an even more challenging and powerful Speaker.

For his part, Carey sounds disdainful of the legislative branch, although he thought highly of individuals. "Toward the end, they overrode my last bunch of vetoes. Then the spending started again. I said, 'Uh-oh, the animals are out of the zoo. Here we go again.'"

Did Carey think that in his experience the Legislature was always trying to outspend him?

> Yes, yes, yes. That is the problem in New York. The local constituencies are strong. The policemen are strong, the firemen are strong. The teachers are stronger than Goliath. And they have their constituencies. And if you let them run the budget, they're going to run you out.
>
> In a time of crisis, they lose their clout, their leverage. Because [the money is] not there. Once the money is there—and they have pretty good economists who study to find where the money is—then the spending cycle starts all over again.
>
> We were able to force through three or four successive budgets where the amount of expenditures was less than the rate of inflation. If expenditures are below the rate of inflation in New York State, you get a surplus.
>
> When you do that, you can reduce taxes. That was our game plan, pure and simple. Warren [Anderson] caught me at it after a couple of years and said, "I'm never going to let you have a surplus again." But Warren did go along with the big tax cut. That's how I got reelected.

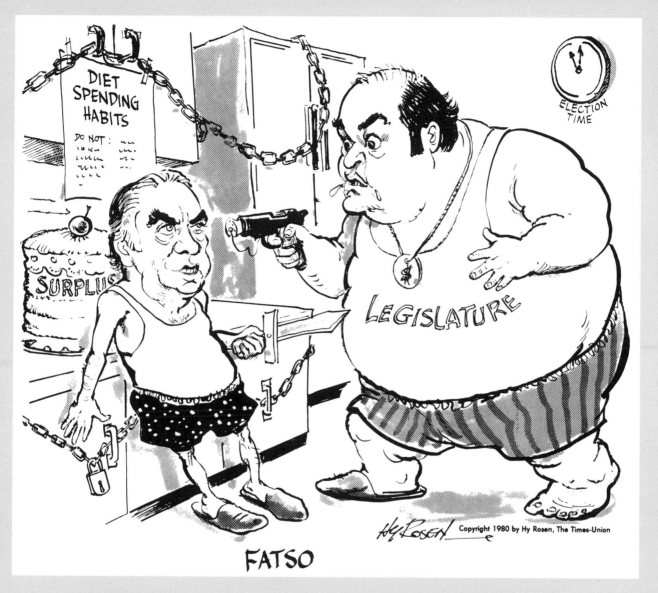

FATSO

Carey spent the years after the fiscal crisis trying to bring state spending under control. The Legislature pushed back many times, representing the needs of their constituents and the demands of various interest groups. Relations between the two branches of government slid downhill, and Carey was the first governor in more than one hundred years to have one of his vetoes overturned by the Legislature. The cartoon was based on a movie titled *Fatso,* starring Dom DeLuise as a man with an insatiable appetite.

They said they'd never do that again. In other words, "If we find it, we're going to spend it."

The tax cut was worth $2.7 billion overall, and no doubt it did help Carey beat Republican Perry Duryea in the 1978 election. Other factors were at play, too. Duryea did not run a good campaign and got tied up in controversy about his own tax returns.

The Budget Division hid something like three-quarters of a billion dollars from the Legislature to help pay for that tax cut. That's one reason the Legislature was so unforgiving after that.

Carey's list of the powerful interests pressing the Legislature for more spending is only a partial list, of course. Hospitals and nursing homes are two prominent institutions that should be added and so should local governments, cities and counties, who were screaming at the cutbacks in revenue-sharing money. Ever-increasing school aid, with the super-powerful teachers union and local communities behind it, was the biggest budget buster. The school aid formula gives relatively more money to the suburban counties around New York City (among the state's wealthiest) because they hold the balance of power in the Legislature. There were numerous attempts to reform the system, and redirect money toward poorer communities, but they went nowhere. Carey budget director Mark Lawton remembered one influential Long Island Democrat concluding, "You could put a gun to our head, but we're not going to do anything on education reform. The only hope is if the courts step in and make us do it."

Ultimately the courts declined to get involved, and the financing system has changed very little in the ensuing years, except that nowadays it costs lots more.

It was during Carey's time that a momentous institutional switch took place, and the Legislature became the driving force behind new spending. The Executive Branch became the conservative force. The Executive Branch, seat of the most powerful governors in the nation, the home of Rockefeller, a conservative drag on spending? Yes, that is what happened.

From 1975 on, for the next twenty-three years, the final budget adopted by the Legislature was bigger, more expensive and spent more, than the proposal submitted by the governor. This was a bipartisan phenomenon—during the whole time, the Republicans controlled one half of the Legislature and the Democrats the other. Republican Warren Anderson reflected on the constituencies:

> What is a special interest? It's democracy organized, really. It's either a chamber of commerce or it's a union, or it's a bunch of fly fisherman or it's mothers who want a better kindergarten. Whatever.
>
> Democracy is marvelous, and we all applaud it. But that's really what we're talking about when we talk about special interests. And when a group becomes organized and has computerized mail and all the rest, it can be very influential.

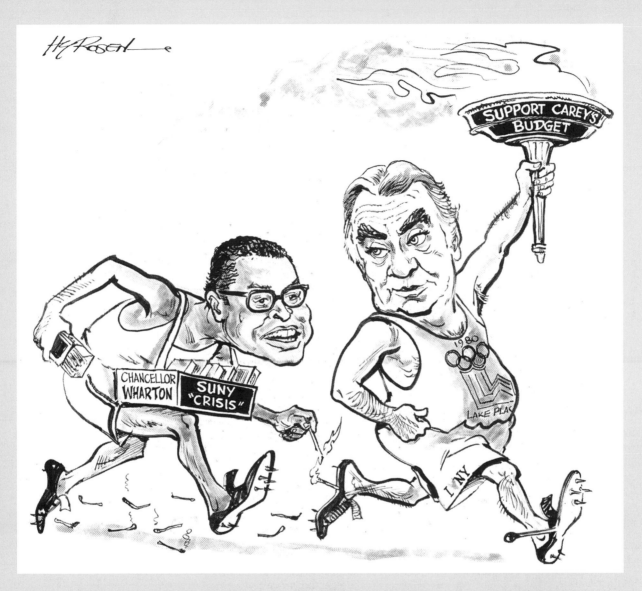

After those years of fantastic expansion under Rockefeller, SUNY was in for tougher times under Carey, who was struggling to cut spending all over the map. SUNY Chancellor Clifton Wharton proved a worthy opponent, and he turned the argument to his side. Carey had to pull back on budget division demands that each and every professor's travel plans be cleared in advance at the Capitol. The 1980 Olympics in Lake Placid were on Carey's agenda.

Carey's budget cutting was extraordinary, particularly for a state that was the biggest spender of all during the boom times of the 1960s. William Hennessy, transportation commissioner during most of Carey's time, recalled: "For a year we never let a new road contract. We canceled existing road contracts. We canceled engineering contracts, actually canceled them." This may not sound like much, but consider that Hennessy's predecessor remembers not being able to find enough contractors in the Rockefeller days to handle all the work the state was pumping out.

Empire No Longer

Carey's own testimony about using a tax cut to get reelected indicates that he had his political reasons for holding down spending. He was also trying to bring New York's taxes more into line with other states, to make the state more competitive for business. With a personal income tax rate of 17 percent, New York in 1975 had by far the highest taxes in the nation. Regionally, the comparisons were astounding. Connecticut had no income tax at all, and was pulling corporate headquarters out of New York City almost weekly.

"We had moved too far off the scale, compared with everybody around us, and with the whole nation. That was the Rockefeller legacy, not structural budget imbalance," said Mark Lawton.

Advances in communications and transportation meant that businesses didn't have to locate in one center any more. Decentralization was feasible, and it was cheaper to relocate than to rebuild aging manufacturing plants in the Northeast, and cheaper to ship the finished goods anywhere in the country.

An economics conference in Buffalo led to a report by Syracuse University's Maxwell School that heavily influenced Carey administration thinking. The report argued that New York could never regain manufacturing supremacy—those days were gone—and that the state should concentrate elsewhere.

I Love New York

At that point, who could possibly think that New York could sell tourism? Here New York was down—lower than the Bowery—kept alive only by the stubbornness of its leaders, hanging onto a federal lifeline, and Carey wanted to make it a promotional centerpiece?

Well, it worked. Here is how.

The state plowed its piddling tourism budget into research in 1976 and found that

a lot of vacationers in the Northeast and nearby Canadian provinces wanted exactly the sort of natural resources New York had to offer—lakes, mountains, beaches, historic sites—but didn't often think of New York as a place to find them. So a unique ad campaign was designed to change that thinking.

"We needed something that could make a difference in a hurry. . . . Things were so miserable in every other way," remembered Bern Rotman, long-time Commerce Department public relations executive. The so-called industrial development advertising, designed to attract businesses, wasn't so credible in those days. Rotman added:

> If you looked at all the different things we had to advertise, there was nothing that came close to tourism. Our taxation problem didn't affect it. Our infrastructure problem didn't affect it.

They shot the first commercial, which featured people from other states declaring their love for New York, in a frantic rush in 1977, fearful they wouldn't get it on the air in time for the summer tourism season. In a memorable last vignette, an aerial camera zooms down on a young man pulling his canoe onto an island in a crystal blue lake. "I'm from Brooklyn, but I love New York," says the actor, with appropriate native accent.

The next series of ads featured Broadway stars from current hits like *Dracula, Annie, Grease,* and *The King and I,* and they sold New York City as the exciting, one-of-a-kind entertainment Mecca it is. In the first week of advertising, the state got 20,000 calls for the Broadway show package brochure.

After less than two months, Broadway's box office was up 30 percent. Revenues had been going the other way.

A hallmark of that campaign was the way New York City's creative community pulled together on the state's behalf. Just as Carey had organized major business and labor leaders to help with the fiscal crisis, he now called on advertising and design professionals to help with the tourism campaign. Many of them did it for free. Some made money later on, but their initial investment was pro bono.

Wells, Rich, and Greene, the ad agency, conceived the marketing plan that sold the governor and Legislature on the whole campaign. Jingle man Steve Karmen wrote the "I Love NY" jingle, and did so well with it he turned it into a song. Carey loved to sing anyway, and he prompted people to sing this composition with him at every opportunity.

Milton Glazer, a hot graphic artist of the day, was asked to design a poster and logo. His first try had the words New York spelled out and inside a lozenge shape. The Commerce Department got sample T-shirts made up with the logo and gave them

to kids to wear at the beach as a test. The reaction? Not much. Back they went to Glazer's studio, and out came a new design. This time there was a bright red heart in place of the word "Love." They had some more shirts made up. More kids on the beach. And kaboom!

The logo gimmick became an international success. Fidel Castro wore an "I Love NY" scarf he was given in New York City and the sticker showed up on the Great Wall in China. The red heart became an international advertising symbol, was copied on bumper stickers all over the world, and was applied to all sorts of places and products that had nothing to do with New York. Back home, it became a regular feature of political cartoons featuring Carey.

When this all started, New York was investing less on tourism promotion than any other state—three cents per capita. Within two years, New York was spending 65 cents per capita, and the effort was paying off with big dollars coming into the state. A state Senate advisory committee concluded that "for each dollar the state puts into advertising its attractions, tourism spending increases at a rate possibly as high as 20:1."

Obviously, it didn't hurt Carey's 1978 reelection effort to have this phenomenally successful promotion campaign going on, making people feel good about New York. (Ronald Reagan used similar positive advertising—"It's Morning Again in America"—as a formal part of his 1984 reelection campaign.) It worked for New York, and that's what mattered.

Two decades later, states and regions are keenly aware of the benefits of marketing their natural beauty to earn image points. An area's natural resources are attractive for different reasons than once were true. In the nineteenth century, industries and communities grew up around natural sources of power (waterfalls, for instance) and around natural transportation avenues (such as harbors and rivers). The modern, post-industrial world is no longer tied down that way. Freed from those limitations, corporations can afford to look at physical location in a different way, and their executives search for pleasant places to live.

Hence the enormous value of protecting and then celebrating the Empire State's magnificent natural environment—the Catskills and Adirondacks, the Finger Lakes, the Great Lakes, Lake Champlain, and the beaches of Long Island—all are invaluable economic development resources.

States as physically disparate as Vermont, Oregon, and Colorado have learned this lesson, to their benefit. In fact, New York's business development recruiters found way back in the late 1970s that the "I Love New York" tourism ads—with their happy outdoor scenes—were telling businessmen all about the state much more powerfully than any direct efforts to sell New York to business. Business leaders were interested in the state because of those tourism ads.

Big Business Dealings

Of course, the core issue of New York's economic struggle was not so much inflow as outflow. Luring Mom, Dad, the two kids, and the dog for two weeks at Lake George was great. But the crucial matter was to keep major businesses from going the other way, from fleeing the state. As that Maxwell School report had pointed out, the new mobility made location less important, and states were bidding against each other like mad for corporations. There is no question that Carey was sympathetic to business concerns.

Raymond T. Schuler, the transportation chief who left government to consolidate smaller business lobby groups into the powerhouse Business Council, was working to persuade business leaders that Carey was their kind of guy: "I'd turn to the business community and say, 'Hey Carey's not one of these flaming social liberals who's coming in to tear apart New York State. He's trying to build the state. He's trying to rebuild it.' He [Carey] could buy into that."

Schuler remembers pulling out all the stops to impress the governor and the whole Carey administration with the collection of corporate executives he had coming to meet the governor at the first so-called Economic Summit. His planning was intense:

> To make this impressive, I insisted that as many of them as possible come in their own jets, and land them out at Albany Airport. I knew that Carey's people were going to be out there, and I was telling them, "I'll get my own limos, but I want some security provided, I want some State Police there."
>
> We had jets flying in, I had a helicopter hover over the Pool House. Three days before the meeting I insisted that our security people be allowed inside the Pool House to make sure there were no wiring devices for listening. Because we were going to meet first, as the Business Council, and then go into the Mansion itself and meet with him. And I wanted it secured. I wanted it controlled.
>
> Well, by the time we met with him, he was sitting there with Frank Carey [IBM], Amo Houghton [Corning], Walter Fallon [Kodak], John Jordan [International Paper], Ed Pratt [Pfizer] . . . the major guys.
>
> I also brought the New York Chamber people in, with David Rockefeller. David Rockefeller was there.
>
> Carey was impressed with this. The message they brought to him was, "What we need from you is an indication that the climate of this state is such that we can comfortably grow here, and not be driven out of business by higher costs—whether it's workers comp costs or the income tax."
>
> He got our message: "Income tax. Not on us, but the income tax in New York State is so oppressive that we have to pay all our workers more to recruit them. People don't want to come into New York. It's got a bad reputation."

Essentially that was Carey's thesis, the operating agenda. His budgetary warfare with the Legislature was about trying to reduce the state's high-tax, antibusiness reputation. Carey's administration was about many other things, too—better care for the developmentally disabled, health care reforms, environmental crises—but the budget battles overwhelmingly dominated the Carey years. His cutback efforts anticipated what would soon happen at the national level and around the country. With the election of Ronald Reagan in 1980, the federal government embarked on a major downsizing; the expansionist days were over.

Did it work? How much did the business climate improve? It is hard to give a simple answer.

Taxes did come down, from the high of a 17 percent personal income tax rate to 10 percent by 1982 when Carey left. Other business and corporate taxes were reduced, too. New York's economy began to shift toward a heavier reliance on the financial services sector, on high-tech development, on services generally, and on health care institutions.

Carey the Environmentalist

Although Rockefeller is justifiably famous for environmental foresight, for beginning the fight to clean up waterways and protect wilderness territory, it was Carey who was forced to deal with a whole new type of environmental issue—direct toxic threats to human health. He also experienced some of the backlash against the environmental movement from unions and business.

The true testing time came at Love Canal, where Carey became the first governor anywhere to be faced with significant toxic industrial wastes leaking into an unsuspecting residential neighborhood. Such environmental problems would later become a common phenomenon, a national problem. But Love Canal in Niagara Falls was the first, and New York had no road map for handling the mess.

It was a monumental mess—an elementary school and rows of small homes, built on or near a covered-over canal filled with chemical industry waste. Following huge snows in the winter of 1977–78, the over-saturated ground in Niagara Falls began flushing the chemicals out into the surrounding neighborhood. Health Department scientists were called in to investigate this black, smelly gunk in people's basements.

The laboratory reports were bad and the Health Department at first ordered a fence built around the dump site. Then it urged pregnant women and children to evacuate, because of the contamination. This order may have been the right health advice, but it created a storm of controversy because it did not account for the other people living there, and it didn't account for the value of the homes in question.

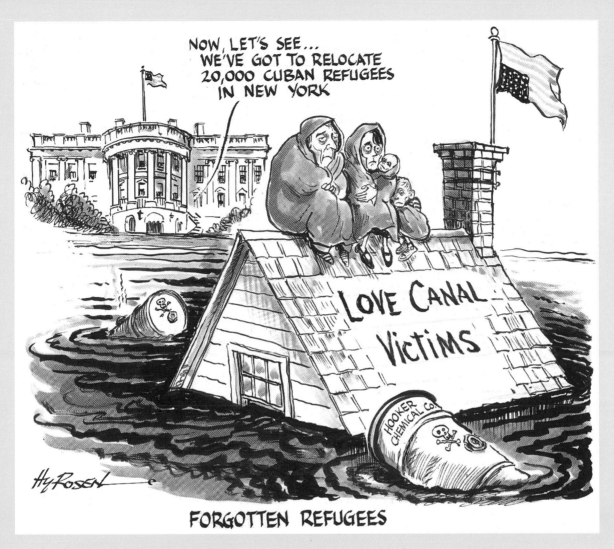

FORGOTTEN REFUGEES

Under Carey, New York was the first state to confront the crisis of toxic wastes in residential neighborhoods. He paved the way for the federal Superfund program with his show of courage at Love Canal, the Niagara Falls neighborhood ruined by a chemical company's waste disposal. The White House seemed more worried about Cuban refugees, including criminals and mental patients released by Fidel Castro, than about the pollution refugees in Western New York.

Transportation commissioner William Hennessy, who had seized property for state purposes all around New York (Albany's Empire State Plaza, Newburgh Airport, West Valley, the Northway), knew a thing or two about the condemnation business. He was urging the governor to get involved in Love Canal, although he didn't know how to get out.

The Love Canal families were up in arms, worried sick about their children's health and furious with the government, some for not getting everybody out right away and some for causing all this trouble in the first place. There was angry debate about health threats. Housewives organized the nation's first blue-collar community protest group (outside the labor movement) in recent times. Many people were also frantic about their lost investment. Hennessy remembers the private debate going on in Albany:

> We had caused it, with the announcement about the pregnant women and the children. Immediately four hundred houses were gone, worthless. I was in a terrible pickle. Nobody wanted to take the houses. The people were getting madder and madder and madder. And I'm trying to convince the governor that we've just got to do it. Our announcement was a de facto taking. Whether we appropriated the houses or not we had damaged the value of that property. It was touch and go.
>
> Then we went to the Love Canal one night for one of those awful, awful hearings. And I was chairing it. Before that hearing started we were up most of the night before, arguing this again. Whether to take the houses. Because, where do you stop taking houses? Do you take a hundred, do you take two hundred, do you take four hundred? I had proposed that we start with a center core. We were on the stage when the governor walked in, and he walked by me and said, "Bill, we're taking the houses" just before he made the announcement. I did not know what the decision was going to be.
>
> And that was before we had any money from the federal government or anything. After that we went to Washington and tried to get President Carter to come through with the dollars. And he never did. He came through with a declaration. But we never got all the dollars we were looking for.
>
> But Carey, he did the right thing. It was a hard decision. Because he didn't have the foggiest idea where this would ever stop. The more he got in it, it was just like a sink hole. But so many times, I could just rely on the governor to do that. He didn't have to always find a compromise.
>
> I don't think there's been a more courageous governor than Carey. He was personally courageous. In his work, if he thought in his heart and his head that something was right, he did it. And the consequences had to trail after that.

Of course, that decision and the Love Canal crisis blazed a trail that led to a whole new level of governmental activity on the environment. The federal Superfund program, which established a clean-up fund and laid out a legal way to recover costs from the polluters involved, grew out of this experience. At Love Canal, the Superfund even-

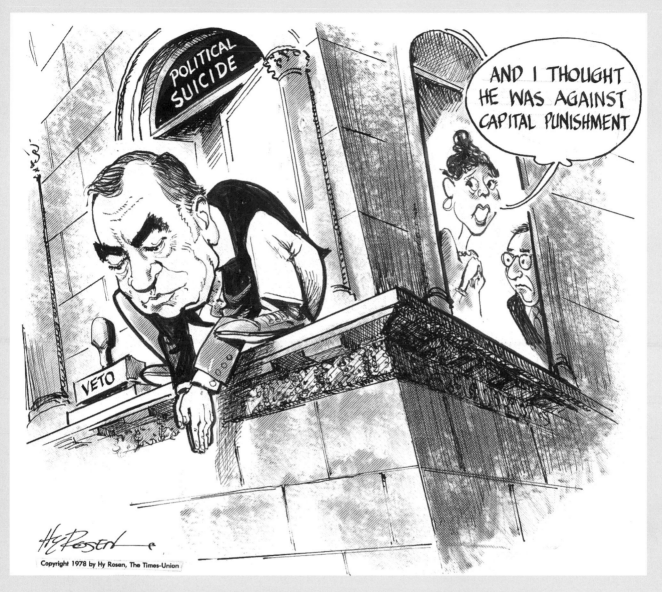

Carey started what became a tradition when he vetoed a capital punishment bill on the eve of running for reelection in 1978. New York repealed the death penalty in 1965 under Rockefeller, and proponents fought to bring it back nearly every year after that. Carey and then Cuomo used their veto power and never were overturned.

tually paid for millions in clean-up costs, and the Hooker Chemical Co., which had deposited the waste in the first place, negotiated a settlement with the state that was worth millions more. But none of that was down on paper or even on the horizon when Carey acted.

Foot in Mouth Disease

If Carey could rightly point to other people who caused Love Canal, he could only look in the mirror when it came to the "Tainted Tower," the PCB-contaminated Binghamton State Office Building. A transformer caught fire in the basement of the new state office building in downtown Binghamton on February 5, 1981, and spread toxins throughout the eighteen-story structure, courtesy of the heating ducts. The result was a film of black, oily soot over floors, desk tops, file cabinets, plants, light fixtures, and everything else.

PCBs were already notorious by this time, thanks in part to precautions taken by Carey's own government (finding PCB-loaded striped bass in the Hudson River, for instance, and banning fishing along certain stretches), and state worker unions were upset. They wanted extra precautions, and accused the state of downplaying the risk. Carey was confronted at a State Capitol news conference, and responded with wit rather than wisdom. He belittled the state workers' concerns by saying he'd be happy to "walk into Binghamton, into any part of that building, and swallow an entire glass of PCBs, and walk a mile afterwards." This was the day of his major State of the Health Message, intended to focus public attention on issues like teen pregnancy and infant mortality. Needless to say, that story line was totally lost, as the press pounced on the PCB story. The health commissioner stood up and tried to contain the damage, explaining that downing one glass of PCBs, one time, probably wouldn't hurt the governor a whole lot—unless he happened to be pregnant.

Nice try, but it didn't work. Now the state workers were really mad, and the clean-up effort was conducted under a totally new kind of spotlight. What might have been handled routinely became a thirteen-year-long nightmare. In one quipish moment, the governor had tossed away the state's credibility.

Adding to the problem was the discovery that the fire had also turned PCBs into dioxin, a more toxic substance. There were no clean-up standards for any project like this. Ultimately the state Health Department brought in scientific experts from around the country, invented new techniques for indoor air testing, and conducted studies that would establish national standards for this new type of work. The decade-long clean-up effort eventually amounted to $47 million, more than three times the building's original cost.

How much of this would have happened anyway? It is impossible to know for

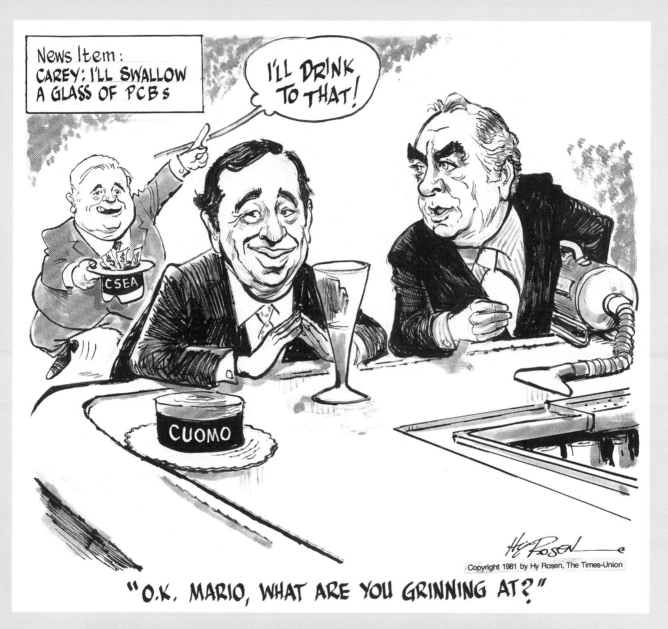

"O.K. MARIO, WHAT ARE YOU GRINNING AT?"

Carey's famous offer to drink a glass of PCBs belittled the concerns of state workers in the Binghamton State Office Building, where a 1981 transformer fire spread the toxic substance throughout eighteen floors. This was the type of poorly timed quip that sapped Carey's popularity and encouraged Lieutenant Governor Mario Cuomo to think about running for Governor in 1982, whether or not Carey stepped aside. This incident also gave the public a glimpse of Carey's basic intellectual contempt for what he saw as irrational hysteria about some environmental concerns. "It's easy to start hysteria, but how do you stop it?" he asked.

sure. But Carey's one-liner raised the clean-up bar to new heights, and it damaged the government's credibility with the public. The building was finally reopened in October 1994.

Carey's costly remark came from more than just a bad mood. As a matter of personal style, he hated doing things he felt forced into against his will. He resisted unpleasant tasks. And as a matter of policy, he genuinely believed that environmental concerns were often blown out of proportion. In an interview nearly twenty years after the Love Canal story broke, he blamed President Carter's reelection drive and housewives' organizer Lois Gibbs for creating more of a problem than there was: "The record will show there is not a single case of serious injury or illness out of Love Canal. That money was wasted. The saga of Love Canal has never been written fairly."

His frustration at being driven by what he regarded as irrational concerns may be understandable. Lots of public officials feel that way. But it is a fact that Carey's own Health Department did report finding serious health effects, including increased miscarriage rates, among the population at Love Canal.

Lasting Damage

The famous PCB quip was not the only time that Carey got himself in trouble, that his penchant for making the offhand remark, for being flip, and for not tending to the personal image side of politics caused him problems. In fact, media coverage of his second term came to focus on personal issues and personal peccadilloes to the extent that they detracted from his ability to perform as governor. The press went nuts when Carey tried to start condemnation proceedings to take over a dentist's new house that was blocking the view from Carey's Shelter Island summer home. The governor backed down.

An inability to mobilize public opinion in support of a political agenda is a fatal handicap for any political leader. Carey seemed to ruefully acknowledge as much when talking about those days, and about the media excitement that accompanied his decision to start dying his hair as he was pursuing the woman he would eventually marry, Evangeline Gouletas: "Ever since then, nobody talked about anything but the color of my hair. I thought it was disappearing so much that it wouldn't be an issue. . . . I'd rather have them talk about my hair than what's in my head. . . . If you don't have mirthology in politics, you get out of it."

Brave talk. But the reality was that the accumulating stories about his courtship of the wealthy and high-flying "Engie," as she came to be known, about his inattention to the day-to-day details of government, about his hanging out at New York City gin mills, were a tremendous drain on his governorship. His one-time friend, New York City columnist Jimmy Breslin, hung the tag "Society Carey" around the governor's

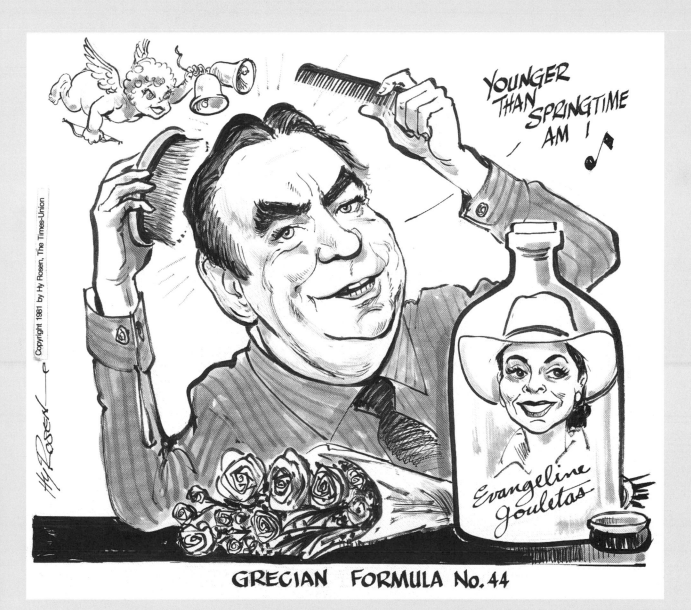

YOUNGER THAN SPRINGTIME AM I ♪

Evangeline Gouletas

GRECIAN FORMULA No. 44

The governor's high profile romance with wealthy Greek businesswoman Evangeline Gouletas preoccupied Carey and public attention in spring 1981. After letting his hair grow gray a couple of years earlier, he now turned up with a reddish tint. In a telling remark about the impact of all the attention paid to his personal life, Carey said, "Ever since then, nobody talked about anything but the color of my hair." Neither the color of the hair nor the marriage lasted.

neck, to symbolize how far he had traveled from his Brooklyn roots. That image and that nickname stuck, and hurt.

In fact, that image obscured many of the positive things Carey accomplished as governor. As he himself says, "nobody ever talked about anything but the color of my hair."

He decided not to run for a third term in 1982 for a variety of reasons—wanting to spend time with his children, wanting to make some money for them, feeling he'd accomplished most of his goals—but surely the political drag of all the personal stories had an effect. A number of Democrats were considering a primary challenge.

When Carey stepped aside, his lieutenant governor, Mario Cuomo, upset New York mayor Ed Koch in the primary and went on to succeed him. This turn of events was a great irony, because Carey had tried to get Cuomo elected mayor of New York City back in 1977, but Cuomo had lost to Koch. In the 1982 governor's race, Carey backed Koch against Cuomo, and Cuomo won the rematch. Cuomo did not forget: for Cuomo's entire three terms in office, all twelve years, Carey did not once set foot in the governor's office. Koch said he urged Cuomo to name something significant for Carey, a park or a building, but Cuomo did not do it.

For Carey personally, the post-Albany years were not always a great success. The marriage to Evangeline Gouletas didn't last, and neither did a number of business ventures. He bragged about "my millionaires," the staff members he once employed in Albany for $30,000 and $40,000 a year who went on to make millions on Wall Street and elsewhere. He himself did not make all the money he had hoped would create a secure future for his children.

He did enjoy something of a comeback as an elder statesman and a wise old head in the mid-1990s after Cuomo left office. Republican governor George Pataki appointed Carey to his transition advisory team, sought the former governor's advice, and highlighted Carey's appearance at his State of the State speeches.

The memory of Carey's public relations disasters faded, and the strengths of the well-managed government he ran began to be recognized. People around Albany also remembered the sense of humor and fun that Carey and his people brought to government. He thoroughly enjoyed being a politician.

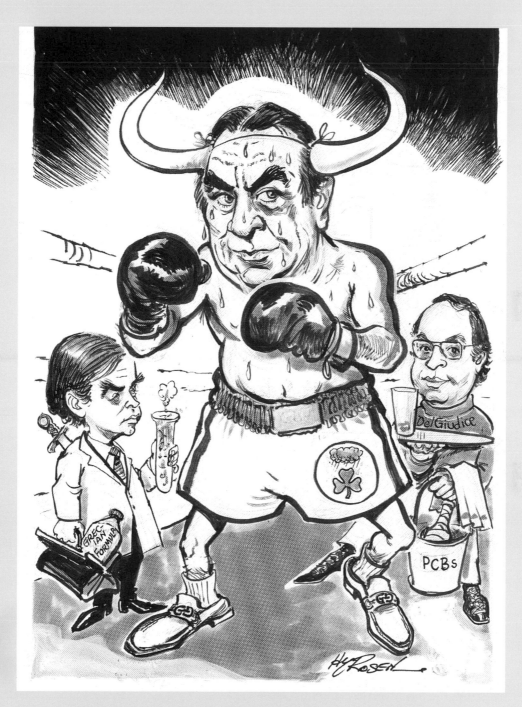

The movie *Raging Bull* about boxer Jake LaMotta was the inspiration for this drawing. It highlighted Carey's pugnacious style, often without benefit of diplomacy. Michael DelGiudice, holding the PCB pail here, was a senior Carey aide who stayed on with Cuomo, and earlier helped build the Legislature into an independent institution. The man in the medical coat is Dr. Kevin Cahill, who was very close to Carey for many years, although later they fell out.

5

Mario M. Cuomo, 1983–1994

I always thought that Mario Cuomo could have been the greatest governor that New York State ever had. He had the intelligence and he knew government. But I don't know what happened. . . . Lord knows he worked hard enough. He didn't take any time off.

—Former State Democratic Chairman William C. Hennessy

Mario Cuomo had his own dramatic baptism by fire as governor. It was not a political and governmental crisis like the fiscal disaster that Hugh Carey faced. This was more elemental.

Cuomo's trial was life and death—a prison riot, with hostages:

It was January 8. I was sitting in a little Mexican restaurant with Matilda [his wife], Christopher and Andrew [their sons]. We had been to Madison Square Garden, I think St. John's beat Georgetown [in college basketball]. A state policeman came into the restaurant and said, "There is an important phone call." And that was Ossining.

Prisoners at the famous Sing Sing prison in Ossining rioted just eight days into Cuomo's governorship, grabbing seventeen hostages. The brand new governor was instantly faced with agonizing choices. He barely had his feet on the ground, and now he had to make decisions that could make or break his whole career, not to mention the lives of guards and prisoners that hung in the balance.

Cuomo freely admits that his first instinct—to rush to the scene—was wrong. He was talked out of it.

Cuomo was lucky on a number of counts. He had seasoned people on staff, holdovers from the Carey days, who knew how government worked, knew each other, and didn't panic. Thomas Coughlin was the corrections commissioner who went to the prison and took charge there as Cuomo's agent. Michael DelGiudice was Cuomo's secretary, the top aide, who talked the governor out of his first instinct. As Cuomo tells it,

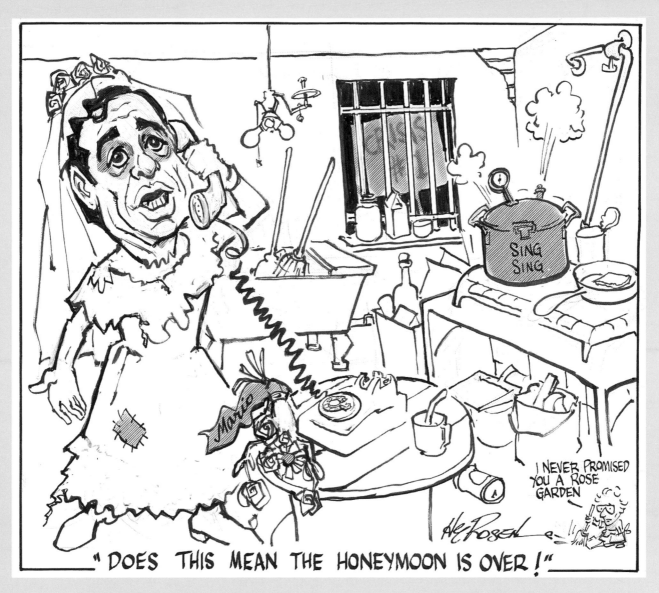

"DOES THIS MEAN THE HONEYMOON IS OVER!"

Only eight days into his term, Cuomo faced a prison riot at Sing Sing Prison in Ossining, with life and death decisions to make. Cuomo held firm and all seventeen hostages got out unharmed. It was a big victory, a strong start for his governorship, and instantly made his image as a tough and decisive leader. Ironically, management turned out not to be his strong suit. But that wasn't apparent in the beginning.

I said, "Look, I have to get up there right away." Mike said, "Gee, I don't think that's a good idea." All I was thinking of was Attica. And I said, "Look, I can't let happen what happened at Attica." Mike, who is very smart and had been around a long time, said, "It is a mistake to go now. We don't know a lot about it. The first thing they'll do is hold you hostage—not physically, but metaphorically, and it is not a smart thing to do". That upset me a whole lot.

But Cuomo agreed, and he set up a command post at the World Trade Center offices in lower Manhattan with an open phone line to the prison.

The Decision

Cuomo recalled:

The big decision, that I'll never forget, came when the prisoners sent out a message that said, "We want amnesty. And if you don't give us amnesty we're going to send out the testicles of the first guard on a plate." . . . I think they said two minutes. We had six or seven guys in the room . . . and the clock was ticking. What do you say?

Anyway, in the last fifteen or twenty seconds I said, "Tell 'em 'no.'" And then I went into the bathroom and threw up."

They waited, the silence stretched out. Then a voice came back on the line. The prisoners had sent out a new demand, a different demand. Cuomo had won the face-off.

The nightmare memory was Attica, Rockefeller's worst moment as governor, when forty-three men were killed in a four-day uprising at that prison in rural Western New York. Rockefeller never went to the prison, and, uncharacteristically, he seemed not to assume direct command of the decision-making, even from long distance. Cuomo insists that he made every decision at Ossining, via that open phone line: when to turn off the lights, whether to turn off the heat.

So, there was Mario Cuomo, ten days into his governorship. His inaugural speech was widely praised from the left and right. It was the coming of a new Democrat, commentators said, who reached back to the party's roots with sensible, pragmatic compassion. Cuomo had escaped the horror of Attica, and in winning the Sing Sing face-off with no deaths and a peaceful settlement, had bested Rocky, the patrician governor-king, at the game of life and death. What a start!

Hamlet on the Hudson

Contrast that dynamic beginning with the scene played out in Albany almost exactly nine years later, on December 20, 1991: national and international reporters mob the Capitol's second floor, trying to elbow their way into the old Court of Appeals room

where Cuomo held news conferences. Satellite switchers stand ready to flash Cuomo's presidential campaign announcement around the world. Cuomo aides tell their friends that he is going to do it, no question about it. Bill Clinton and other Democratic hopefuls brace for the news that the most imposing man in their party is getting into the game. Near the runway at the Albany Airport, a plane is poised to fly Cuomo over the mountains and into New Hampshire, where he will file the papers to enter the first presidential primary for 1992.

But guess what? It's off. The bridegroom's not coming. Cancel the wedding. Cancel the plane. No campaign. There will be no presidential race for Mario Cuomo.

Ever since 1984, when he delivered a powerful thunderclap of a speech at the Democratic national convention in San Francisco, Cuomo was the presumptive favorite for his party's presidential nomination. He was the liberal hope, the powerful northeastern ethnic who eloquently called forth the party's historic commitment to the poor and downtrodden, the striving immigrant families struggling to get their feet on the American ladder of success. But the elections of 1988 and 1992 passed by without Cuomo in the lineup. He declined to get into the game.

In many ways, the elaborate dance over whether he would or would not run dominated much of his governorship. This was the man who got tagged as "Hamlet on the Hudson" because he supposedly could never make up his mind.

Ironically, prisons and the presidency helped define much about Cuomo's years in Albany. Prisons because he built so many of them, more than all other governors combined; they were his main physical legacy. And the presidency because the idea was fixed in so many people's minds, and then he didn't even go for it, despite two enormous build-ups.

The Boy from South Jamaica

Looking back from beyond his three terms, and after all those years of Cuomo's dominating political presence, it is hard to remember that he started out as a true underdog, fighting for votes, fighting for attention, fighting for respect.

Mario Cuomo was born in 1932 into a shopkeeper's family in Queens, second son of immigrants from southern Italy who never spoke English very comfortably; his father was illiterate at the time of his birth. Mario was always the scrapper, striving to belong. On the athletic fields and in the classroom, he had no trouble. He was a star athlete at St. John's Prep and then at St. John's University in Brooklyn. And he finished tied for first place in his law school class. But after clerking two years at the state's most prestigious bench, the Court of Appeals in Albany, this son of immigrants couldn't get a job—or even an interview—at any of the big time Manhattan law firms.

Even for young men of his obvious talents, those doors were closed to Italian

ethnics in the New York City of the mid-1950s. It was the type of slight that Cuomo was sensitive to all his life. This sensitivity wasn't selfish, he was extraordinarily aware of discrimination against others: blacks, Jews, Irish, gays, women.

There was a determination about Cuomo, a fierce combativeness so dominating that even friends would say that he wore it on his sleeve sometimes. It showed in his flair for debate. He just couldn't resist engaging in debate on a radio show or at a press conference, sometimes to the point of haranguing people. And he sought out physical contests, too. Cuomo often walked or jogged over to Albany's public parks on weekends, in sweats, with a lone trooper sometimes trailing along, and joined in the games usually dominated by young black men in their teens and twenties. (More than two years after leaving office, being interviewed for this book in his splendid law office overlooking Central Park, a fit-looking, sixty-four-year-old Cuomo happily recounted his basketball adventures of that very morning, playing a pick-up game with young men on a local court in the neighborhood. "Hey man. He call you guv?" one surprised player said to Cuomo, when he heard another player refer to this muscular older ballplayer that way.)

As with everything, Cuomo did not like to lose at sports, and would do most anything to win. The scouting report on him when he was playing minor league baseball in the Pittsburgh Pirates system was, "He will run over you to score." There are more than a few political opponents around who believe that assessment applied way beyond sports.

During one minor league baseball game, standing in the batter's box ready to hit, the young outfielder Mario grew so enraged by the opposing catcher's ethnic slurs that he punched the other fellow in the face—forgetting about the big metal mask the catcher was wearing.

It took another injury, though, to convince him that law school was a wiser course than baseball. That was the fast ball he took to the side of his head, knocking him unconscious and into the local hospital in Georgia. Cuomo joked—from the comfortable perch of the governor's office—that after being hit in the head he didn't have any option left except politics. He was also in love with his future wife, Matilda, by then, and this young primary school teacher from a strict Catholic family in Queens had no desire to become a traveling baseball widow. Instead, she became a political widow of sorts, raising four children mostly by herself for many years, while her husband was out in the rough and tumble of New York politics. The family did quite well—the kids grew into successful young adults, and the father was elected governor three times. But it wasn't always easy, especially at the beginning.

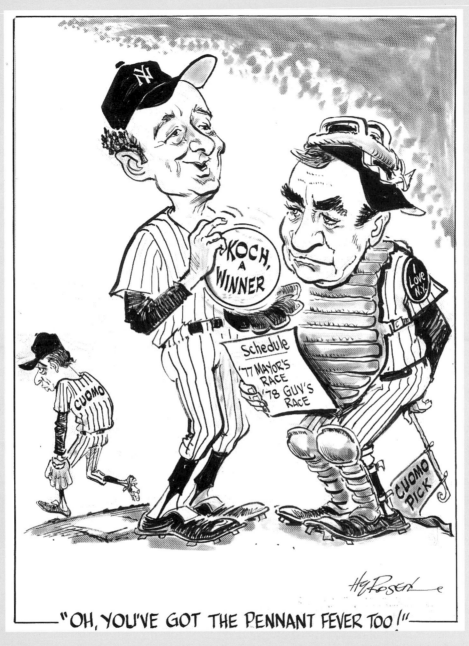

"OH, YOU'VE GOT THE PENNANT FEVER TOO!"

Relations between Koch, Carey, and Cuomo were incredibly tangled. At first, Carey tried to get Cuomo elected mayor of New York City in 1977, to replace Abe Beame amidst the fiscal crisis. But Congressman Koch won the Democratic primary, and Carey jumped to his side. This drawing shows an unhappy Cuomo being sent to the showers. A year later, he was back, as Carey's running mate, and that set Cuomo up to run for the top spot in 1982, when he went head-to-head with Koch again—and won.

Bloody Bedfellows

The governor-mayor dynamic in New York—the man running the state versus the man running its biggest city—is unique in American politics. No place else are there two such equally balanced power structures, with so much overlap of policy and influence and such enormous potential for conflict. No president must share so much of the spotlight with any one governor as New York's governor is forced to share with New York City's mayor.

The tales are legion. Governor Franklin D. Roosevelt deposed the corrupt Mayor Jimmy Walker in order to prove himself a credible national candidate, but he had to be very careful politically in exorcizing the cancer, lest he turn the New York City Democratic organization against him, mortally wounding his own future. Rockefeller and Mayor John V. Lindsay had a brief honeymoon—Rocky helped elect Lindsay—but then fought through years of conflict. Carey had his bankruptcy falling-out with Mayor Abraham Beame.

But it is hard to see how any other rivalry compares with the relationship between Mario Cuomo and Ed Koch. These two ambitious and sometimes vindictive Democrats rose to the pinnacle of power in the same period, had to knock each other down, bloodily, to get to the top, only to end up as uneasy partners. Strange bedfellows, strange courtship. The fact that they were able to work together at all suggests that political self-interest overrides all personal consideration in politics.

Cuomo and Koch first crossed swords when they each explored the idea of running for mayor of New York in 1973. Both dropped out before things got hot, for lack of money and support. Four years later, with the city deep in its fiscal crisis, both men tried again. Governor Carey had decided that the city's recovery required Beame's ouster, and that Cuomo, whom he had named secretary of state, was the man for the job. But Koch, who had made his name as a liberal congressman from Greenwich Village and then turned more conservative, gave Cuomo and Carey much more than they had bargained for. The two men emerged from a seven-way Democratic primary and ended up head-to-head in a run-off election for the Democratic line.

It was raw street politics, and among the most vicious campaigns in memory. Koch kept hammering on crime, lambasting Cuomo over the death penalty, which Koch supported and which Cuomo opposed.

Cuomo, in what he admitted later was a mistake, lost his cool and let his righteous prosecutor side take over. Some people in his campaign went much further. "Vote for Cuomo, Not That Homo" signs cropped up in the outer boroughs, where conservative Democrats were likely to be turned against Koch by the suggestion that he must be gay because he was a bachelor from Greenwich Village, which was home to many homosexuals. Cuomo disavowed the signs, but he couldn't turn off his own anger. Koch remembers:

He decided to come on like he was the district attorney, very harsh and critical in attacking me. He is a wonderful debater. And he lost because of the meanness that he exuded. I, following the advice of David Garth [campaign consultant star of the time, who later worked for Cuomo], totally ignored him, and the meanness. So I came over as a nice guy, which I am. And he came over as a bad guy, which he is, in the sense that we're talking about. And he lost.

Carey was the third partner in this tangled web. He first talked to Koch, then decided to sponsor Cuomo, and then switched back to Koch when Koch won the Democratic nomination in the run-off. Cuomo continued campaigning because he had the Liberal line on the ballot. It was a fratricidal mess, and Carey said later that getting involved in that battle was his biggest political mistake.

But the weirdness didn't stop there. A year later, when Lieutenant Governor Mary Anne Krupsak, the first woman ever elected statewide in New York, bolted Carey's ticket at the last moment to run for governor herself, Carey turned to Cuomo to be his new lieutenant governor. The Carey-Cuomo ticket won, but the marriage was not exactly a happy one. When Carey decided in 1982 not to seek a third term, Cuomo was all ready to run; he'd been planning it for some time.

Then here came Koch again. Fresh from a resounding reelection as mayor, now Koch was running for governor. He scared off all other Democrats except Cuomo, and they settled in for another bloody primary battle. Cuomo remembered:

> If I think I'm better than all the other people, then I should run. That's why I ran for governor. That's what I told Andrew, "Look, I'm going to run against Ed Koch. I'm better for this state than Ed Koch. The best arrangement is that he should be mayor, he's a good mayor. I'll be governor. The city will be better served and the state will be better served."

This time Cuomo stayed cool, and it was Koch who made a fatal mistake. He gave an interview to *Playboy* magazine ridiculing life outside New York City. Suburbs were "sterile," he said, and he typecast rural families as "wasting time in a pickup truck when you have to drive twenty miles to buy a gingham dress or a Sears Roebuck suit."

Still, Koch started out hugely popular, and had most of the money, as well as Governor Carey on his side, for whatever that was worth. Carey by that time was very unpopular. Cuomo won the uphill battle by 52 percent to 48 percent, and then the general election, too, against Republican Lew Lehrman. He was fifty, had failed three times at the polls, and this election was the first he'd won on his own.

Looking back on it all, fifteen years later, Koch took his defeat philosophically:

> Well I believe that I actually lost because the people thought that I was too identified with New York City. And even though Mario Cuomo came from Queens, he was not perceived as a New York City person. And I was, and so I am. They were right.

They were only wrong in thinking that I wouldn't have been fair to them. I would have been very fair.

And they got Mario Cuomo, and ultimately they threw him out. They were really angry with him, upstate [in 1994].

And to what did Koch attribute that? "His personality. They resented him. They saw him as hectoring and lecturing. They didn't see him as sweet and kind and gentle." When asked if he wished he had been governor instead of mayor, he answered, "No, actually, I was quite lucky. The people decided to keep me as mayor. I would have been very unhappy up there. There are no Chinese restaurants in Albany. Well, none that I would want to go to."

Ironically, given that history, Cuomo lost the 1994 election in part because he was seen by upstaters as too friendly to New York City.

Koch and Cuomo managed to avoid major public battles during most of the six years they were both in office, until Koch lost his try for a fourth term in 1989. But the state Financial Control Board, created during the City fiscal crisis of the 1970s, which the governor is legally required to chair, kept Cuomo in an official overseer position that Koch never liked. And the two men never were able to work together to improve city schools, or to stop the deterioration of Kennedy and LaGuardia airports. They certainly never became friends.

"I like him more than he likes me," Cuomo said when he learned Koch was going to be interviewed next for this book.

"That's nice," Koch quipped, when told of that remark. "I didn't like him."

Soul Man

Unlike Nelson Rockefeller, who is remembered for his "edifice complex" and built massive public works, or Hugh Carey, who is remembered for saving New York City from bankruptcy, Mario Cuomo is known less for specific gubernatorial accomplishments than he is for his magnificent ability as a leader and public speaker; he had a capacity for articulating the lofty ideals that most Americans feel, deep down, even if they don't live their lives that way, day-to-day. He had a wondrous touch with words, a stop-traffic kind of power that set him apart from every other politician in the country, and he had talented writers.

But Cuomo was not born that way. He had to work at it. Sol Watchler, former chief judge of the Court of Appeals, who fell from his high post in disgrace and spent eleven months in federal prison after being convicted of extortion in a case involving his former girlfriend, knew Cuomo a long time. He recalled that Cuomo didn't always have the magic:

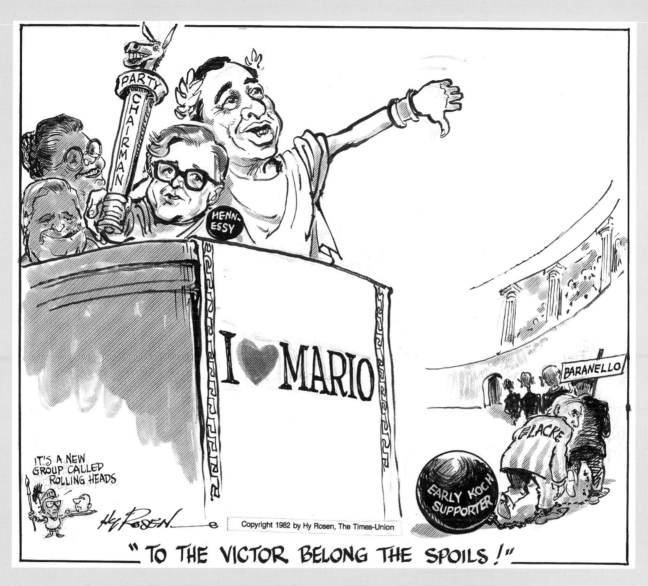

"TO THE VICTOR BELONG THE SPOILS!"

Cuomo got rid of Carey administration commissioners who had backed Koch in the 1982 primary. On the platform with Cuomo are William Hennessy, the new state chairman, Polly Noonan of Albany, the deputy chair, and William McGowan, president of the Civil Service Employees Union. Slinking away are former environmental conservation commissioner Robert Flacke and Suffolk County Democratic leader Dominick Baranello. Cuomo could carry a grudge.

He never was as sure of himself, in the early days. I can remember when I spoke with Mario, at the Israel bond dinner, when he was just secretary of state, and I was a sitting judge at the time . . . and I was so much better than he was. He read his speech, he was not at all sure of himself.

And then this maturation came over him. A confidence and ability, to the point where he could eclipse anybody, including me, as a speaker. Bright, sharp, sure, witty. Cutting. All the virtues. And the more he did it, the more confidence he gained. Some people mix up confidence with arrogance. If you don't have confidence, you don't project well. But sometimes when you have a lot of confidence, people think you're arrogant. And confrontational, and all the other things.

He's really confident. And you very seldom see someone who speaks as well as Mario, who has that kind of confidence in his own ability, who doesn't have some degree of arrogance. . . . It's heady stuff. When you finish speaking, when you walk off the stage and people are saying, "God that was fantastic, I never heard anyone like that." You read an editorial in the *New York Times,* saying how incredibly smart you were, how wonderful your remarks were. You see the commentators on television say, "There's a man who has a unique wisdom." Jesus, what are you going to say?

That's exactly the kind reaction that Cuomo earned just a year and a half into his first term, with an extraordinarily celebrated speech to the Democratic National Convention in San Francisco. It is vital to remember that Cuomo was elected governor two years into the Reagan era, when the idea of releasing the energy of private enterprise and the profit motive took over as the reigning political philosophy. Government was bad, and unchaining individual initiative was the best way to move the country forward. This was not Cuomo's ethic, and he railed against what he saw as the selfishness of the 1980s, the get-rich-quick individualism, the "Me Decade," from the very beginning. In his 1983 inaugural speech, a preview, really, of the more famous San Francisco speech, the new governor did not talk much about things he hoped to do or accomplish as governor. He spoke at length about "what I hope will be the soul of this administration." And he set forth the slogan that he would use to govern, The Family of New York: "We must be the family of New York, feeling one another's pain, sharing one another's blessings, reasonably, equitably, honestly, fairly, without respect to geography or race or political affiliation."

At the California convention that was nominating former vice president Walter Mondale to run for president, Cuomo characterized Reagan as a heartless proponent of Social Darwinism:

> The Republicans believe that the wagon train will not make it to the frontier unless some of our old, some of our young, and some of our weak are left behind by the side of the trail.
>
> The strong will inherit the land!

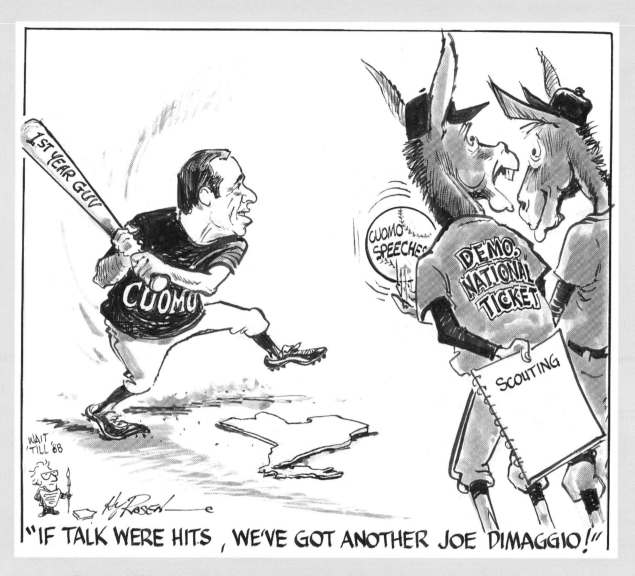

"IF TALK WERE HITS, WE'VE GOT ANOTHER JOE DIMAGGIO!"

This mid-1983 cartoon shows how popular the new governor was, and also suggests a theme that would dog his later years: the government's inability to produce results that matched the lofty ideals articulated by Cuomo's wonderful speaking talent. The scene also begins raising the presidential speculation. Sports images are a natural for communicating basic ideas to a broad audience. As a former minor league ballplayer and still a competitive school yard athlete in his fifties, Cuomo was perfect for the baseball imagery. The Joe DiMaggio label touches on the governor's Italian heritage, an important part of his make-up.

We Democrats believe that we can make it all the way with the whole family intact. We have. More than once.

Ever since Franklin Roosevelt lifted himself from his wheelchair to lift this nation from its knees. Wagon train after wagon train. To new frontiers of education, housing, peace. The whole family aboard. Constantly reaching out to extend and enlarge that family. Lifting them up into the wagon on the way. Blacks and Hispanics, people of every ethnic group, and Native Americans—all those struggling to build their families and claim some small share of America.

Cuomo likened contemporary America to a "tale of two cities." One was a "shining city on a hill," but the other was gripped in despair, where there lived "the woman who'd been denied the help she needs to feed her children because you say we need the money to give a tax break to a millionaire."

This was powerful stuff, and it seared Cuomo's image into the national consciousness. But in a political sense, Cuomo was swimming against the tide. The American middle class was tired of reaching out to lift people into the wagon, especially with expensive welfare programs that didn't really seem to work anyway.

The Teacher, the Political Communicator

Religion and his old-style, almost old-world sense of family were profoundly important in Cuomo's political make-up. He behaved like a teacher, like a father, overbearing sometimes, but never indifferent.

Part of the passion came from his love of ideas, of learning and of teaching. He told people that he might have become a teacher, but that the law offered the chance to make more money for his family. His passion for teaching is apparent in his speeches, the way he used language to explain and debate complex ideas. He didn't just use speeches to pump up a rally or promote one of his proposals—though he could be very good at that, too. Cuomo's speeches also examined philosophical conundrums, explored the motives behind human behavior.

The other factor that infused his message was his own religious grounding in humanistic Catholicism, his belief that man is put on earth to assist God in the never-ending task of trying to improve the human condition, to work toward the perfection of Christ. Man may not be perfectible, but through love and good works, man can move closer to that ideal. Pierre Teilhard de Chardin, a twentieth-century Catholic philosopher whose writings Cuomo discovered and studied while in college, represented this sort of activist humanist. Cuomo defined his approach to public service through Teilhard de Chardin. He sent the priest's writings to all kinds of people.

If Cuomo thought about being a teacher as a young man, he also told people that he once considered being a priest, but doubted he could be pure enough.

As governor, he loved the chance to use his extraordinary speaking skills to teach and to uplift, to explain and to elevate. This was no ivory tower exercise. Cuomo saw these functions as an integral part of the political process, a way to advance his cause, just as he used his debating skills as a lawyer. His Notre Dame abortion speech is the best example. Cuomo gave this speech in September 1984, still flush with his grand success at the Democratic National Convention, which had made him a national figure. Now he was embroiled in a nasty abortion controversy back home, with Catholic bishops headed by John Cardinal O'Connor, the newly appointed, strongly anti-abortion leader of New York City's Catholics. O'Connor was brought in from Scranton, Pennsylvania, by a pope who wanted a strong conservative voice in the U.S. media capital. Pope John Paul II got what he wanted.

The churchmen were arguing that public officials of Roman Catholic faith, like Cuomo, had a duty to oppose abortion and even work to outlaw the practice. Cuomo had long held the position that while personally agreeing with the church's position on abortion, he did not have a right to impose that view on others. So he did not oppose, for instance, spending public money for poor women to get abortions under the Medicaid program. Some religious leaders even suggested that Cuomo should be excommunicated, be barred from confession, among other things, if he did not press the church's agenda. Matilda Cuomo remembered the shock of watching television with her children and hearing this threat. This was an affront, a challenge, that Cuomo could not ignore.

Responding in newspaper and television interviews was not enough; this called for a full discussion of complicated and sensitive issues. Cuomo seized a marvelous theatrical opportunity when he accepted an invitation to address the topic at Notre Dame, the nation's best known Roman Catholic university. He was guaranteed national exposure. In addition, he got the advantage of appearing to be at a disadvantage, the underdog playing the game on the other team's field.

Even more than usual, Cuomo prepared meticulously, with the help of his speech writers. They worked on the talk for weeks, reading widely in philosophy and theology, in the sciences and history, amassing notes in forty-three different piles of five-by-eight cards and redrafting section after section of the speech. (The Legislature was in summer recess, so he did not have lawmakers around to distract him.)

Hy Rosen got a look behind the curtain:

I had a unique look at this speech in progress. I was down at the Capitol one day with [author] William Kennedy, my former *Times Union* colleague, for a cartoon exhibit sponsored by the Foreign Policy Association. One of Cuomo's aides spotted us, went inside, and came back to invite us to see the governor who was working on the Notre Dame speech.

Cuomo read some of it to us. And I remember thinking, "Wow, this guy's got guts."

This is going to be a direct challenge to church leaders, right in their own house. That's just how it turned out.

Cuomo flew out to South Bend, Indiana, on the state plane with a few aides and a cluster of reporters from the Albany press corps. Television cameras from all the networks were there to record this extraordinary event; after all, the long-distance debate did touch directly on one of the major social issues of the times, and abortion was an issue in that year's presidential campaign, even if Cuomo was not a candidate.

The governor argued that there was an important distinction between religious teaching and political action, that while certain beliefs were absolute, the ways to apply them in secular and political life were open to constant debate: "My church and my conscience require me to believe certain things about divorce, birth control, and abortion. My church does not order me—under pain of sin or expulsion—to pursue my salvific mission according to a precisely defined political plan."

This speech by no means ended the guerrilla warfare between Cuomo and some Catholic leaders. Dedicated abortion foes did not appreciate the point Cuomo made about the many Catholic women who clearly, by their own behavior, rejected official church teachings on abortion. In 1990, an auxiliary bishop from Newburgh, in the lower Hudson Valley, who was arrested for blocking access to a Planned Parenthood clinic, claimed Cuomo was "in danger of going to Hell if he dies tonight" and then compared the governor to Nazi soldiers who "supported the German government's right to murder six million innocent Jews" even if they did not believe in that policy.

Overall, however, Cuomo's speech was a huge success, solidifying his growing national reputation as an articulate public official willing to speak out complex and dangerous issues, unafraid to confront his opponents, no matter how powerful they were. These are not easy questions for public officials with deep personal convictions. Carey, for instance, said after he left office that he had made a terrible mistake in not working against abortion. But Cuomo stuck to his principles, to his strong belief in the separation of church and state, and he stuck with his opposition to the death penalty, too.

Of course, skeptics might ask what the Notre Dame speech had to do with being governor of New York. Why wasn't he using all those weeks to woo new business to Utica and Poughkeepsie? Then again, somebody has to lead.

The Governor of Small Steps

Okay. A great speaker, a spellbinding leader. Where did he lead?

Ronald Reagan took his huge election victory in 1980 and turned it into a massive tax cut and started an equally massive federal downsizing, pushing responsibilities down from Washington to the states. Cuomo took his giant reelection victory in

"IT'S HELL ON EARTH WE WISH TO AVOID!"

A particularly outspoken antiabortion Catholic bishop claimed in 1990 that Cuomo risked going to hell because of his stance on abortion. Cuomo had a long struggle with his church on the issue, and delivered a major address at the University of Notre Dame, where he drew a distinction between his personal beliefs as a Roman Catholic and his public role as a government leader. The cartoon clearly supports Cuomo, arguing that the root causes of unwanted pregnancies need to be attacked, at school and at home.

1986, the largest margin ever in New York history, 67 percent to 38 percent, and did—what?

Cuomo's essential dilemma was that he wasn't elected to downsize the government, but that's what the times demanded. He believed in using government as a activist instrument to improve social and economic conditions. He spent twelve years straddling that disconnect. Here he was orating like the second coming of Roosevelt, calling upon people to sacrifice for one another and share each other's burden, but he didn't have the resources of Rockefeller's era to satisfy the expectations he was creating. When citizens zinged the governor at town meetings around the state, his tactic was to demand that they come up with cuts elsewhere to balance out their increases.

"So, what should I cut? Schools? Day care? Snow plowing? Tell me. Prisons? Police, we'll cut the police!"

That response might work rhetorically and convince people there was a problem, but it didn't solve the basic issue. Considering everything he had to confront, Cuomo did a remarkably good job of straddling for a long time. For all his big talk, and the grand vision of his speeches, Cuomo tended to be a governor of small steps.

Take the matter of health insurance, an issue of growing importance in the late 1980s. Some 14 percent of New Yorkers had no health insurance—neither public nor private—and the burden of providing care for those people was a financial strain on the state's health care system. No insurance meant that a lot of kids went without basic health care, too, never getting immunizations or simple treatments to stop larger problems from festering.

In his 1989 State of the State message, Cuomo called for a plan to attack this problem and assigned the task to state health commissioner Dr. David Axelrod. Axelrod came up with an aggressive plan called UNY*Care that would create a state requirement for all employers to provide health insurance, with help from state subsidies in some cases. The state would save money by converting the complex web of insurance payment systems into a single-payer system.

This plan was ambitious—only Hawaii and Massachusetts had tried universal insurance before—and it preceded President Clinton's attempt to solve the problem at the federal level by several years. At the time, it seemed a perfect way for Cuomo to build his White House credentials and lead the nation in solving one of its more vexing problems. South Africa was the only other developed nation besides the United States without national health insurance, Cuomo used to say in his speeches. However, Cuomo declined to go for the whole hog. Instead he proposed a plan just for children. With 700,000 uninsured kids below the age of eighteen, this was not a trifle, but it was just a step.

The plan was adopted, using state grants to subsidize insurance policies that working poor families could buy for their children at vastly reduced cost. The program

turned out to be quite successful, and Cuomo's Republican successor, George Pataki, bragged about expanding it during his first term.

Cuomo's era was different from Rockefeller's. He didn't have the resources that Rockefeller had; he didn't have a unified party controlling the whole Legislature; and the political world had changed. Cuomo reflected on the difference: "In those days the way you got to be president was based on ideas. It was the period of exciting ideas. Rocky was spending his time as governor, always wanting to be president, trying to demonstrate that you could do new and exciting things, that you push the horizons of success."

Cuomo the Democrat did not launch Great Society–type programs, as the health care example illustrates. In fact he was criticized by the left wing of his party for not doing more.

But Cuomo knew that his time was different. And he saw the evolution: "Now, in a different period, in order to put needs before wants, you have to get rid of some of those wants, because you can't afford them. Therefore, let's use thresholds. Affluence tests for Medicare. I always agreed with that, always believed it. Needs before wants." It was Cuomo's curse to govern at a time when the public's patience with helping programs had ran out. People still wanted to believe in those lofty ideals that Cuomo called forth, and in their own generous spirit, but they were fed up with the price tag, and with the obvious failure of many social programs to do much good.

Ralph Marino, GOP leader of the state Senate during most of Cuomo's years in power, commented:

> When Nelson Rockefeller was there, he had a lot of the same programs, the same social programs. But he had a united party.
>
> At that point we were as generous with social programs as the Democrats were. It was only in later years that Rockefeller recognized that people were becoming more conservative . . . tough criminal laws, retrenchment on budgetary matters. Because he recognized that he had to pull in the reins on the more ambitious spending, that people weren't going to stand for it.

If Rockefeller was riding the wave of rising new expectations on the way up, Cuomo was stuck riding the wave the other way. Rockefeller did adjust, as Marino's remarks suggest, toward the end of his governorship, and took a more conservative tack. Carey was forced to recognize cold reality with the threat of New York City's bankruptcy, and he began a reduction in government spending and service expectations. New York itself was changing, in its attitudes and its ability to pay for expansive programs.

For Cuomo, the problem was one of adjustment. People were tired of reaching out a helping hand, and people believed that the helping programs didn't work anyway. They cost a lot of money, especially in the mind of many middle- and working-class

families who saw their real dollar incomes stagnate or decline in the 1980s. Teachers' salaries shot up dramatically, but student test scores went down. Welfare spending was rising, but all that money never seemed to solve any of the basic problems of poverty. Teen pregnancy kept going up. At the same time, the poor were becoming more cantankerous, more marginalized, as the postindustrial world left them behind.

In such an environment, managing public policy was crucial. The key was making government work better, making schools do a better job teaching skills to children, making the welfare departments help people get jobs, not just more cash. And Cuomo wasn't able to accomplish much on that front. Back at the end of 1988, the year he had decided not to run for president and had wallowed through a whole series of budget problems, Cuomo admitted to a *Washington Post* reporter that New York had spent too much on human services programs: "We have just put too much money too fast in some of these programs. The sixties taught us it's one thing to have your heart in the right place, and another thing to do it right. Sometimes, when you don't do it right, you lose the political capital needed to get the agenda done."

Reversing the years of government spending and emphasizing tough minded management was much harder for a leader than pointing "ever upward," as the state motto, "Excelsior," dictates. This was especially true for a leader whose whole political persona was tied to the idea that government should reach out and help people, and whose political constituency was tied to the money that flows through those helping programs.

Cuomo did rail against failures in education and other programs: "There is an overwhelming consensus that the New York City school system is failing those students most in need. . . . What has the Education Department been doing in New York City?" he said in 1988. He talked about doing more with less. But he was not able to sustain a major efficiency drive, in part because he did not have the political ability to force major changes in the way things operated. The education union and local political leaders resisted any significant changes in New York City school operations, even as test scores kept dropping and janitors got fat contracts guaranteeing them their own jeeps—both on and off duty.

Welfare

Welfare policy was the symbolic front line of the basic political divide in Cuomo's era:

> My view of welfare is very simple. I take it exactly from my own background. My father worked like a horse, so did my mother.
>
> My father in his grocery story. The blacks would come in. They used to sleep by the railroad tracks, they had little hovels. They would come in, they would ask him for bread, the end of the Italian bread. He would make the sandwiches and cut the end off, because people didn't want the narrow end in their sandwich, they thought

The "Decade of the Child" was an umbrella term for a whole series of education, health, labor, and social services programs aimed at helping poor kids get a leg up. This cartoon reflects concerns that the underlying problem of family breakdown was not being addressed. Divorce rates and out-of-wedlock births were skyrocketing all around the country, and especially in New York, during this period. Cuomo invited Hy Rosen to join in a teen-pregnancy prevention program, holding cartoon workshops in schools. It did not last.

they would get cheated with the amount of salami. So you would cut the end off, and you save a bag of the ends, and the guy would come in and say, "Do you have something handy to eat?" You'd say, "Absolutely," and you'd hold up the bag, And the ends of the salami, the end of the prosciutto, where it's so narrow you can't get it on the slicing machine. "I'll give you this, too, but I want you to do me a favor, go down in the basement, I got to clean a little something up." Or, "Go clean the back yard." Or, "Do this or do that, or deliver some orders for me." And if the guy said "yes," he would give him the bread. If the guy said "no," he would kick him out of the store.

So, with welfare. I say, everybody has to work, as soon as possible. But you have to give them the capacity to work. They have to read and write. Now they have to handle computers for them to be useful to you.

Give the people a good education. That means day care for the kids. Invest in them. Now, make absolutely sure they are working, and as soon as they can. And as soon as they don't show up for class, that's it. They're out. They're on their own. 'll give you that.

As governor, Cuomo did move toward reform. Local governments were authorized to require recipients to work and were told to combat fraud by recertifying recipients from time to time. Cuomo even took New York City to court to enforce that rule.

Cuomo also tried a limited experiment based on the largely forgotten 1986 national welfare reform law that aimed to get welfare mothers to work by giving them training, child care, and transportation, and by letting them keep welfare's medical insurance as they began to earn some money on their own. This more humane reform approach actually did work in New York—it saved $10 for every $1 invested in a three-county pilot project over five years. But it was not enough to satisfy the antiwelfare politics of the times. And when this type of progressive reform didn't work, or more accurately, when it didn't achieve striking enough results nationwide, the conservatives came in and blew the house down, imposing strict time limits and work requirements with no training or education tie-ins.

Essentially, Cuomo and the Democrats (in New York and nationally) failed to fix a broken system when they had the chance. So in 1994, the Republicans swept into power, in New York and in the Congress, on a tide of antiwelfare sentiment. And the Republicans enacted relatively radical changes, politically unthinkable in New York just a few short years before: time limits on benefits, absolute work requirements, food stamp cutoffs.

Here was a classic case of a politician, Cuomo, who knew that major changes were needed, but who was unable to lead the way to change because his constituency base didn't allow him room to maneuver. The welfare families, and the not-for-profit agencies, and the health care agencies who served them, tied Cuomo down. In the end, of course, the failure of reform led to much heavier cuts and a virtual wipeout of some cherished programs.

"AND YOU KNOW I BELIEVE IN MIRACLES..."

Cuomo had tough budget times, suffering through two recessions, even as taxes were being cut. Businesses were downsizing and leaving the state, in part because of high taxes, but also because the national economy was changing. Cuomo always had his eye on the White House, or so it seemed.

Cuomo's years were an economic roller coaster, down, then up, and then down again. He did not face the absolute cliff-edge disaster that Carey confronted, but he had to scramble just to keep afloat. Cuomo recalled:

> My twelve years came right in the middle of two recessions: '82, '83, and '89, '90, '91. I'm probably the only governor in the modern history of the state to face two recessions, one of which was the worst since 1932. . . . And you look at this, the debates in '82 with Koch and Lehrman [Lew, the millionaire drug store king who was Cuomo's GOP gubernatorial opponent in 1982] never mentioned HIV. Did you ever hear of crack in '82? No sir. No HIV, no crack. And in '83, my first State of the State in '83, you saw the first HIV program, first crack program.

Those two recessions tore up the New York economy. Jobs just poured out of the state, like water going over Niagara Falls. The stock market crash of 1987 took its toll. The end of the cold war wiped out Grumman, the massive defense contractor on Long Island. In just ten years, the Grumman payroll went from 25,000 to 3,500. When a huge TWA jetliner (Flight 800) crashed into the ocean off Long Island in 1996, investigators had no trouble finding an empty hanger big enough to reconstruct the wreckage; there was that much abandoned industrial capacity.

In the three worst years of the recession, Long Island lost about 10 percent of its one million jobs, as many jobs as there were people living in Albany, the state capital. And IBM, the computer giant, was downsizing drastically in the Hudson Valley. IBM had had a no-layoffs policy for years, from its very beginning as a company— but no longer, not in the Brave New World of corporate restructuring.

This was a cultural shock. These were areas where steady employment with one company was an article of faith, where three post– World War II generations grew up confident in the strength and security of work and community.

Did the state government bear some responsibility for this? Yes and no, depending on where you sit. Grumman's fate was tied more to the end of the cold war defense budgets than it was to New York policy. IBM's main problem was that it's mainframe computer operations were outclassed by a new generation of personal computers, and that it lost out to Microsoft in the software wars. A graph tracing unemployment levels during the Cuomo years goes up and down with these recessions. So does a graph showing the welfare rolls, which dropped as the economy recovered in the middle 1980s and then started climbing again in the final years of that decade and kept on rising into the 1990s.

But the truth is, New York recovered much more slowly than other parts of the country from the downturn, and Cuomo definitely got blamed for breeding a bad

business climate in New York. Justified or not, the man in charge gets the credit when things go well, and gets the blame when things go badly.

Cuomo's administration spent lots of money in tax incentives, luring companies to New York and trying to hold others. New York joined in the increasingly fierce competition among states to attract business, and under Cuomo it created new economic development zones and handed out tax benefits worth millions, vastly more than most any other state. Despite those efforts, the Cuomo administration had a clear antibusiness reputation. It wasn't just the high taxes—after all Cuomo presided over huge cuts in state taxes—it was an attitude of the government toward business. Part of this perception stemmed from aggressive regulators in the environmental, health, tax, business, and labor areas, and part of it stemmed from the personal attitude of the man at the top. He gave off an antibusiness feeling.

James Featherstonhaugh, a lobbyist and Cuomo confidant who worked on Cuomo campaigns, remembered a story on this point:

> I was quoted in the newspaper, from one of those business roundtables, about the government's antibusiness attitude. I was at work on Saturday morning and the phone rings and it was the governor, He said, "I'm just reading your comments here."
>
> I said, "If you don't believe me, talk to some small business people." So they did, they put together this meeting of small business people from all around the state. We all went in and the governor came in and gave a forty-five minute soliloquy about all the things he's done. It started out very polite. Then, finally, about the fourth guy to speak (I can't remember his name) just unloads, I mean unloads on the governor. He not only unburdened himself about everything that the agencies make you go through, he said, "Governor, you've invited us all here to hear our concerns, and you just talked for forty-five minutes. Don't you think it would be of some use to you if you listened for a change?"
>
> I've never been in a room, in a campaign or otherwise, where anyone was ever that direct or even rude to the governor. It froze the room.

Out of the meeting came a symbolic suggestion for a moratorium on all new regulations. Nothing ever came of it, however, despite the generally positive reaction from the governor and his staff. Agencies balked. The moratorium was one of the very first things that Pataki did upon taking office. And the business community loved it.

Taxes and Budget

Ironically, for all his reputation as the big-spending Democrat, it was a series of tax-cutting decisions that Cuomo and the Legislature made about halfway through his administration that got him and the state into big trouble and led to some messy fiscal games.

The first big tax cut under Cuomo was passed in 1985 (he was getting ready to run for reelection in 1986) and took the top income tax rate in New York below 10 percent for the first time since Rockefeller. That was a milestone. The reelection was a walkover. Cuomo trounced Andrew O'Rourke, the Westchester county executive, by the largest margin in state history. The economy was picking up, taxes were going down, and Cuomo seemed to be a likely candidate for president. He was riding high.

Then in 1987, tax-cutting fever struck again, in the form of a three-year tax cut, designed to take the top tax rate down to 7 percent by 1990. It became more of a millstone than a milestone because when the recession hit, the state ran out of money and couldn't afford the final part of the tax cut, not while carrying the expense of ongoing programs and the multibillion-dollar payments due on all that debt built up over the years. Neither party wanted drastic cuts. Republicans controlled the Senate in those days and Democrats controlled the Assembly. Both had a very limited appetite for cuts, because the members got reelected by bringing home more money for local schools, highways, and special projects. Nor did either party favor boosting the income or sales tax, for fear of a political backlash.

The exact same scenario happened to Ronald Reagan at the beginning of the 1980s, when his big tax cuts and a recession caused the federal budget to career way out of balance. But the federal government can run a deficit and can literally print money, and Reagan raised the federal deficit by more than all his predecessors combined. A state does not have a printing press for money. It cannot run a general deficit, although it can borrow for capital expenses. So, with New York running out of money, Cuomo and the top legislators began a series of financial games to paper over the problem and not raise any of the basic taxes.

Mark Lawton, the long-time fiscal specialist who was Carey's last budget director, is typical of the critics: "Mario, he didn't try to get hold of the issue. He tried to get by. How long can you string things out? Pretty far. You sell a road back and forth. Sell a prison." These are not some madman's imaginings. The state actually did those things under Cuomo. It sold Attica prison to the Urban Development Corporation—the quasi-independent agency that Rockefeller created in the 1960s to build housing and develop jobs for the poor—and then rented the prison back. It sold part of an interstate highway to the Thruway Authority, and rented it back.

It was all part of the scheme to keep the state going without making the tough political decisions, without facing up to the ugly truth and either cutting spending radically, or raising broad-based taxes. Either approach would have solved the problem, but would also have generated intense political opposition. What happened in New York was that as the broad-based state taxes declined, local taxes went up. At the time Cuomo left office, New York was no longer even close to the most heavily taxed state when it came to *state* income taxes. Cuomo actually *cut* income taxes sharply, by $1.1 billion in 1985 and by $1.5 billion in 1987. But New York was number

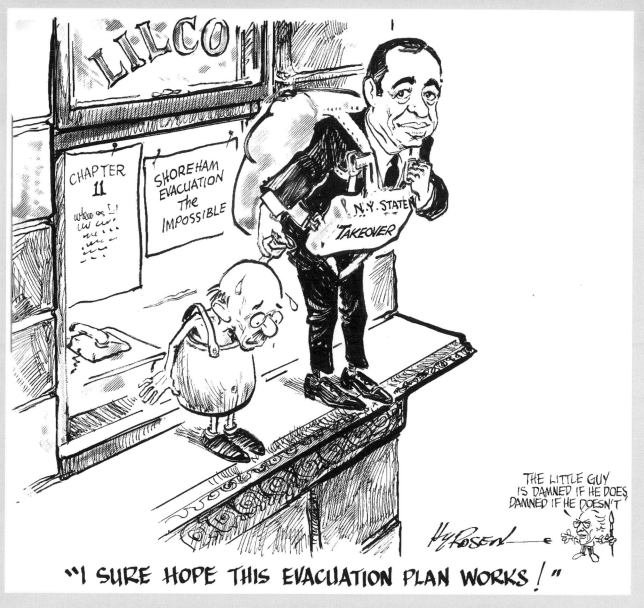

"I SURE HOPE THIS EVACUATION PLAN WORKS!"

The Shoreham Nuclear Power Plant on Long Island was a bipartisan nightmare. Cuomo and other antinuclear politicians used their muscle to keep the almost-finished plant from opening. Paying off the cost—without being able to sell any electricity—proved to be a political nightmare of its own. Cuomo first proposed a partial state takeover in 1986, but the issue was still hanging around more than a decade later. Republican Governor Pataki won approval for the largest public borrowing ever at a state level, $7.8 billion, to buy out the utility. His 1997 plan was similar to the Cuomo idea, and was designed to cut electric rates for the politically potent Long Islanders.

one in the country when it came to local taxes—property taxes and sales taxes—burdens that fall most heavily on the elderly and the poor. New York enacted a series of exemptions for senior citizens.

What happened during this period was a general pushing of the burden downward all over the country. As the Ronald Reagan tax cuts reduced the amount of money available to the federal government, Washington pushed burdens down to the state level. Then the states cut taxes, and that pushed burdens—school funding, particularly—down to the local level.

Rockefeller had once used his national influence to get revenue sharing adopted, to help state and local governments with federal funds. Now those days were over. The conservative Republicans who took over Rockefeller's old party aggressively reversed course, and sharply cut back the flow of federal funds to the states.

Shoreham

In the case of the Long Island nuclear power plant at Shoreham, Cuomo rode a wave of political popularity and forced the plant to close.

Carey calls the decision to close the plant the "worst economic decision ever made by New York State. We'll never pay for it. . . . I think you'd still have Grumman now if it wasn't for that."

"We had Shoreham all done. Carey had it set," said Bill Hennessy, the former Transportation commissioner . "We agreed we were going to approve the evacuation plan." Doing so would have meant taking considerable political heat, because the Republican power structure on Long Island was turning against the nuclear plant in the early 1980s, after years of supporting all the Long Island Lighting Company (LILCO) plans and proposals. In the last weeks of the Carey administration, Hennessy tried to force Suffolk County leaders to take the necessary emergency planning steps to get the plant licensed. Carey was prepared to step in with special state authority, but Cuomo took office and went the other way.

Cuomo later appointed a special commission to evaluate the situation. And then, as the local sentiment turned solidly against LILCO and the Chernobyl nuclear plant accident in the Ukraine further turned off the public to nuclear power, Cuomo led the charge against Shoreham. He refused to have anything to do with emergency safety planning, arguing that Long Island could not be protected in case of an accident, that people could not be evacuated. Ultimately, he negotiated a deal to prevent the plant from ever opening.

The bill for constructing this massive, never-to-be-used plant still had to be paid, however, and there was no power being generated to help pay the freight. Carey's assertion that the huge defense contractor Grumman would not have left Long Island had Shoreham opened may be extreme, but certainly the nation's highest electric rates

badly damaged Long Island's economic prospects. In his 1994 campaign, Cuomo proposed a state takeover of the entire utility company, to reduce and spread out the $7 billion pay-back costs. This idea was roundly condemned as a political ploy, by Republican George Pataki among others. But after he won, Pataki had a sudden change of heart and pushed through a very similar scheme to reduce rates.

Those Long Islanders, they vote, which is why both governors spent so much time and energy fighting to get the Shoreham monkey off their backs. By the time of the 1994 Cuomo-Pataki election, densely populated Long Island was arguably the key to statewide election victory. While upstate was overwhelmingly Republican, and New York City was overwhelmingly Democratic, the Island's suburban voters swung back and forth. Ironically, Long Island–based Italian-American delegates to the 1958 GOP convention that nominated Rockefeller went home disappointed because their man, Joe Carlino, was bypassed. By the nineties, ignored no longer, Long Islanders watched as Cuomo and then Pataki scrambled to lower their electric rates.

Not Going for the Gold

Of course, the biggest political risk Cuomo didn't take was running for the presidency. Three times the country elected presidents during Cuomo's time as governor of the second most powerful state, and three times he was a possible Democratic candidate. Twice (in 1988 and 1992) he could have been, would have been, the favorite to win the Democratic nomination.

Why didn't he run? Only he knows for sure. The answers he gave left a lot of people wondering.

In 1988, it was because he wasn't ready, and couldn't both run for president and be governor. In 1992, he set the stage for a campaign, and even had the airplane waiting at the Albany Airport for the trip to New Hampshire. But at the last minute, he said "no," claiming that he couldn't go because he and the Republicans couldn't solve the budget impasse of the moment. The scenario seemed incredible: he told Ralph Marino, the GOP Senate Leader, that he wouldn't run unless the budget deal was done, and tried to persuade Marino that it was to Marino's advantage to have Cuomo running against Bush, his fellow Republican. Here is Senate Leader Marino's take on the situation, in a 1997 interview:

> And since I didn't want to discuss Cuomo's fifteen-month budget proposal, he may have thought that his presence was necessary to resolve the deficit and the budget for the following year. So in his mind he may have thought, "I can't leave because Marino's not letting me leave because he's not agreeing to this budget." Now that's probably his mental process. But he never, he never talked to me about the presidency, and whether he should run. You know, "Ralph, let me go," or any of this stuff, which

I have read. He may have intellectually gone through this exercise with himself or with others, but not with me.

Marino and other senators watched the governor's press conference on television that day, believing that they were going to witness the beginning of a presidential campaign. Marino was on the phone with another senator as he watched:

We had C-span on, and we're all watching C-span, the world was awaiting this decision. We thought he was going to run. As we're speaking, he said he wasn't going to run, and blamed me. I about dropped the phone. It was news to me. Unnecessary. I thought he could have run, and [Lieutenant Governor] Stan Lundine carried on, which is what I thought he would do. He'd be running around the country, running for president, and telling Lundine what he wanted done. I almost had a heart attack when he mentioned my name.

The other thing I recall, the following day was a Saturday, the phone rang and it was the White House, and President Bush thanked me for knocking off Mario Cuomo, which of course I didn't deny doing, but I didn't say I had. I just listened to him. He was very excited that Cuomo was not going to run against him, because he [Cuomo] was thought of as being the toughest opponent.

When Marino was asked if he had been in communication with the White House beforehand, he answered:

Oh, no, no. This came out of left field. We had not discussed . . . the president and I had not discussed this. But he [Cuomo] kept thinking, or kept saying, that this was some Republican plot. It never happened. Neither the president nor the vice president nor anybody at the White House called me. But after the fact I guess the president believed that I was screwing him [Cuomo] up. He could have run, Stan Lundine's a very capable guy.

But the governor always micro managed state affairs, so I'm not surprised. I can't go through the thought process he went through. He may really have thought he was needed.

People around the country speculated about other reasons. Mafia connections, maybe? Nothing drove Cuomo to hotter anger than this charge, which he ascribed to prejudice against Italian Americans. Investigators of all types looked under every imaginable rock in an almost desperate attempt to turn over an organized crime clue. The top-flight Long Island newspaper *Newsday* assigned its award-winning investigative team to the project. They invested years, and came up empty. Republican operatives did the same; after all, here was a powerful, popular Democrat who might do some serious damage on the national scene. They also came up empty. No evidence ever emerged.

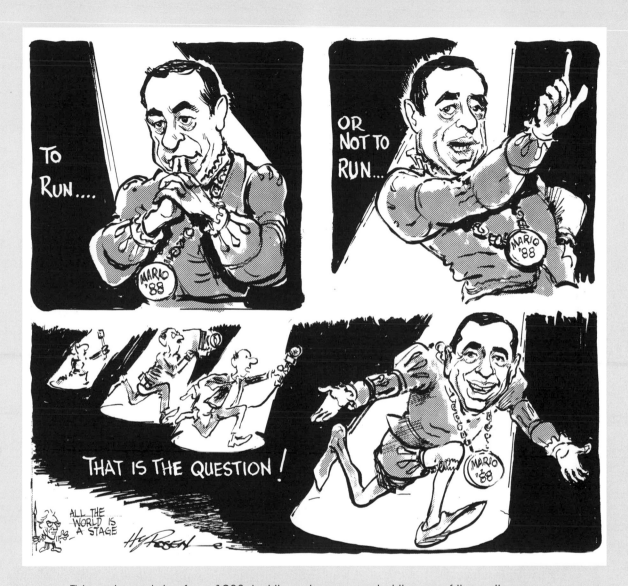

This cartoon dates from 1988, but it captures a central theme of the entire Cuomo period. Presidential speculation dominated Cuomo's years, fueled in part by his apparent flirtation with the idea of running for the White House. This speculation boosted his popularity at home, but over time it gave him that "To be or not to be" reputation for indecisiveness.

So what held Cuomo back? Maybe he simply didn't want it bad enough to risk what he had. Maybe he figured he had it so good, what was the great bonus? Maybe he didn't want to lose. At any rate, the talk about running, the "Cuomo for President" buzz, dominated his time in office as did nothing else. He and his allies encouraged it; it boosted his popularity at home. Reporters fed on it and wrote about it incessantly, because they knew those stories would please their editors and make them look good. The national preoccupation with the presidential horse race was nonstop, especially on the Democratic side because the Republicans held the White House during all but the last two years of Cuomo's terms. Gary Trudeau's nationally syndicated cartoon strip, *Doonesbury*, even ran a whole series called "Waiting for Cuomo."

Coincidentally, in September 1987, Cuomo was scheduled to speak at the Association of American Editorial Cartoonists' Washington, D.C., convention the day after Senator Gary Hart was forced out of the presidential race because of an extramarital affair. The topic was the role and responsibility of the press in American politics. Hy Rosen remembers:

> The governor had accepted my invitation to speak, months before, but back then nobody knew what a big news event it would be.
>
> The National Press Club was crawling with reporters and they were frenzied with excitement. It was like a Super Bowl or something. Here was the big guy from New York, right here in Washington! We all thought for sure Cuomo would jump in now that the coast was clear.
>
> The news cameras were everywhere; the elevator going up to the ballroom was jammed with press.
>
> Cuomo started out with a typical wisecrack: "Hy Rosen is the cruelest human being I know," he said, always sensitive about my exaggerated characterization of his baggy eyes and face.
>
> And then he disappointed everyone, me included. We all love to be in on a big story, so when he said, "No," the air went out of our balloon, too.

Still, Cuomo refused to issue the Shermanesque denial that reporters always press for, the line that says, "If nominated, I will not run, and if elected, I will not serve." He argued that to echo the Civil War general's flat-out rejection would be silly and dishonest, because there might be a circumstance out there somewhere, although he couldn't foresee it, that would lead him to run. At any rate, keeping the buzz alive certainly kept him in the news.

This is how intense it was: on the morning after Democrat Michael Dukakis lost the 1988 election to George Bush, the *Albany Times Union* led its front page with a story headlined, "Cuomo Becomes Party's Favorite for '92 Campaign."

For the governor, it was a blessing and a curse. "The 1984 speech changed everything," Cuomo said. And in recent political history that one speech probably had as

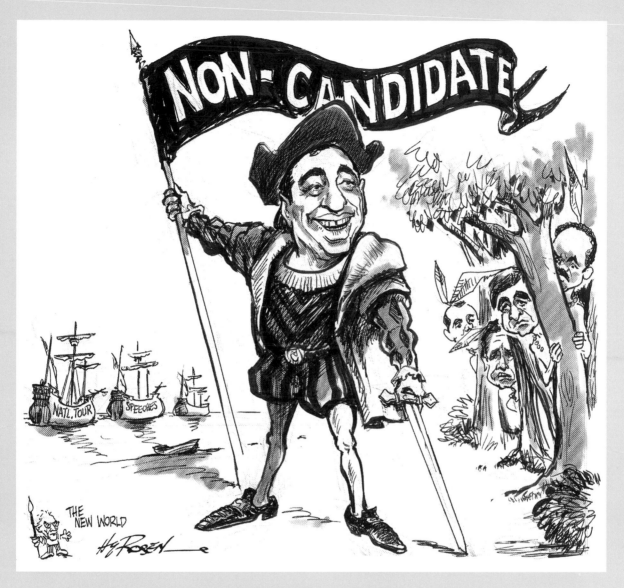

Here is Cuomo, in a Columbus Day 1987 cartoon, bedeviling other Democrats who want to run for president. Cuomo declared he wasn't running, but did a national speaking tour that often got him more attention than the men who *were* running.

much of an impact on one party's politics as any other. It established Cuomo as the standard bearer of the lost Democrats. It created a dynamic that everything he ever did was measured against. It created great expectations.

Disappointment

In the years right after his 1994 defeat, there was a definite sense of disappointment about the Cuomo years. He had commanded the governmental scene and the New York political world like a Caesar, but he didn't accomplish as many things as people expected. Even Cuomo, a proud man, admitted disappointment, in his own way:

> I'm telling you I knew what I wanted to have happen. I had very clear ideas of what I wanted to have happen. But who could tell you were going to have two recessions? Who could tell that? Hey, the whole situation got skewed by the convention. The '84 convention, that changed everything. In negative ways.
>
> It's great to say that you can give a speech which people like. But that made me a speechifier. I wasn't a speechifier! Nobody called me that in 1982, in the election. Nobody said, "The guy's great at speeches but nothing else." They were saying just the opposite. They said, "No, he's a pain in the neck. He's a professorial type. Books, everything books. Facts. Tedious. He's boring. Stays in the office all the time. He's anti-social."
>
> Now all of a sudden you make a speech. "Nah, he doesn't do anything else. Just makes great speeches." It's the dumb blonde syndrome.
>
> Plus it started talk of the presidency, which skewed everything.

Cuomo remembered that before running for reelection in 1990, with the state in the grip of a tough recession, his son and most trusted advisor, Andrew, observed that even by winning he'd be a loser.

> I remember Andrew telling me not to run in 1990. He said, "You'll win, but the state's in such terrible shape, that it's going to be an awful four years. You'll never survive it."
>
> I said, "You're probably right but wouldn't it be a heck of a thing if having had eight good years, I now leave because the state's in trouble. What would you think of your old man if he did that?"
>
> He said, "I'd think he was very smart."
>
> But, it came out just the way he said, and just the way I expected it. We did win, but it was a terrible four years.

Cuomo puts the disappointments down to bad luck, bad timing, the recessions. And politics, the presidential craziness. Others put them down to his style and his management of the government.

Bill Hennessy, transportation commissioner under Carey, whom Cuomo appointed state Democratic chairman, started with high hopes:

I always thought that Mario Cuomo could have been the greatest governor that New York State ever had. He had the intelligence and he knew government. But I don't know what happened. Maybe just the idea of managing government. The idea of keeping his priorities, or even if he had priorities, his priorities may have been in a different direction than what a lot of us would have hoped.

Maybe there is no way he could have spent the money any more wisely than he did. But New York State didn't fare well.

I don't know if it's something that you can hang on the governor or hang on the Legislature, or what happened. But I don't think history is going to treat Governor Cuomo well.

Maybe he was always busy doing something else. Lord knows he worked hard enough. He didn't take any time off.

Hennessy remained loyal throughout, serving Cuomo in a number of posts, and even helping lay the foundation for a possible presidential run. Richard Parsons, president of Time Warner in the late 1990s, who was plucked out of Albany Law School back in the 1960s to work for Governor Rockefeller, observed all the governors.

Now Mario Cuomo, who was a very bright guy, in my judgment, failed to live up to what people expected of him because he tried to do it by himself. And you can't do that. The state is far too big, far too complex. He didn't have exceptional talent working for him. And at the end of the day, what was accomplished?

The lesson of why Cuomo, who was a brilliant guy, got very little if anything done is that, the way you bring together a staff, and your expertise at managing the human resources, are the key.

Stanley Fink, Speaker of the Assembly under both Carey and Cuomo, and a long-time student of government, put it this way: "Mario Cuomo was too hands-on. Cuomo delegated very little to his staff. The staff was very leery of stepping out, for fear the governor would find out. Carey had brought people in from outside who had achieved, who had star power. Cuomo was much more insular, played it close to his vest." On the other hand, Fink thought that Carey delegated far too much authority and decision-making to his staff, and sometimes paid too little attention to what was going on.

Independent Action

There were exceptions to Fink's rule, however. The following example shows that one commissioner was able to operate independently.

Cuomo's most favored, most powerful cabinet officer was the health commissioner, Dr. David Axelrod. Axelrod [for whom coauthor Slocum worked] was given wide latitude, and was able to violate the Fink rule because Cuomo's staff didn't dare cross the

man who had the governor's ear. For instance, when it came time to decide whether families could move into once-abandoned homes around the Love Canal toxic waste site, Axelrod made the decision on his own, based on masses of scientific sampling data. He didn't even tell the governor's office what his decision was until just hours before he flew out to Niagara Falls to announce it. This story was huge national news, and Axelrod's decision to let families occupy houses again was highly controversial. But he got away with his independence, because the scientific work was well done, because the governor tended to trust him, and because he convinced Cuomo in advance that it was in the governor's best political interest to stay away of the controversy.

Axelrod did get in trouble with the governor, however, when he issued a policy statement saying that doctors and nurses with AIDS should be allowed to keep practicing without informing their patients, if they took proper precautions. Scientific evidence said the risk wasn't very great, Axelrod reasoned, and certainly did not justify the uproar and cost of a mass testing program and the purge of qualified medical people that was sure to follow.

There was a major national controversy over this issue at the time. The Congress in 1990 was actively considering legislation to ban all infected medical people from practice, and public opinion was running strongly in that direction. The American Medical Association and even the U.S. Centers for Disease Control were close to supporting a ban on infected doctors.

Cuomo learned of his own administration's contrary policy on the front pages of the state's newspapers one Saturday morning. He was not happy, to put it mildly. Axelrod spent long, uncomfortable hours at the Executive Mansion that weekend explaining his scientific position. Among other things, he told the governor that this issue had first come to him from a respected leader of the Catholic Church who was himself in a quandary over an AIDS-infected physician at a Catholic hospital in New York City.

Axelrod ultimately prevailed. The whole country gradually calmed down, and New York's policy became the national policy. Later, Cuomo even bragged about this triumph of science over political hysteria in his book, *The New York Idea.*

But it was not easy for Axelrod at the time. He had used up valuable political chits, in part by surprising, not advising, the governor. Looking out his window toward the State Capitol one afternoon, he mused, "Imagine if I had gone to his staff with this policy. We'd have never got it out."

Out of Step

In many ways, Cuomo was out of step with his time. He was a throwback, politically and culturally. He was an old world family man—hardly ever caught out of a dark

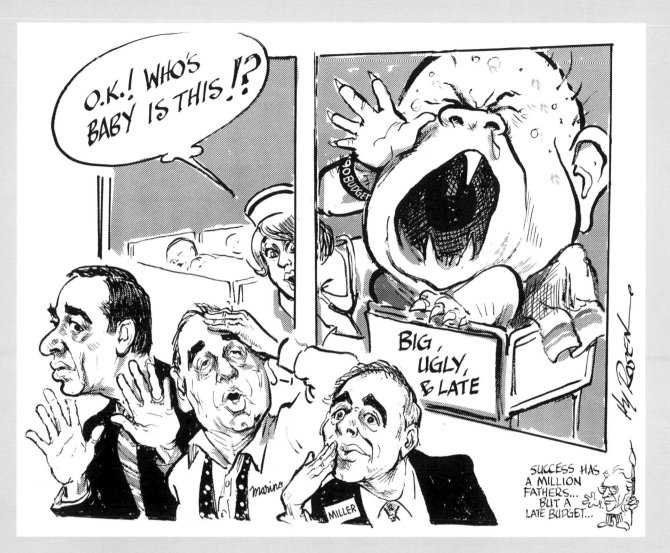

Budgets of the late 1980s and early 1990s were a political mess, and were never done by the April 1 deadline. It was a standoff between GOP Senate leader Ralph Marino, Cuomo, and Democratic Assembly Speaker Mel Miller. One major problem was the national recession sucking jobs and revenues out of the economy. Cuomo later said Marino's failure to agree on a budget kept him from running for president in 1992. Marino denied it. Bill Clinton was happy.

business suit and white shirt—governing in the time of Madonna and Michael Jackson, one rock star parading around the stage in steel-tipped bra, her underwear on the outside, and the other blatantly androgynous.

Philosophically and socially, Cuomo was the old-fashioned son of a grocery store owner who believed you had to work and save for everything. You had to give back to the family, and the community, before spending your fortune on yourself. Personally, Cuomo wore a hair shirt when it came to money. He drove around in a Chevrolet instead of a limousine and was so cheap that he held onto an aging state plane for so long one of the engines quit on the way back from one speaking trip, and the reporters on board were terrified for their lives.

Cuomo proudly proclaimed he was a virgin at the time of his wedding. But before he was through, Cuomo learned to use the term "anal intercourse" in public, at news conferences about safer sex techniques to protect against the spread of AIDS. His administration published graphic booklets on the subject.

His own frustrations with the new age, and with a society beyond his own cultural experience were obvious:

> You put them in a ghetto situation when they are two and a half years old, and they are surrounded by nothing but deterioration, nothing but horror, if they grow up realizing that they're very poor but all around them there is great wealth, and there appears to be no way they're going to escape their particular imprisonment. In this ghetto—not true of all of them, obviously, but a lot of them—why should we be surprised that some of those women would say, or girls would say, "OK, I'll make a baby. At least that will give me a credential. Maybe even get me on welfare. And it gives me something to love and something that will love me back."
>
> Well, that's wrong. Of course its wrong. I mean absolutely it's wrong. But *you* created that environment, she didn't. She didn't walk into that neighborhood and say, "I choose to live here." She was born to it.
>
> There are all sorts of explanations, economic and so on. But there is something else at work, that there is no explanation for. There has been a general deterioration in what people call morality, discipline, mores.
>
> And it didn't start with poverty. It started in the middle of the sixties. In the middle of the sixties we invented heroin, big time. In the middle of the sixties the kids started going crazy. In the middle of the sixties—maybe it was that we were so content. There was no religion. You killed Bobby Kennedy, after you killed John Kennedy, and you killed Martin Luther King, Jr., all at once. You had Vietnam, which was an atrocity, in many ways, because nobody understood it. You had no great war, no great cause, no great hero. No great heroine, nothing to believe in, nothing to fight for. Because the Second World War was over and there was no war to replace it.
>
> And the people were lost. So they invented acid, they invented, "Let me try this, let me try that. Let me sleep upside down. Let me sleep with a monkey. Let me sleep two guys, one girl. Fourteen of these, twelve of those."

When I got married, the priest gave you a book. I was a virgin when I got married. I didn't know what to do. They gave you a little book that said, this is the way you make a baby. It was wonderful.

I am absolutely certain of this, without being able to prove it, without really being able to understand it, that the biggest thing that happened in our lifetime was television. And not just that they seduced you by showing you violence or sex. I don't think that's it.

It kept you from thinking. For fifty years we have been saturated by information without context, without interpretation, without relativity, without understanding the relativity. We're just sitting there. Learning all about anything, adults and children, and the net result is we wind up after fifty years with more facts and less philosophy. With more information and less inspiration. With more knowledge and possibly less intelligence. But certainly with more facts and less philosophy. In the old way, you got it a little bit at a time.

My mother, before she got sick, said to me, "You know why there are so many divorces now?"

"No, why Ma?"

"Because now, when they get married, they think they are supposed to be happy."

Up until that point, until television, you were constantly being instructed in responsibility. Now all of a sudden you are being introduced into a life experience without the requirement of responsibility.

Morality and responsibility weighed upon this man. He had a big public smile and could charm a roomful of kids out of their lollipops, or a busload of seniors into dropping their canes. But deep down, Cuomo was never the true Happy Warrior. He craved victory, but the battle did not bring him joy.

"ABC, Anybody but Cuomo"

Cuomo lost in 1994 to a virtual unknown named George Pataki, and three reasons for his defeat were most obvious: the state's economy was still down, people were scared about crime, and Cuomo had stayed too long.

New York suffered huge job losses in the recession of the late 1980s and early 1990s, and started to bounce back later than the rest of the country. The reasons for that were complex, and some were beyond any governor's control.

By 1994, signs of a recovery were beginning to appear. The state was gaining jobs again instead of losing them, and investment was picking up. But the public perception was that New York's economy was still depressed. Raymond Schuler, the first president of the Business Council and the chief representative of big business in the state, supported Cuomo for a long time and even helped raise money for him around the country. He said that personal relations between Cuomo and top business executives didn't always work well: "Carey liked business leaders. Mario didn't."

Cuomo lost no time in attacking business leaders who complained about their own taxes and campaigned for corporate tax breaks.

Is it necessary for corporate executives to make 120 times more than what workers make, when they used to make 37 times what workers make? Is that necessary for the free enterprise system? How about if I start taxing you guys at the top? Everything over $15 million, I'll tax at 70 percent.
"Ah, Jesus Christ, you can't do that to us!"
" Why?"
"Then we won't feel like working."

Cuomo concluded this make-believe dialogue in a voice dripping with ridicule. He rose to the debate going on at the time about the huge salaries and stock options arranged for corporate executives, at a time when the income gap in American society was widening.

However much his personal attitude translated into state policy, the antibusiness image his administration built up certainly contributed to Cuomo's defeat in 1994. He could not turn that perception around.

Like the economy, crime tends to run in cycles, both in reality and in perception. Crime statistics rose dramatically during the late 1980s, and the public's fear of crime shot up, too. The link between drug abuse (especially the new scourge, crack) and violent crime, particularly in and around New York City, created a growing outlaw element, an untamed wild bunch from the ghetto, primarily young kids who thought nothing of shooting down young girls in a schoolyard if they happened to be in the line of fire.

Cuomo, who put more criminals behind bars than any governor in history, and built more prisons than all previous governors combined in order to do it, was never able to get out in front of the crime issue. Felons came out of prison and committed more crimes, young kids were newly recruited into the violent drug trade. In the meantime, the governor kept vetoing a death penalty bill whenever the Legislature, reflecting popular sentiment, passed one. (Carey, before him, had done exactly the same, and had gotten reelected.) Cuomo proposed "life without parole" for a variety of crimes, arguing that it would be a swifter and surer route to punishment than the death penalty. But he never really won the public argument, even though voters for years said they respected his principled opposition.

This man had doubled the prison population, but the public was still frustrated, and the death penalty was the symbol, certainly in the campaign of 1994. It certainly was one reason he lost the New York City mayor's race back in 1977 when he was starting out, and the issue came back to bite him as he tried for a fourth term in Albany.

In that final campaign Cuomo did a politically crazy thing: he tried to bring a convicted murderer named Thomas Grasso back from death row in Oklahoma so he could

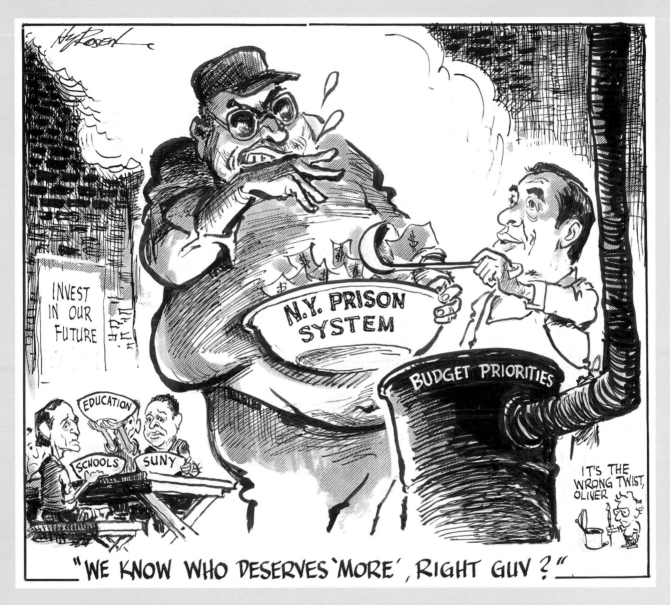

"WE KNOW WHO DESERVES 'MORE', RIGHT GUV ?"

Cuomo's physical legacy in the state is a vastly expanded prison system. He built more prisons than all other New York governors combined, and the size of the population behind bars doubled while he was in office. Spending for education got crowded out of the budget as a result, although higher Medicaid and welfare costs were also a problem. Did he build so many prisons because he opposed the death penalty and was worried about the "soft on crime" label? Maybe, but the crack epidemic that hit during his time had nothing to do with politics, and prison populations increased nationally at about the same rate as in New York.

serve a life sentence in New York. This complicated case—Grasso was a two-state killer, caught and convicted twice, and Cuomo argued that legally Grasso should serve New York's punishment first—highlighted Cuomo's disagreement with the public.

Why did he have to drag that case out of nowhere and make a big deal out of it? To prove his point? To uphold principle? To educate the public? To the public, it came across as Cuomo going too far. He had to know it would hurt him at the polls. Cuomo did things like that. He deserves major credit for saving the *New York Post* in 1987 by keeping talks going long enough for Rupert Murdoch, the worldwide media giant from Australia, to come back in and buy it. Some thanks Cuomo got; Murdoch's men used the old tabloid like a conservative club to beat up on Cuomo and his policies. Ironically, back in the 1970s, when the *Post* was a liberal organ, the editors considered Cuomo too conservative even to interview for a possible endorsement in his first run for political office.

In the end, four terms were just too much. There is no law, merely tradition. Two terms is usually the practical limit. The public tires of one leader. Nobody wins four terms. (Only Rockefeller before him ever did, not counting DeWitt Clinton back in the early 1800s.)

Cuomo overstayed his welcome. And, truth be told, Cuomo was not an easy guest. He was not the kind of fellow to sit quietly at the table and let the conversation flow around him, waiting for a natural opening. Cuomo would leap in at every point where he had something to say, and lecture anyone who disagreed with him, hammering, hammering, until he beat you down.

He was that way in person with reporters and staff members, browbeating them. Sometimes he was that way in public settings; people felt lectured, preached to. His post-defeat experiment with a national radio talk show suffered from this tendency to challenge aggressively every caller's assumptions and ideas.

By the end, Cuomo gave off a sense of arrogance that hurt him with his own supporters, not to mention his opponents. His staff complained he wouldn't listen to anybody's advice any more.

"If I Can Be Governor . . ."

As of this writing, in 1998, New Yorkers may not have heard the last of the name Cuomo in public life. If the proud father has anything to say about it, son Andrew, appointed secretary of Housing and Urban Renewal by President Clinton, has a limitless political future in his own right. With his son's photo staring down from a prominent spot in his law office, the former governor had this to say about Andrew's prospects:

> Andrew has everything you need to be a successful public official. He has high intelligence, great commitment, great savvy, much more than I do, much more knowledge about politics. He learned it from the time he was a kid.

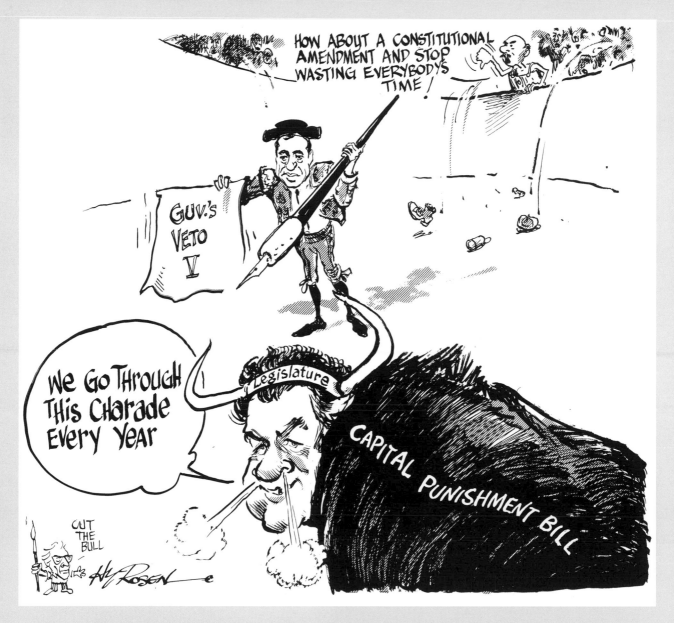

Year after year, Governor Cuomo vetoed capital punishment bills, and the Legislature never could override him. The cartoonist supported the death penalty and was fed up with the annual stalemate. Senator Dale Volker, the perennial death penalty sponsor, was the model for the bull's face in this drawing. Actually, Cuomo did secretly suggest a constitutional amendment referendum on the subject, which would get the issue off his plate. But Assembly Speaker Stanley Fink, a death penalty opponent who thought a referendum was irresponsible, turned him down. The issue helped defeat Cuomo in 1994.

He has a beautiful wife, with a romantic, celebrated, name [Andrew married Kerry Kennedy, daughter of the former U.S. senator and attorney general, Robert Kennedy]. Twins. So he's got it all.

He is very, very humble. You can't tell that because he fights like hell. He'll take your head off if you come after him.

He's a terrific combination. If you ask me is there any limit . . . hey, if I can get to be governor, this guy can get to be king, because he's so much better than I am.

There is no limit to what he could do. Will it happen? Mostly luck from here on in. Right place, right time, right circumstance.

6

The Legislature Grows Up

Some of those old guys, maybe they didn't have a professional staff or anything, but they knew what they were doing politically.

—*Former Assembly Speaker Stanley Fink*

IN JANUARY 1972, the doors opened on the grand new Legislative Office Building in Rockefeller's Albany mall. The gleaming white marble building was nine stories tall, as long as the average city block, and its opening represented the birth of the modern New York State Legislature.

As symbols go, this huge edifice did a pretty good job of suggesting that the Legislature was an important and powerful body in its own right. The building simply didn't fit the image of a sleepy, part-time body with no professional, year-round staff.

Queens district attorney Richard Brown, a former legislative staffer, lobbyist for New York City, State Supreme Court judge, and counsel to Governor Carey, said: "Everything changed with the building of the mall. When I worked there, a dozen guys shared one secretary. Very few of them had district offices. When they moved to the mall, they all had office suites."

They filled up the place fast. One journalist wrote that it was like turning on a tap into an empty bathtub. The Legislature's budget, spent largely on staff, jumped by about one-third in the two years right after the LOB opened, from $25 million in 1971 to $33 million in 1973. By the end of the decade, the budget had tripled, to $74 million.

Before the mall, legislators were jammed into shared space with ten or more other lawmakers, in offices pieced together with temporary partitions in hallways, all over the Capitol. One assemblyman got his picture in the newspapers by spreading out his arms and touching both walls of his office at once, without moving an inch. Now even the lowliest freshman had a private two- or-three room suite, committee chairs had grand conference rooms, and leaders had major sections of a whole floor. There was a gym, a sauna, three mammoth hearing rooms with tiered theater seating for hun-

dreds, and a giant entrance hall that rose up four stories, complete with a twenty-foot indoor waterfall.

Ever the clever politician, Rockefeller sped up the construction schedule so that this was the first building in the Empire State Plaza to open, to reward lawmakers for their support of the controversial project. The Legislature also got a $275,000 pot of money to buy art work for its new digs.

The Legislature's growth wasn't just about nine stories of white Vermont and Georgia marble. Reformers and students of government all over the country were calling for stronger, more independent legislatures. This was just a few years after the U.S. Supreme Court's one-man, one-vote decisions focused new attention on the institution, and there was pressure everywhere for more open, accountable, and professional legislatures that would do more than take political orders.

Rocky Got His Way

The New York Legislature was good at taking orders under Rockefeller. Until the late 1960s, the Legislature had no capacity to keep up with the governor's budget staff and the complex state agencies, or to figure out how much school aid individual districts were going to get. The legislative session ended by April 1 every year, and the lawmakers only met one or two days a week when they *were* in session. They were totally dependent.

W. T. "Cadillac" Smith, the farmer turned legislator from Big Flats, near Elmira, was the only senator to vote against creating the Medicaid program in 1965; nobody had any realistic idea what it would cost. He was asked if, in those days, legislators did whatever the governor said. He answered, "Well, sure. You couldn't get any information out of Senate Finance. They weren't staffed up as they were later. Hell, they didn't have anybody to compete with the governor's people."

Joseph L. Bruno, from Rensselaer County, across the Hudson River from Albany, who rose to become Republican leader of the state Senate in the mid-1990s, was a young aide on the staff of Speaker Perry Duryea during the 1960s. He saw up close how the Rockefeller domination worked:

> I remember when I worked for Perry, when Perry had seventy-six members, and you couldn't pass a budget without seventy-six votes. I was helping shepherd people down into Rocky's office who didn't want to vote for the budget. Rocky was making deals with these guys to get their votes. Because these guys would not otherwise commit to support the budget that had tax increases. It was just a troublesome budget. You know, one of the exits on the Thruway is a direct result of one of those conversations, with one of the assemblymen who is now deceased. I sat listening to that, and he said, "I got to take something home. I can't go home, voting for this budget, unless I have what I need."

The movie *Animal House* about wild college fraternity parties is the metaphor for this cartoon about the wild closing days of the 1980 legislative session. The players were Assembly Speaker Stanley Fink, Senate majority leader Warren Anderson, Governor Carey, Senate minority leader Manfred Ohrenstein, and Assembly minority leader James Emery.

Rocky says, "So what do you need?" And he says, "I need an exit." And there's an exit there today.

The assemblyman, Eugene Levy, who died in 1990 after serving in both the Assembly and Senate for more than twenty years, represented Rockland County, which did indeed get an additional Thruway exit, 14B at Suffern.

Among the rawest demonstrations of Rockefeller power was the 1968 vote to establish the Urban Development Corporation, a super-powered state authority he wanted for slum clearance and urban renewal. At the height of civil and racial unrest in America's cities, Rockefeller demanded a special agency that could respond, with $6 billion in bonding authority to undertake housing and economic development projects.

As it happened, Martin Luther King, Jr., was assassinated just as the issue was coming to a head in the Legislature. Rockefeller wanted the Assembly to pass the bill the weekend of King's funeral. Almost thirty years later, former assemblyman Alan Hevesi, now New York City comptroller, remembered the occasion with awe:

> When I first arrived there [mid-sixties], if Nelson Rockefeller lost a fight, it was for a day. I have one in mind, the creation of the Urban Development Corporation. It was defeated on the floor of the Assembly by more than thirty votes. Upstate conservatives opposed it because of too much money going to New York City, liberals because it took power away from New York City. And a number of hours later, after individual conversations between the governor's staff and Speaker Travia and individual members, it passed by almost the same number of votes. *That* was impressive.

It was even more impressive than Hevesi remembered. Rockefeller wasn't even in town when his bill went down. He was in Atlanta, at Dr. King's funeral, when he heard about the defeat in Albany. He had told people at the funeral about his new plan, which was about to be passed in King's memory, and now he got on the phone, with a vengeance.

The day's session was put on hold, and the scene in the Capitol was a wild one, with the arm-waving and arm-twisting going on right out in the open. The bill had failed early in the day, 48-85. Just before midnight they tried again, and it passed, 86-45.

By his own admission, Rockefeller threatened to stop signing bills and approving appointments for *anyone* who crossed him. "Now I don't like to take this position, but I think that one has to use whatever authority one has when something of major importance to the people comes before you," Rockefeller told reporters at the time, adding, "These guys have never seen this side of me before."

As Hevesi recalled, "Nelson Rockefeller knew the uses of power, and had enormous resources to go after members in their own districts. And he had an attitude

"BURN, BABY, BURN!"

Any added benefit for lawmakers was sure to draw the ire of critics around the state, and editorial pages of the local papers were always ready to sound the alarm. This 1968 cartoon highlights the sweeter pension bill for its own members that passed the same year inner cities were exploding into riots. Rockefeller appears to look the other way, and he signed the bill after the Legislature agreed to his demand that the super-powered Urban Development Corp. be created to help respond to urban troubles. He denied any connection between those two events, but he did admit to threatening the lawmakers in other ways.

about getting his way. The culture of the time was that the Legislature would hold out to get its piece of the action, but not affect the general tenor of the major legislative program."

A final footnote to the UDC tale: the night after the big battle, the Legislature quietly passed a sweetheart pension bill for its own members and employees, allowing retirement at half pay after twenty years. There was no debate, not even a public explanation of what the bill was about. Rockefeller, always denying any connection to UDC, agreed to sign it. In Senator Bruno's words, "You knew that when Rocky was on it, it was going to happen. That's all there was to it. Because he wasn't going to let it go."

Duryea Made the Difference

Ironically, it was a Republican, not a Democrat, who began the institutional effort to fight back against Rockefeller's domination. The change started with Perry Duryea, the Republican Assembly Speaker from 1969 to 1974, who began by putting together a solid central staff. Stanley Fink, the longest-serving Democratic speaker in history (1978–86), and a man credited with making big policy ideas part of the legislative currency, described Duryea as the father of the modern legislative system: "Perry Duryea is the guy who put the Legislature in an intellectual position to debate the budget and other policy with the governor. I guess by the time I became speaker I just put the finishing touches on it."

By the end of Carey's rather unfocused second term in 1982, the Legislature was overriding vetoes with impunity, was rejecting cabinet nominations, and was, arguably, setting the agenda for state policy. The Legislature won two major budget lawsuits against Carey, which further shifted the balance of power. First, it won the authority to appropriate federal funds coming into the state, and second, it forced the governor to spend the funds that it had appropriated for local aid, which Carey wanted to impound to save the state money.

Cuomo recaptured some of the initiative, through the power of his rhetoric if nothing else. But he never enjoyed the command over the Legislature that Rockefeller did, or that his national reputation might suggest. Pataki got major goals accomplished in his first term, but he also traded away tremendous authority, even giving the two top legislative leaders authority to pick multimillion-dollar capital spending projects on their own, for sports stadiums, museum additions, or almost anything. That sort of thing was unheard of in the old days, but those days were gone.

Duryea recalled the pivotal budget battle, when he had the staff support and the gall to go toe-to-toe with Rockefeller, his fellow Republican.

I remember the '71 budget, when he came in with a budget that was the largest single increase up to that point in New York State's history. And I set out to cut it, and

I was supported by all my members who had elected me, to cut the budget substantially. It was a tough fight. He [Rocky] did what one would expect. He turned his forces in state government against me and he had commissioners complaining over this and that. But that's OK, that's the way it was. And we beat him. I mean we cut his budget very substantially.

One day on the second floor [the governor occupies the Capitol's second floor], it got so heated that I said "Well, I'm leaving the party, I gotta walk out." I had my hand on the doorknob.

And he said, "Come on back, Perry. We can work this out." He said, "What's your number? What do you want? Do you really want the billion in cuts?"

I said, "Well, with certain considerations, I'll take $600 million."

It was a watershed, facing down Rockefeller like that. In an interview right afterward, Duryea boasted that the Legislature was now a "co-equal branch of government."

Duryea at this time was planning to run for governor himself, once Rockefeller left, and was staking out his leadership claim. He traditionally was not as big a spender as Rockefeller was, and he had to answer to a rank and file that was largely fed up with the go-go, spend-spend, Rockefeller years. Nationally, the rosy economic conditions that had prevailed since the early 1950s were fading. To assert his own agenda, and represent his own members, Duryea needed to build a staff that gave him the raw material to work with.

The Legislature was forever changed. The balance of power had started to shift. As Hevesi observed, "Constitutionally, the Legislature had a lot of power; what it didn't have was a lot of knowledge. Knowledge is power. So the increase in staffing and then the computerizing of the operation were the major variables. And now the Legislature is an equal partner in decision-making with the governor."

Ultimately, the Legislature also reached to grab hold of the policy reins by initiating ideas and programs on its own. This started under Speaker Stanley Fink, who set up a policy planning group charged with the job of developing new ideas and proposals. The early 1980s emphasis on infrastructure investment grew out of this Fink team. Fink and his Republican counterpart in the Senate, Majority Leader Warren Anderson of Binghamton, were largely responsible for the massive long-term capital spending plan that rescued the New York City Metropolitan Transportation Authority (MTA) and began rebuilding a crumbling system.

Mel Miller, a committee chair in the Fink days and later Speaker himself, remembered the aggressive policy role the legislators took in the seventies and eighties: "Each committee chair had his or her own program at the beginning of the year. Our own bills. And we didn't call up the governor to see how he liked them. Remember, this was with a Democratic governor."

Later, under Cuomo, it was Fink who pushed through the mandatory seat belt law, which the governor at first toyed with vetoing, but later bragged about as one of his signal achievements. New York was the first state in the country to enact that law.

During this period, certain basic reforms forced lawmakers to be more accountable and accessible to the public. For the first time, committee meetings were opened to the press and public; they had been secret. Agendas were printed in advance and given to members, too. Even payroll records were made public.

All over the country, pressure was on to democratize and open up the legislative process in state capitals. When reformers who had cut their political teeth in the Vietnam protest movement and the civil rights struggle turned their attention toward state government, they found an insider's game that was not much used to sunlight and public examination. At the beginning of 1974, the year that the New York Legislature passed a Freedom of Information Law giving citizens access to records and to government meetings, the New York Civil Liberties Union called the Albany scene "one of the most undemocratic" legislatures in the country. On the other hand, a 1971 report by the Citizens Conference on State Legislatures had ranked New York's Legislature very high when it came to being informed and representative. There was room for improvement in many states, obviously.

Bye-Bye Bosses

The year 1972 also deserves to go down in legislative history for a much-less-noticed event than the opening of the Albany mall. This event was a private dinner hosted by Assembly Minority Leader Stanley Steingut, the round-faced Brooklyn pol who had lots more savvy and intelligence than he is usually given credit for. Steingut seized control of political power as it related to the Legislature, wresting it away from the county chairmen, who used to pick the candidates, handle campaign funding, supervise the campaigns, and even choose staffs and leaders in the Legislature. This dinner was held to raise money for a legislative campaign committee, to begin building a campaign operation that was independent of the county political party leaders.

H. Carl McCall, who became state comptroller in 1993, first arrived in Albany as a state senator in 1975, after the old system had died. He recalled what it had been like: "The county leaders would raise the money. That's how they had the hold on you. They'd go out and raise the money and unless they supported you, you didn't win. They supported you, and therefore you were beholden."

Assembly Ways and Means Committee chairman Herman "Denny" Farrell, Jr., who, like McCall, was part of the influx of African Americans who won legislative seats in the 1970s, laughingly refers to himself now as "Boss Polyester." He is the Democratic "boss" of New York County, head of what was once Tammany Hall, and heir to the infamous Boss Tweed's old mantle. But his title carries none of the power of the old days. "Well, the county leaders are not what they used to be, and they won't be. One of the things that used to happen with the staff here was that the staff spots

were all filled by the county leaders. And the county leaders chose the Speaker and chose the health committee chairs, and so on."

The host town Albany Democratic organization chose the support staff, Farrell remembered:

> In the old days when you came up here, Polly Noonan, of well-known fame [Albany County Democratic vice chair and behind-the-scenes powerhouse for years], was responsible for bringing "the girls" in. When you came up to Albany, they told you to see Polly, and she'd get you a secretary for $3,000. You got $6,000 for your staff. You gave $3,000 to Polly, she had a selection up there, and you'd go and pick 'em out. And you had $3,000 left over, which you gave usually in six parts to members of your political club back home, $500 apiece. They came up once, and for that they got a $500 check.
>
> When I came up, and I asked about African Americans, everybody looked at me like I was strange. You know, what do you mean African Americans? I never went to Polly. I said, "Does Polly have any African Americans?" They said, "What are you doing, trying to start trouble?"

Polly Noonan recalled that she herself started as a secretary in 1936 for $3 a day, one hundred days a year, for a total of $300. Later, she was in charge: "They would call me and say, 'Mrs. Noonan, I need a girl.' I always got them decent girls. I never got girls who couldn't spell. I met more girls who didn't know a dangling participle from a split infinitive."

The Legislature Takes Political Control

What Steingut started that night with a fund-raising dinner, creating a separate fund that he could control, led to a totally new political animal, statewide legislative political parties, powerful multimillion-dollar money machines for both Republicans and Democrats, within twenty-five years.

Michael DelGiudice was an architect of the revolution. He came to Albany from Long Island as a two-day-a-week aide to Steingut back in the late 1960s, when the Democrats were still in the minority. He stayed to help build the statewide Democratic machine that has controlled the Assembly since the last days of Nelson Rockefeller's dominance. He remembered the beginnings:

> A big problem initially was giving the money that we raised to the county leaders. Most of the county leaders in the state, except for a couple, couldn't win a f——ing campaign if their life depended on it. They were not very good.
>
> We focused from 1970 on three things that we concluded we needed. Number one, you needed a good candidate. Some Joe's grandmother was not going to become a good candidate. So we went out and recruited candidates ahead of time. Then we did

separate campaign financing, so we could control the campaigns. And, number three, we used television and radio upstate, which they had never done before. You know, you could buy [blanket television advertising in] Rochester for $70,000 or $80,000 the few weeks before election.

Steingut succeeded beyond his wildest dreams. He won the majority in 1974, with help from the Watergate scandal that flushed Republicans down the drain all over the country, but owing also to his own campaign organization. Democrats haven't lost that majority yet, and have strengthened it.

The Senate, the last bastion of power for the Republicans, started to build up its own policy and political operations significantly after the 1974 election. The Republicans had lost the Assembly and the governorship. Not only did they need to be able to challenge Carey, they needed to crank up a fund-raising operation because their sugar daddy, Nelson Rockefeller, the man who made money rain down upon them from the heavens at campaign time, was gone from the scene. The Republicans had grown accustomed to Rocky's largesse, and had forgotten how to run a party.

This decline in the role and power of county-level party organizations was a national phenomenon, driven by special interest politics, the ability of television and radio to reach voters persuasively, and the impact of targeted fund-raising. In New York, it was also driven by ever more powerful political institutions in the Legislature, where public and private money fuse together to create formidable statewide campaign operations.

The public money came in the form of legislative staffers who "volunteered" their time to work on campaigns when their state work is done. This involved nights and weekends, but it also meant spending weeks on the road toiling in campaigns while still getting a state check because they were technically on vacation or using "comp time." Although all the leaders denied that employees were required to do political work—that would be illegal—lots of staffers do get the idea. For instance, busloads of Albany GOP Senate staffers spontaneously decided to spend some time in Brooklyn during the fall 1996 primary campaign helping Senator Robert DiCarlo. This was not exclusively a Republican trait; Democratic staffers helped his opponent.

Both majority parties run well-financed campaign organizations, able to pay for polling, sophisticated telephone banks, mailings, and television advertising, and able to hire campaign managers. In effect, all the elements of a modern, year-round political machine, controlled by the leaders, are tucked into the Legislature. Campaigns, then, were part of the reason for large and duplicative budget, policy, and administrative staffs in the Assembly and Senate.

A major scandal erupted in 1987 when a number of Democratic legislators were accused of campaign abuses, maintaining "no show" political operatives on their payrolls, people who did only political and campaign work and never did any real legislative work. The practice was well-known and long-standing, although most work-

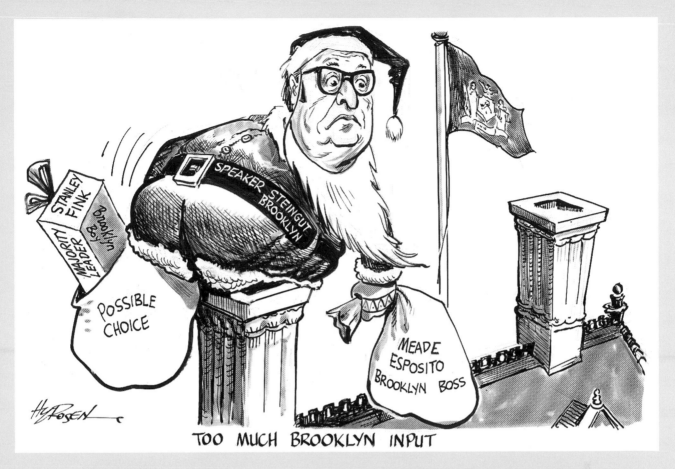

TOO MUCH BROOKLYN INPUT

Brooklyn Democrat Stanley Steingut played a major role in the emergence of the modern Legislature. Although he was naturally close to legendary Brooklyn county leader Meade Esposito, it was Steingut who seized political control of the legislative operations and campaigns from the county political leaders. He started what ultimately grew into multimillion-dollar statewide organizations, funded by special interest contributions and controlled by the legislative leaders of both parties. Stanley Fink, who followed Steingut as Speaker in 1979, solidified the political operations and strengthened the Legislature's policy arm as well.

ers tried to create the appearance of some legislative connection. Manfred Ohrenstein, the one-time firebrand reformer who was leader of the Senate Democrats at the time, was indicted by the Manhattan District Attorney in the most significant part of the scandal. He appealed the indictment and got it thrown out when the state Court of Appeals ruled that there was no specific law against the practice.

Cash Fuels the System

While the public's money maintains the volunteer shock troops, the private cash for the political operations comes from lobbyists, people representing organizations doing business with the Legislature. In 1996, these organizations spent more than $13 million to help pay for campaigns. Almost half the money given to legislative candidates by lobbyists in Albany changes hands during the actual legislative session. In January, at the beginning of the session, lawmakers rent out meeting rooms in local hotels or restaurants and invite lobbyists to come down for a drink, for a price. This annual practice makes it clear what role money plays in the Legislature; the fund-raisers are held in Albany, where the lobbyists are with their money, and not back home, where the constituents live.

Blair Horner, legislative director of New York Public Interest Research Group, a reform watchdog group, was caustic:

> The most revolting spectacle in Albany, the fund-raising at night, is as indefensible, as despicable, revolting, and corrupt as you can imagine. I can't think of a more un-seemly scene than the "Gang," Albany's nomads [lobbyists], working the halls of the Capitol during the day, and then walking down Washington Avenue, or in the winter into the Empire State Plaza, so they are hermetically sealed, at taxpayers expense, to these cocktail parties where the legislators can shake them down for campaign contributions. It's not that we are uniquely bad, when you look at the rest of the country, but we are excessive, and the stakes are higher, because New York is the financial capital of the country.

For example, just hours after the state Senate finally shut down for the year on August 4, 1997, with an all-night session that ran well past dawn, the lobbyists—Albany's nomads, in Horner's terminology—trekked across the Hudson to pay $1,000 each for the privilege of playing golf and having dinner at the Troy Country Club with the Republican senators. Democrats held the same type of parties, and so did Governor Pataki, but their tee times were not so dramatically linked with the Legislature's activities.

The state Lobbying Commission keeps track of money lobbyists spend explicitly to influence the fate of legislation—writing reports, running media ads, getting information to legislative staffers, testifying at hearings, taking legislators to dinner. That

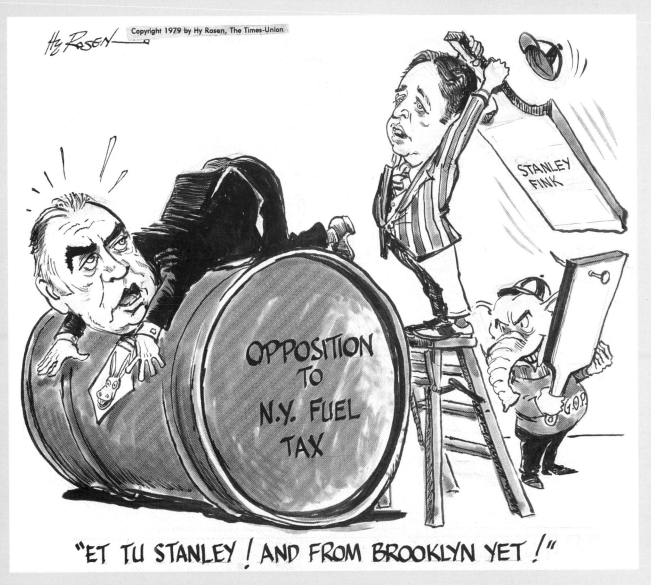

Copyright 1979 by Hy Rosen, The Times-Union

STANLEY FINK

OPPOSITION TO N.Y. FUEL TAX

G.O.P.

"ET TU STANLEY ! AND FROM BROOKLYN YET !"

Hugh Carey was the first governor in 104 years to have a veto overturned by the Legislature, and he routinely had to deal with independent-minded Democrats who had their own ideas. Speaker Stanley Fink began coming up with policy plans of his own, and put the Assembly on an equal footing, intellectually, with the executive branch. Understandably, this led to some brawling, as in this cartoon, over a fuel-tax debate in the late 1970s. Fink and Carey were both from Brooklyn, but that didn't count for much.

spending shot up like a rocket, by nine times, from $5.7 million in 1978, when the commission began counting, to $51.4 million in 1997. There was more than simple inflation behind the big boom in this influence peddling. The stakes were higher in Albany, and other state capitals, than they once were. Said Horner:

> New York is consistent with other states, with everything else we've seen. There has been a giant increase in spending on lobbying and campaign contributions in state capitals, the triggering event having been Reagan's revolution in the early 1980s. Once he pushed that stuff down [decisions on dividing up money], there's evidence across the country of a big increase in spending at state capitals. That's not surprising; as state capitals became more powerful, powerful people seek influence.

So two different trends came together in Albany in the late 1970s and early 1980s to vastly increase the amount of money people were willing to lavish on the Legislature: first the Legislature grew up as an institution, becoming more powerful and influential in policy matters, in dividing up the resources; second, the amount of money the Legislature controlled grew tremendously.

Hevesi, who wrote a book about the Legislature in 1975 that said lobbyist money wasn't significant, admitted that the landscape changed in the next two decades:

> The more the Legislature plays a role in policy-making the more the lobbyists pay attention. There's a correlation between the increase in knowledge base and the increase in power in the Legislature, so the lobbyists know where to go, where the power is. Constitutionally the Legislature is the institution with the power. So there's a huge involvement of the lobbyists in the life of the Legislature, and in contributing to campaigns.

Is the place truly for sale? There has been no proof, no grand jury, no take-it-into-a-courtroom type evidence. No federal agents masquerading as businessmen trading cash for votes descended upon Albany as happened in Arizona, California, South Carolina, and Washington D.C. Secret videotapes of those transactions led to convictions. But many people who watched the New York system at work thought it was corrupt. Maggie Boepple, who lobbied for New York City when Ed Koch was in office, and later became a prominent enough private lobbyist to make the Lobbying Commission's top ten list in the early 1990s, says the system has become blatant—in both the legislative and executive brances.

> I now advise any client that however good I am at understanding the system, they have got to be willing to contribute politically. I think public policy is decided this way in many instances.
> I've been doing this for twenty-five years, and it is more true now than it has ever been.

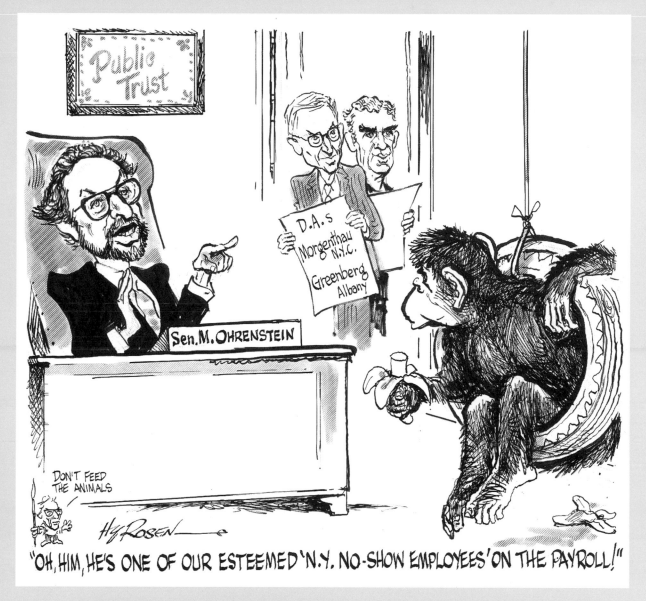

"OH, HIM, HE'S ONE OF OUR ESTEEMED 'N.Y. NO-SHOW EMPLOYEES' ON THE PAYROLL!"

Democratic Senate leader Manfred Ohrenstein was indicted for keeping "no show" employees on the legislative payroll in 1987. Having "no show" or "seldom show" political employees on the payroll was common practice for decades; it was a way to reward supporters and pay for campaign help. Ohrenstein beat the rap when the Court of Appeals ruled that there was no specific law against having legislative employees do political work, but the Legislature did institute some reforms, like time sheets to keep track of its staff. Although it was against the law to order staff to do political work, the cartoonist thought there was monkey business on Capitol Hill.

Speaker Duryea, now in private business, believes there is no question about the buying of influence:

> If I don't get five dunning letters a week it's nothing. And it used to be $50 dinners or $100 dinners. Now it starts at a $1,000. I go to those every once in a while, and I see the people who are buying the tickets are the pressure-group people. They're not Joe Blow off the street, or XYZ businessman. They're the people who say our association can buy three $1,000 tickets. Well, the guy who's getting the money or the gal who's getting the money knows full well where it came from. And they know that when the phone rings, well, they respond to it.
>
> The world is now full of pressure groups. Whether it's education, social welfare, the environment. Are they effective? Of course they're effective.
>
> There's no doubt that somewhat on the state level and certainly on the national level, on the other side, the business groups, the interests which have a big checkbook, and contribute to campaigns, have a very substantial impact. And I was with a congressman recently, who shall remain unnamed, and he told me he cast a vote on a very delicate issue that reflected the fact that a certain group had supported him financially and otherwise during his campaign. Now I guess it takes a tough person to stand up to that and say, "Forget it. I'm not going to help you with this."

Even as the scandal about campaign financing broke in Washington, focusing on President Clinton's fund-raising in 1996, New York's campaign financing system, with much more relaxed rules than at the federal level, got almost no attention. One reason: with Democrats controlling the Assembly and Republicans in charge in the Senate, both parties had an interest in maintaining the status quo. Nobody with any real power was left to fight for change.

Pedagogue Power

Who is the most powerful of them all?

James Featherstonhaugh, a lobbyist who worked to built up civil service union power in the Rockefeller days and was close to Cuomo, says the teachers are king: "Who's the most powerful? Not even close, it's NYSUT." The New York State United Teachers.

Here's one example of pedagogue power in Albany. Former New York City mayor Ed Koch:

> You've got to take on the teachers. You know the teachers couch everything they want in terms of the children. Bullshit. What they want are better pensions and higher salaries. And I like the teachers. I don't dislike the teachers.
>
> I remember saying what I'd like to do is put in a system of bonuses, where we give you a class and if the class is not at a certain reading level or math level, and you brought them up to that level at the end of the semester, we would give you a bonus

of $10,000. They said, "We want every teacher to have that $10,000 bonus." I said, "That's not a bonus, that's a salary increase." And I said you get it one year. Then we give you a new class and you have to re-earn it.

Well they know how to do it with the State Legislature. They get whatever they want from the State Legislature.

What happened was that the Legislature turned the bonus idea into a flat-out salary hike; the rationale was that higher salaries overall were needed to attract new teachers. Salaries went up, with that state money flowing to school districts beginning in 1986. Then when the state ran short of money a couple of years later, Albany stopped funding those so-called Excellence in Teaching awards. But teachers around the state had negotiated that new money into their contracts, so local districts still had to pay the higher salaries. The bonus had become the floor, a part of the base, not a reward for special achievements. Maggie Boepple, Koch's Albany lobbyist at the time, said:

> It was bastardized. Everybody got the ten grand. He [Koch] and Bobby Wagner put this incredible plan together, and I worked on it up here. It was fabulous. It was, "If you're a good teacher, and your kids are doing well, you get this bonus." And when the legislation came out, what's its name, Excellence in Teaching, everybody got it! I mean such a great idea, and it got a lot of support from the media. All the editorial boards loved it. But . . .

So Boepple agrees that teachers have the most power? "It's interesting. First of all, they have the largest political action committee of anyone, and also they work in campaigns. So we're back to our original discussion about politics and money. It's out of control."

Some states have tried the Koch-type bonus system with mixed success. Private donors proposed something similar in New York City in 1998.

In 1996, the teachers union political action committee put up almost $1 million to finance legislative campaigns. NYSUT gave to both Republicans and Democrats, and the vast majority of the money went to the majority party in each house, rewarding the decision-makers, reinforcing the political status quo because, obviously, it served their interests. That was easily tops in the state, more than double the second biggest giver, the state Medical Society, which clocked in at $444,000. The total for all political action committees was $13 million. And even after all that spending, at the end of the campaign year 1996, the teachers had a surplus of about $1 million in their PAC.

Governor Carey was the first governor in 104 years to have a veto overturned by the Legislature. It happened in 1976, and the bill was a bill pushed by the teachers, allocating money directly to the New York City school system, bypassing City Hall, where some dollars intended for education inevitably got stuck. Said Carey: "The teachers are stronger than Goliath."

Interestingly, in 1997 U.S. Senator Alfonse D'Amato began a series of attack ads against the teachers's union, no doubt reflecting his own political polling data that showed that the union was increasingly unpopular with the public at large, even while it maintained solid strength in the Legislature.

A scene early in 1998 provides striking evidence of NYSUT's strength. Raymond Skuse, longtime lobbyist for the New York State United Teachers, was retiring. Both houses of the Legislature took the highly unusual step of passing a resolution in his honor, and legislators of both parties took turns standing up to extol the virtues of the man seated in the balcony above, who was, in effect, the single largest campaign financier of the last decade. Skuse was a one-time Republican assemblyman who had represented part of Albany County in 1969 and 1970, which was one rationale for the honor paid to this biggest money lobbyist of them all.

Lulu and Pay

When it came to money and the Legislature, most attention focused on the salaries and other benefits the lawmakers voted for themselves. This money probably had less impact on policy decisions affecting the public than the private money given by special interests. But salaries were very easy for the press to track, and it *was* the taxpayers' money, after all.

The *Albany Times Union* spotlighted legislative money with a campaign in 1975 against "Lulu," the cartoon dance hall girl, complete with feather boa, revealing dress, and spike heels, who came to stand for all the various transgressions of the Legislature, both fiscal and sexual. "Lulu" actually was the shorthand term for payments in lieu of expenses. The lulu system is part of the time-honored, bipartisan, and partly secret way of adding to legislative pay. Lulus were introduced to reward top leaders and committee chairmen, supposedly to help them cover the extra expenses of their more senior positions, such as buying coffee for committee meetings.

Denny Farrell, the senior Assembly leader, explained how in earlier times the legislative leaders dangled the promise of fatter lulu payments to control members:

> You came back at the end of each session to pass the supplemental budget, and that's where the members got their lulus. In those days, the lulus were not fixed in law as they are today. If you were a good boy you got a $10,000 lulu. If you weren't a good boy and you gave leadership a problem, you got a lot less. The Speaker and the leadership made that determination. The supplemental budget was the last thing that you did as you left town, and that had all the gravy in it, all the local pork and the lulus.

By the end of the 1990s, the Speaker and the Senate majority leader got an extra $21,000 on top of their base pay of $57,500. And the idea that this was special pay for special service became harder to rationalize when it was revealed that every mem-

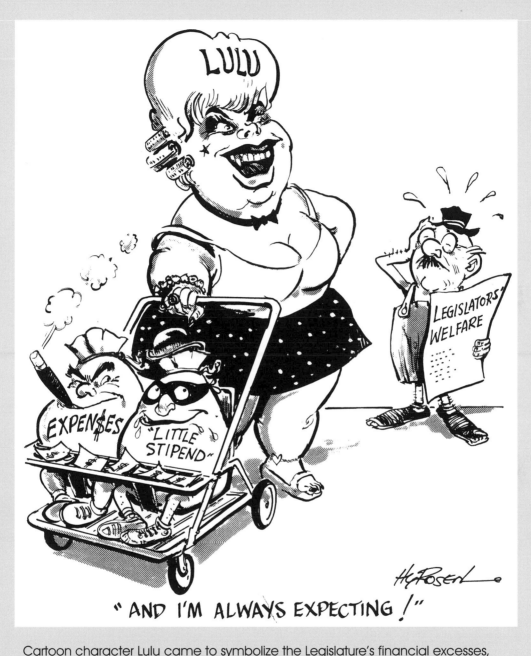

"AND I'M ALWAYS EXPECTING!"

Cartoon character Lulu came to symbolize the Legislature's financial excesses, overlaid with a not-so-subtle hint about sexual behavior. The name "lulu" came from the extra money, "payments in lieu of expenses," that leaders handed out to committee chairmen and other lawmakers. This cartoon appeared in 1975, the year a government reform group challenged the "lulu" system in court, but lost.

ber of the majority party in the Senate got an extra lulu, because the Republicans created enough committee chairmanships or other so-called leadership posts to give everyone something. This is one of the many ways in which the leaders still maintain control, because they decide who gets what post and therefore how much each lawmaker's lulu will be. Lulus ranged from $2,500 to $21,000.

Despite avalanches of unfavorable publicity—newspaper series accompanying the cartoon character—lawmakers stuck to their stipends. The New York Public Interest Research Group challenged the lulus in court, arguing that the system was an illegal end-run around the constitutional rules for setting legislative pay. But lulus have survived into the late 1990s.

The basic pay for legislators rose through the period, as it did in other states, but then stalled in the 1990s. The base pay was $7,500 when Rockefeller was first elected, and lawmakers voted to raise it six different times, as their institution evolved more and more into a full-time operation, and they had less and less time for other jobs. Of course, there is a chicken-and-egg argument here: if the pay wasn't so good, maybe they wouldn't be so full time.

At any rate, by the dawn of the 1990s, as the public's esteem for government in general sank lower and lower, the legislators' political courage on the question of their own basic pay faltered. Salaries got stuck at the $57,500 level set in 1988, and stayed stuck into 1998. There was great pressure from the rank and file to raise the pay, but the leaders were worried about political fallout, particularly because the Legislature seemed to have developed chronic late-budget-disease.

No Sex Scandals

Although sex scandals in Washington made big news during this time, the Albany scene was untouched by this particular drama. A good number of legislators were fairly open about being sexually active while away from home, but it seemed that the press, too, abided by what was known as the "Bear Mountain Compact." That unwritten rule said that personal indiscretions taking place north of the Bear Mountain Bridge, about fifty miles north of New York City, were not to be discussed back home. (The custom is expressed in terms of a city lawmaker, but the "rule" applied to someone from Buffalo, Plattsburgh, or any place else.) Unlike the national press corps in Washington, which leapt to a feeding frenzy in early 1998 over President Clinton's sex life, and probed congressional behavior, too, the Albany media generally accepted a dividing line between public responsibilities and private behavior. Nighttime activities between consenting adults were not considered news.

There was plenty of activity. When the now-discontinued governor's annual dinner for legislators rolled around each year, and wives came to Albany for the fancy

LULU MUST GO

Printed as a public service by The Times-Union, Albany, N.Y.

The *Albany Times Union* had so much fun with the Lulu character that it printed bumper stickers and started an official campaign to get rid of the practice. Obviously this gimmick crossed some line of journalistic objectivity, but it probably sold some papers.

party at the governor's mansion, all the girlfriends had to move out for the weekend. "A full red alert" is the way some Assembly figures in the 1970s described the pending arrival of wives.

Young women who came to the Legislature as bright-eyed and eager staffers quickly learned which legislators not to get in an elevator with alone. But that type of sexual harassment only made it into the papers when one woman lodged a formal complaint with the Legislative Ethics Committee in 1988 about the behavior of her boss, Assemblyman Mark Siegel of Manhattan. Siegel was never indicted for anything, but he decided not to run again and went off to start a new career in Florida. The Assembly organized a comprehensive sexual harassment training program.

Bigger legal trouble came to three out of the seven Assembly Speakers who served in this period—they got indicted. Neither Perry Duryea nor Stanley Steingut ever even went to trial because the charges were dropped. Mel Miller, speaker from 1987 to 1991, was convicted on mail fraud charges related to an apartment sale—nothing to do with his public job—and was forced to resign his seat. The conviction was later tossed out on appeal, but it was too late for Miller, who had planned to run for governor himself. He eventually came back to Albany as a well-paid lobbyist, paired with U.S. Senator D'Amato's younger brother, Armand, among others.

Reapportionment

The third of the three seminal events in the life of the Legislature during this period—in addition to the professionalizing of staff and the seizing of political control—came entirely from outside. It was the arrival, thanks to a series of federal and state court decisions in the mid-1960s, of the "one-man, one-vote" standard for drawing legislative districts in New York and across the country.

Revolution is not too strong a word for what this change meant in Albany. Republicans had long had a lock on the state Assembly because of the county rule written into the constitution in 1894. This rule said that every county in the state got at least one of the 150 Assembly seats, and then the remaining eighty-eight seats were divided up roughly on a population basis. That meant that upstate towns controlled the Legislature, and numerous policies flowed from that reality. According to Stanley Fink:

> The rural, old style legislature. One-man one-vote changed all that. These things had an impact. Look at telephone service. Upstate it costs more to provide service than in big cities because the distances are bigger. But the state set the rates the same, so the cities subsidized upstate. Auto insurance was different. There, they had differential pricing, because upstate didn't want to subsidize the cities. And public power, that stayed upstate. Some of those old guys, maybe they didn't have a professional staff or anything, but they knew what they were doing politically.

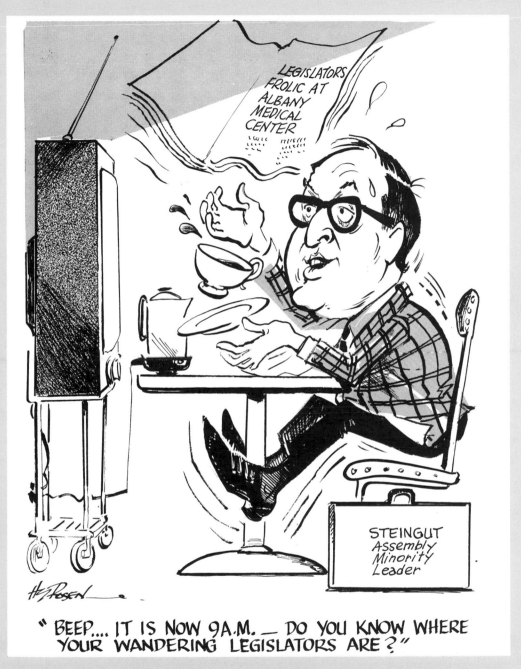

"BEEP.... IT IS NOW 9 A.M. — DO YOU KNOW WHERE YOUR WANDERING LEGISLATORS ARE?"

Albany was never hit with the sort of sex scandal that rocked Washington from time to time, even though many lawmakers were well known to have a wandering eye and to keep mistresses in town. The so-called Bear Mountain Compact dictated that anything that went on north of Bear Mountain wasn't ever discussed back home in New York City. The press pretty much played along. This cartoon is about a couple of legislators who allegedly harassed a nurse while taking their annual stress tests at Albany Medical Center in the early 1970s. A great furor erupted, fueled by the dislike that many Albany area citizens felt for the out-of-towners, who were often portrayed and perceived as arrogant and self-aggrandizing.

Albany was thrown into turmoil as it faced this massive shift of political power from upstate to New York City and its booming suburbs and had to redraw all the Senate and Assembly district lines according to new principles. To add to the confusion, the change hit at the same time that the 1964 Lyndon Johnson election landslide over Barry Goldwater produced Democratic majorities in both the Senate and Assembly for the first time since the Great Depression.

Faced in 1965 with a rare golden opportunity, to redraw legislative lines while they controlled both houses of the Legislature, the Democrats blew it. They had a once-in-a-generation chance to remake the political map to their own design, and they couldn't handle it. Internal feuding broke out and the Democrats couldn't decide on a Speaker or a majority leader for months. Finally Rockefeller had to break the deadlock, cutting a deal with New York City mayor Robert F. Wagner, leader of one faction, and throwing Republican votes behind Anthony Travia in the Assembly and Joseph Zaretzki in the Senate.

The delay and confusion meant that the Democrats were not able to agree quickly enough on a redistricting plan, and the courts ordered a special election in November 1965. Republicans recaptured control of the Senate, and the Democrats' magic moment passed. In 1968, the GOP won back the Assembly, which it held until the Watergate year of 1974. Needless to say, Republican Rockefeller enjoyed significant influence with the Democratic leaders he had helped to install. That was one source of Rockefeller's extraordinary power while Travia and Zaretzki were around.

Dick Brown, who worked for Travia, described the nuts and bolts scene before the dawn of the computer age: "They had a reapportionment room upstairs, up in the eaves of the Capitol. You got up on a platform in your stocking feet. There were pins on the map, with colored yarn marking off districts. They used white poker chips, and wrote numbers on the chips to represent the number of people in one district or another."

Redistricting became an every-ten-year battle, after each national census produced a new demographic snapshot of the state and its voters. To blacks and Hispanics in and around New York City, these new proportional representation rules meant they had a chance to elect legislators from their own communities, and the Black and Puerto Rican Caucus became a force to be reckoned with beginning in the late 1970s. To the legislators themselves, where the lines were drawn was the most important single thing that happened, because it determined whether they would live or die at the polls. Duryea said, "We all know that reapportionments are political. I mean, they're not designed to satisfy the League of Women Voters."

Computers came along, and added precision to the process. Democrat Mel Miller said, "When we drew the lines in 1982, Jack Haggerty [senior GOP lawyer] said to me, 'Don't you want to leave any Republicans in the Assembly?' 'Not if I can help it,' I said."

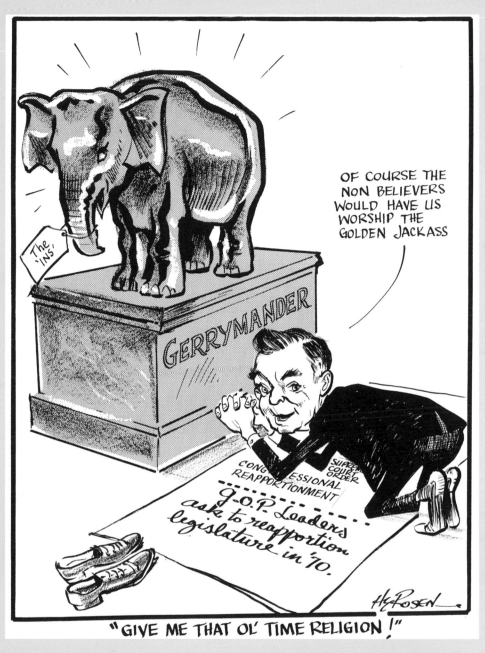

"GIVE ME THAT OL' TIME RELIGION!"

Drawing the boundaries for legislative districts is the most crucial political issue for legislators—it determines whether they live or die. Republicans had run things their way for decades, until the "one-man, one-vote" court decisions of the 1960s forced a realignment and ended upstate's total domination of the Legislature. This drawing shows Senate GOP leader Earl Brydges praying for a return to the good old days. As for the shoes, in the old precomputer days, the redistricting was done on huge maps, laid out on a raised platform in some Capitol hideaway, where legislators would tiptoe around on those maps in their stocking feet, using colored yarn to mark off district lines.

Ralph Marino, GOP leader of the Senate in the late eighties and early nineties, was frank about the way the process was designed to protect the incumbents at all costs:

> You take care of your house, and you leave us alone. Generally, that's the way it works. In my experience, the Assembly would tell us what district lines they suggested for the Assembly. And we'd tell the Assembly what were good Senate lines. And the Congress was up in the air. You'd try to accommodate the incumbents as much as you could.

The Legislature seems impervious to change. It does not swing with elections (like Pataki beating Cuomo, Clinton trouncing Dole). "Yeah, well, that's the way it works. There's no sense in denying it," said Marino.

The result is what Senate Minority Leader Martin Connor called "the permanent majorities." Connor (for whom coauthor Peter Slocum worked) said, "There is less turnover in the New York Senate than any other legislative body in the United States, only 48 percent from 1987 to 1997." Nationally, state senates had an average of 72 percent of their membership turn over during that period. Incumbents in New York, who get almost all the campaign cash that the lobbyists dole out, also enjoy a big advantage in pork barrel spending for their districts. They rarely lose.

As Blair Horner said, "You were much more likely to get beat running in the old Kremlin than running in the New York Legislature. I wouldn't compare it at all to the Russian parliamentary elections now, which are certainly way more competitive."

Albany's Endless Stalemate

So where is the Legislature now? It is hard not to see a link between recent trends—the increasing intelligence, power, and political independence of the Legislature—and the lengthy political stand-offs that have characterized state government in the last two decades of the twentieth century. Ever since the Legislature "grew up," it has become a pain in the neck to one governor after another.

Late budgets are one measure of this shift in power. Governor Cuomo made a big deal out of getting his first budget home on time. It was supposed to be a new era in Albany, after years of increasingly tough bargaining between Carey and the Legislature. But Cuomo's first budget was a one-time event; all the rest of his twelve years the budget was late, and Pataki set new records for tardiness in his first years. The length of the legislative session is another measure of dysfunction, and the tape kept stretching out further and further. What was once a three-month process stretched into a six- or-seven month affair by the late 1990s.

In a way, one explanation for the current problem is obvious: real democracy tends to be messy. A dictatorship is nice and neat; there is no debate. The trains, as they used

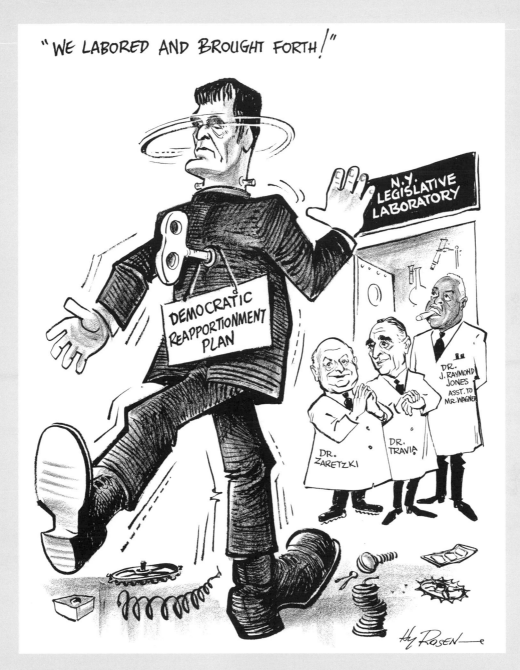

"WE LABORED AND BROUGHT FORTH!"

In 1964, thanks to the Lyndon Johnson presidential landslide, Democrats captured both houses of the state Legislature, and they set out in 1965 to comply with "one-man, one-vote" court orders on reapportionment. But a fight broke out among Democrats over the new leadership, and nothing seemed to go right. The whole mess went back to court and in a special election that fall Republicans regained control of the Senate, which they've held ever since. The lab scientists are Senate majority leader Joseph Zaretzki, Assembly Speaker Anthony Travia, and New York City mayor Robert Wagner's assistant, Raymond Jones. Wagner called a lot of the shots.

to say about Mussolini, run on time. Rockefeller's own party controlled both houses of the Legislature during most of his time, and he had a claim on some of the Democratic leaders, too. As Carey once quipped, "My predecessor owned one party and leased the other." Not once since Rockefeller has the Legislature been under single-party control: the Democrats have held the Assembly since 1975 and the Republicans have owned the Senate since 1965.

Michael DelGiudice, a key Democratic Assembly aide during the sixties and seventies, who later became a top advisor to Carey and then Cuomo, reflected back on the move toward more independence:

> I think the idea of having a stronger legislative branch is a good idea. Because if you don't have a check, what you wind up getting is the unchecked force of a very strong governor. And a Rockefeller becomes a Napoleon and he runs over the Legislature and he increases taxes and he increases spending and doesn't give a s———. It is good to have the institutions strong, and also competent. You can have a strong Senate majority leader, or Assembly speaker, and if they don't know what they're talking about, or they just react to the political moment, then you're going to get the same bad judgments.
>
> You have to negotiate to get a solution that is a good solution in both the substantive sense and the political sense. If you have weak negotiators, weak forces, you wind up getting excesses because one of the parties is always going to want to get as much as he can. There's no counter force.

There is a political imperative behind the drawn-out negotiations, the long delays. As former Senate majority leader Marino explained, Republicans used their majority in the Senate to counter the proposals and programs of Democratic governors:

> The minute the Rockefeller period was over, we had to try to exist as a party, the Republican Party, and we had to try to communicate the differences between ourselves and the Democrats, so this ongoing, philosophical argument just kept going through the years. In order to assert yourself, you had to say, as a party, and as a house, "We're going to veto that. We're not going to go along with that." It was the only weapon you had. You were only one part of the triangle.

Marino was describing life as the lone Republican leader under a Democratic governor. He sounded a lot like a Democratic Speaker living under a GOP governor; now Democratic Assembly Speaker Sheldon Silver is the odd man out in the Albany triangle. He has worked to blunt or modify Pataki's proposals, in order to preserve Democratic priorities: "Governor Pataki's first tax cut would have given 62 percent of the money to the five percent of the people earning over $100,000 a year. The tax cut we finally passed gave 62 percent of the money to people earning less than $100,000. That was the debate."

Silver also says that his ability to generate his own economic forecasting and budget estimates enabled him to fight off Pataki's big cuts in higher education. Pataki tried to slash budgets at the state and city university systems, to raise public college tuition twice (he did it once), and to cut scholarship aid to poor students as well as subsidies to private colleges. Thirty years ago, when Rockefeller was pushing the Medicaid program down legislative throats, the lawmakers had virtually no ability to evaluate the proposal independently. Now, in the late 1990s, Silver and his Republican counterpart in the Senate have expert staffs of their own, and they hire expensive outside consultants as well.

For the record, Pataki takes the high road on this question:

> I certainly understand that when you talk about the magnitude of change that we have achieved in the state, that it's extremely difficult for those who were part of the older system and were in many instances reluctant to look at the changes that I wanted to impose. So I like to think that the debates represent legitimate policy concerns and legitimate questions about proposals we advance.

This continuing battle between powerful legislative majorities of the two parties means that change happens slowly. Legislators themselves hardly ever lose elections, and the established special interests pour influential money into the incumbents' campaigns, to insure that life doesn't change too radically.

Silver also commands a sophisticated political polling operation that focuses on voters in districts where Democrats have the narrowest margins of victory and therefore the greatest chance of losing. That political radar naturally tilts Silver toward a more middle-of-the-road posture, which fits his own politics, too.

No Friendly Fistfights

As an institution, the Legislature closes the twentieth century with more intelligence, more power, more money, and more influence than ever before. And yet the Legislature is held in lower public esteem and is a less happy place to work, to serve, than it was decades ago. Continuous campaigning, political hardball, whatever the name for it, angry politics were the reality in the late 1990s.

Clarence Rappleyea, the Assembly leader who recruited an ambitious young George Pataki to run for the Legislature back in the eighties, used typically colorful imagery to describe his view of a government process that seems "so personal and ugly." He continued, "It's just a reflection of the in-your-face mentality that's out there. Getting in a fight. You see it in the street, driving a car. I mean you don't get out and whack anybody's hood anymore. You could get shot. There's no such thing as a friendly fistfight any more, it's big time stuff."

The lack of basic civility is astounding. Speaker Silver issued orders in 1997 that his members were not to socialize with Republicans in the Assembly. In the old days, the Senate held a formal dinner each year, and members from both sides of the aisle could let their partisan differences drop away in camaraderie. No more. Socializing diversions like the Senate softball team disappeared.

Silver agrees that the atmosphere is much worse than it once was and found fault with Republicans. "Absolutely, I agree 100 percent. It is probably a result of the Contract with America, and Newt Gingrich. It has filtered down to the state level. It has become a political battle over every issue." Gingrich wrenched control of the House of Representatives away from the Democrats for the first time in forty years with a tough campaign that cast government itself as the enemy. For his part, Pataki also detects a destructive partisanship:

> I don't think it is an inevitable result of the political process. But over the time that I've observed the Legislature, both being in it, first as a staffer, and now as the governor, I think there has been more and more partisanship, which is unfortunate. I remember when I first came up here in 1975 as a staffer with Bernie Gordon, who was chairman of the Senate Judiciary Committee, I never saw people work more closely together than Bernie Gordon and Abe Bernstein, the ranking Democrat on the Judiciary Committee. They did everything together. They had disagreements. But they would try to work them out in an effort to try to achieve a consensus.

As Stanley Fink, the late Democratic speaker put it, "Nobody had yet perfected the politics of division."

Pataki continued:

> Obviously, elections are partisan. But governing shouldn't be partisan. And I think there is way too much partisanship in Albany. It was astounding to me, as a Republican in the minority in the Assembly, that the majority often were not interested in your ideas or suggestions, simply because of the source. You're always going to have philosophical difference, you're always going to have policy disagreements, that's understood. But certainly, in governing, you should try to limit partisanship when it comes to governance.

In the modern Legislature, no significant bills sponsored by minority members are ever allowed to pass, period.

It wasn't that long ago that things were very different. Senator Emanuel Gold, a Queens Democrat, sponsored the 1977 law that prohibits criminals like the famous New York City serial killer Son of Sam, for whom the law is named, from making money on books or movies that tell their criminal stories. Gold, retiring in 1998 as the longest-serving member of the minority party in the Senate, would not be allowed to sponsor and get credit for such a popular measure in the late 1990s.

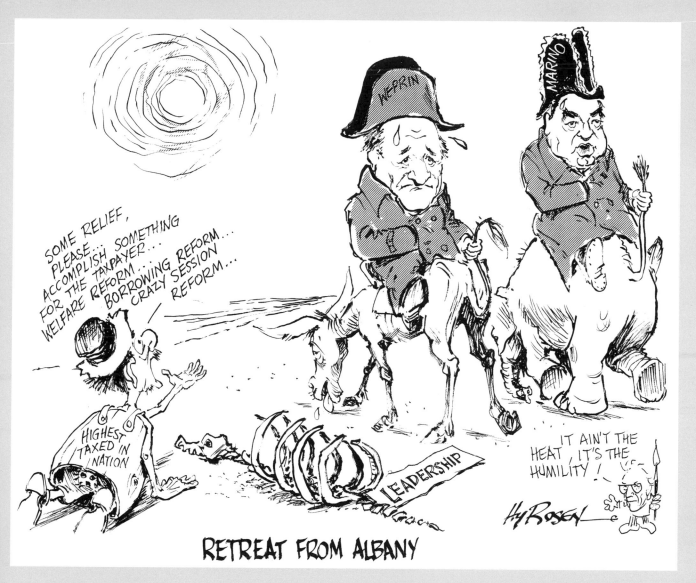

RETREAT FROM ALBANY

Napoleon came to grief in the snows of Russia, and the Legislature took the heat for a late budget in July. By the early 1990s, the Legislature was more powerful and better funded (by taxpayers and special interests) than ever before. But the public held the lawmakers in low regard, and the legislators themselves were not so contented, either. Constant partisan warfare destroyed working relationships. Things got even worse after the departure of Speaker Saul Weprin, who died, and Senate leader Ralph Marino, who was ousted by fellow Republicans after the 1994 elections.

On a personal level, too, the Legislature was friendlier in earlier years. When a young Republican staffer named Bill Powers got fired by his GOP boss because he supported Al D'Amato over Jacob Javits for U.S. Senate in 1980, it was Democrat Stanley Steingut who found him a job to keep the Powers family health insurance alive. Powers had a young son about to go into the hospital.

When Steingut arrived in Albany, virtually all legislators stayed in one of two hotels downtown, just down the State Street hill from the Capitol. Republicans traditionally stayed at the Ten Eyck, on the corner of Lodge Street, and Democrats put up at the DeWitt, on Eagle Street. Reporters bunked at one or the other, too. There was plenty of commingling, dining together, partying together. Social friendships easily crossed party lines. Then the downtown hotels closed, the Ten Eyck in 1968 and the DeWitt in 1975. Legislators dispersed to motels spread around Albany's outskirts, and to apartments. The "work together, play together" atmosphere dissipated. The same change happened in other state capitals, as urban renewal took its toll on old downtowns. In Montpelier, Vermont, for instance, a flood wiped out the old hotel near the Statehouse.

Powers remembers the old days with affection, serving drinks to top legislators of both parties, and to newspaper reporters, too, as everyone relaxed at the end of the day. It is impossible to imagine that kind of cross-the-aisle relationship in the Legislature of the late 1990s.

Maggie Boepple, the lobbyist, said, "I don't ever remember another Democratic leader telling his members that they may not go to dinner with Republicans. I don't remember this sort of real personal dislike. There's a level of real dislike that affects what is happening."

During the 1997 public debate about whether to hold a constitutional convention, which some critics said was a chance to "fix" the legislative mess, most top legislators argued against a remake of the state constitution. Senate Majority Leader Joseph Bruno put the case this way:

> There isn't anything that you can do in a ConCon that we can't do through the Legislature. The problem that we have with the budget is, in my mind, the process has been totally politicized. It is so politicized that we deal with it in the media. You almost lose track of the merits of everything. It's, "How will this go?" "How will this sell?" "What will this editorial be?" That's what's wrong with our budget process. And any person, Silver or myself currently, or the governor, can stop a budget from happening.

But even as the players bemoaned the politicization of government, the Republicans and Democrats were busy capitalizing on the situation. Powers himself bragged about his success at the modern brand of politics:

I love it when Shelly Silver won't give up, and drags the budget process out, I love it. It's perfect for us. If I could write a script for what I want the other side to do, I would ask Shelly to write that script every time. Now, he thinks he comes out of it with a victory, and he gets so full of himself on rent control and so on.

We did a direct mail [fund-raising] piece using a picture of him sitting behind a desk, when Pataki was out of state for a couple days, and somebody had written "governor" on the nameplate in front of him. I mailed that picture out to 300,000 people with a letter that said, "We can't afford to let this happen."

Of course, Democrats go after the Republicans when they can. Politics helped turn rent control into a major partisan brawl in 1997 when Bruno's attempt to wipe out the controls that Malcolm Wilson had reinstalled in 1974 proved wildly unpopular in New York City. Pataki took his lumps, too, as Democrats and the tenant groups organized a joint campaign, before he brokered a face-saving compromise.

Personal Chemistry Counts

The current highly charged political atmosphere is, obviously enough, not conducive to comradely problem-solving conversations. It deprives the place of the chance to develop the working relationships that Pataki remembered from when he first came up the river to Albany. Ultimately, that hurts government's ability to do its job.

Fink often spoke about the importance of personal relationships between leaders in state government. When he died in February 1997, his obituaries were full of praise for him as a man of ideas—and that was certainly true—but he believed, too, in the power of personal connections: "I've always been convinced that a lot of the things that happened, the events of the day, had a lot to do with the chemistry, the trust between people in power in the Legislature."

Fink developed a special, personal relationship with Senate Republican leader Warren Anderson from Binghamton. They were from different parties and different houses of the Legislature, so they posed no direct threat to each other's leadership. Fink was about the age of Anderson's children, and for whatever reason, they developed a chemistry that had a major impact on New York's citizens. In this case, it was the New York City subway system: "Warren and I met one day and had a long philosophical conversation. We both understood that the economic future of the state depended on the vitality of New York City. We agreed we'd be willing to raise taxes to make sure operating dollars are pumped into the MTA region."

By the late nineties, that sort of bipartisan cooperation just isn't happening. There is precious little consensus-building around substantive issues. There was one glimmer of progress with the appearance of conference committees in 1995, when dele-

gations from each house sat down in public and hammered out their differences on certain specific issues. But the Albany lawmakers employed this technique, long used in Congress, very tentatively and, despite public promises to the contrary, were reluctant to put the budget itself into that forum. Finally, in late March 1998, Silver and Bruno did convene the first-ever public conference committees on the budget. Rank-and-file legislators of both parties were so excited at the prospect of being allowed to play a formal role that they filled the huge auditorium to overflowing, like eager young students jamming the room to sign up for the most popular classes on campus. How important was this first tentative step toward reform? It is too soon to tell, but it will take years to repair the damage.

By and large, the legislative world consists of stalemates and trade-offs. Each side agrees to something the other side wants only if it gets something it wanted in return. One side might trade a new prison for a law on food stamps, with no attempt to really address the underlying policy questions. There is minimal personal contact across party lines, and the major players do not trust each other to keep secrets or not leak tentative agreements to the press for political advantage. It is a tense and unhappy place.

Former Speaker Perry Duryea, a Republican, spoke about this problem the morning after attending a legislative reunion dinner:

> Two or three people last night who were speaking said there isn't the relationship between the members, and between the leaders that there was in the past, that service in the Legislature is less enjoyable and fruitful, because there is this lack of working relationship. Stanley Fink and I, for example, were good friends, above and beyond people with shared experience in the Legislature. He lived twenty miles from me on Long Island, and he came to my house for dinner and parties. And vice versa. And today I don't think there is that relationship, that mutual respect. And from what I gather this isn't true in the Congress any more, either.

In fact, as Duryea said, the same thing was happening in Washington in the middle and late 1990s, where the nonstop partisan fighting was driving out moderate lawmakers of both parties.

What a paradox! Here is an institution, powerful beyond anything its predecessors might have imagined, incredibly efficient at resisting any challengers, controlling more money and more policy decisions and more jobs and politics than ever before. And yet the public is contemptuous, and the members of the Legislature themselves are so afraid of voter backlash they haven't had the courage to raise their own salaries for over ten years.

In truth, while the Legislature was building up its power, the American public was losing its appetite for government, hence the turn in New York State away from Rockefeller-style activism. The Legislature had the bad luck to achieve its pinnacle of power

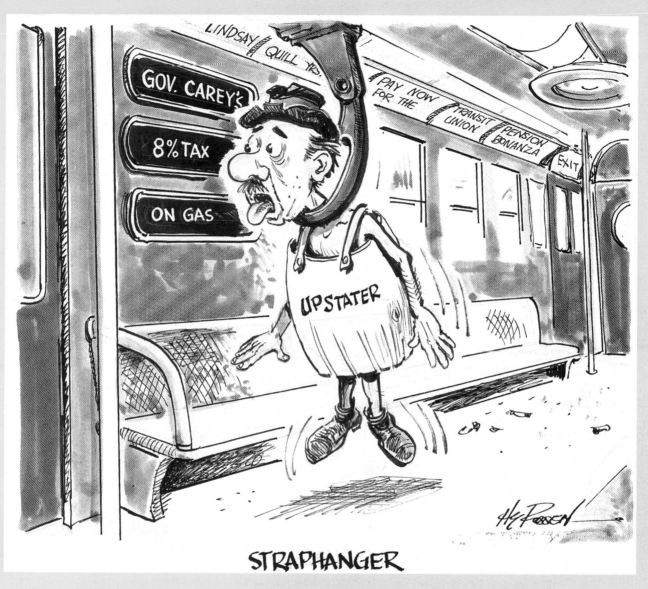

STRAPHANGER

A major capital rebuilding plan for the New York City transit and commuter rail system was a long time in coming. The system, crucial to the region's economy, was in terrible disrepair and wildly outdated. Finally, in 1980, the governor and Legislature put together a long-term program, thanks mainly to the strong working relationship between Democrat Stanley Fink and Republican Warren Anderson. They were able to overcome the upstate-downstate politics that often make things difficult.

only to find that the public didn't much respect those who arrived at those heights. In an environment where the old American appreciation for the tradition of healthy debate seems to have given way to the simple slogans and plot lines of television and advertising, it is hard to make a case for the complicated give-and-take of the legislative process.

The Historic Abortion Vote

For sheer human drama, for raw emotion on the floor of the Legislature, nothing beats the abortion debates of 1970. Yes, there were tense moments during the New York City fiscal crisis in 1975, and when the Legislature overrode the governor's veto for the first time in 104 years. But the abortion battle was something special, presaging as it did the society-wide battle that split American politics along new fault lines over the next three decades. New York, with its politics heavily influenced by the powerful Roman Catholic Church, was where the battle broke out for all to see.

Grown men wept on the floor of the Legislature and priests denounced lawmakers from the pulpit on Easter Sunday as "murderers." Ultimately, New York's historic moment turned on one man's decision to switch his vote from "no" to "yes" at the last possible second, after it looked like the bill had lost—a decision he said was tougher than his stint with the marines in the South Pacific during World War II.

The vote cost Assemblyman George Michaels his political career, as he predicted it would, but it also helped pave the way for U.S. Supreme Court's decision to legalize abortion nationwide in the *Roe v. Wade* case of 1973; the justices pointed to New York's experience to back up their conclusion that legal abortions would not damage women's health.

The relatively young abortion rights movement had pushed for legal abortion through the late 1960s, in New York and a handful of other states. California had passed a modified law (Governor Ronald Reagan signed it), as did Colorado and North Carolina. Rockefeller appointed a commission, which recommended something similar, but the Legislature resisted. By 1970, however, the pressure was too intense for Earl Brydges, the powerful Senate leader and a devout antiabortion Catholic, to simply bottle up the issue any longer. So he devised a new strategy, to allow a vote on a bill that simply removed the word abortion from the criminal law. It would legalize "abortion on demand," and he figured it was too radical to pass. But he miscalculated, and the bill passed when a number of upstate Catholics surprised him by voting for it.

Alan Hevesi remembered what happened next, when the scene shifted to the Assembly. At first, the Assembly shelved the Senate bill and took up a measure that would legalize abortion only in the first two trimesters of pregnancy: "There was a nine-hour debate. A brutal debate, bottles of formaldehyde held up with fetuses inside. Very

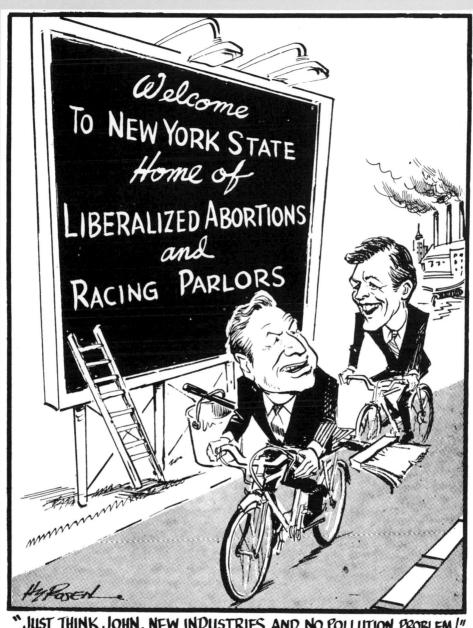

"JUST THINK JOHN, NEW INDUSTRIES AND NO POLLUTION PROBLEM!"

New York became one of the first states in the country to legalize abortions, after an emotional debate and roll call vote that was decided on one man's last-minute switch. It was the most dramatic moment in the Legislature during the period, and it helped pave the way for the national abortion ruling by the U.S. Supreme Court in the *Roe v. Wade* case. This cartoon accurately predicted that New York would attract women from other states who were seeking safe and legal abortions. In the years right after 1970, more than half of all abortions were for non–New Yorkers. The Legislature also set up offtrack betting that year, to help close New York City's budget gap. Governor Rockefeller and Mayor Lindsay look happy about that.

rough stuff." The bill missed passing by two votes and was laid aside and rescheduled for another vote two weeks later. Easter Sunday fell during those two weeks, and Catholic priests all over the state denounced the abortion bill from the pulpit, in some cases directly denouncing Assembly members sitting right there in church.

Hevesi continued:

> The story switches to the saga of George Michaels, a liberal Democrat, Jewish, from Auburn in Central New York. Over the recess, his daughter-in-law asks him, "Dad, how are you going to vote?" He says, "I voted against it before. I promised my [Democratic party] committee."
>
> "Don't you think women should have that right?"
>
> "Well, yes, I think so, but I promised my committee."
>
> Then, he is stunned by the next question: "Well, what happens if you're the vote that decides it?" And that agonized him. He goes back to the chambers in Albany, and he's walking around in a daze.

Back in Albany, there was another long, brutal debate, and then they called the roll. Michaels voted "no." The vote was 75-75; the bill was defeated. But seconds before the final result was announced, Michaels rose to his feet:

> I say to you in all candor, I say this very feelingly to all of you. What's the use of getting elected, or reelected, if you don't stand for something? Before I left for Albany this week, I had a conversation with my son Jim [a rabbinical student], who you will recall gave the invocation before this Assembly on February 4. And he said, "Dad, for God's sake, don't let your vote be the vote that defeats this bill." I had hoped that this would never come to pass. But if am going to have any peace in my family, I cannot go back to my family on the first Passover Seder and say that George Michaels defeated this bill. . . . I fully appreciate that this is the termination of my political career. . . . Mr. Speaker, I vote aye.

The chamber exploded with emotion. It was the seventy-sixth vote, the last one needed. Hevesi said:

> It is inconceivable that there's another single vote by a single legislator in all of America that had greater import, for the following reason: This bill becomes the law.
>
> The Supreme Court now takes up the issue, the abortion prohibition laws in all the other states. The case goes before the Supreme Court as *Roe v. Wade* in December 1971. Normally the Court issues a decision at the end of the term. They don't. They wait until January of 1973 and review the experience in New York. Mortality rate, health of pregnant women, and the whole thing. On the basis of that review, they come up with the decision in *Roe v. Wade,* which substantially replicates the law we had passed in New York. And that becomes the law of the land.

The Supreme Court heard debate on other issues, too, when the case was reargued in October 1972, but Hevesi is correct that data from New York's experience were part of the record. The new Right to Life movement counterattacked aggressively, and in 1972 got the vote overturned in the Legislature. But Rockefeller vetoed that change, and the law remains essentially the same through the end of the twentieth century.

George Michaels was right; the vote did end his political career. He was denied renomination by his fellow Democrats. His son Lee remembered being shocked by the venom unleashed upon his father at the Democratic committee meeting, by long-time friends. Michaels ran in a primary, and then on the Liberal line, survived a near-fatal car crash, then lost his seat to a Republican, who ironically, was a pro-choice vote throughout his career.

Michaels wasn't the only legislator who struggled with that 1970 vote. Former lieutenant governor Mary Anne Krupsak, from the relatively conservative upstate city of Amsterdam, was one of only three women in the Assembly at the time:

> This was not an easy vote for many people like myself who consider themselves a good Roman Catholic person. There were a lot of sermons going on. What made me finally vote in support of the legislation was the overwhelming evidence of the botched and backdoor abortions taking place, especially on poor women. It was a struggle. I have a lot of aversion to abortion. It was probably the toughest decision I had to make, ever. It was early in my career. It made me take a hard look at what a legislator was. I learned a few things about myself, too. I never really considered myself a leader in the abortion movement, you know, marching with banners and all that. I remember some nights I was surrounded by antiabortion people with candles. They called my mother on the phone and told her that she should have aborted me. It was a very tough time.

One political footnote. Lee Michaels said that two years after the drama of 1970, the local Democratic leaders came back to his father and asked him to run for his old seat. But his father, who practiced law successfully for years, had had enough. He declined. When George Michaels died in 1992, and his obituary appeared in the *New York Times*, hundreds of letters poured in to the Michaels home in Auburn from all over the country, marking his remarkable moment in modern American history.

7

A Tale of Two Women

From Rocky to Pataki? Well, it's been rocky.

—*Lieutenant Governor Betsy McCaughey Ross*

NEW YORKERS ELECTED two women as lieutenant governors, Democrat Mary Anne Krupsak in 1974 and Republican Betsy McCaughey Ross exactly twenty years later.

On the surface, there is an eerie similarity. Both women were unlikely candidates to begin with, both very bright, policy-oriented types with strong academic credentials and no "old boys network" political experience. Krupsak earned a law degree at the University of Chicago, and McCaughey Ross got a Ph.D. at Columbia University. Both of them fell out with their governors, complaining that they were ignored. Both were right; they were ignored. Both of them then tried to unseat their former running mates.

They got to near the top very differently, however.

McCaughey Ross was a stylish upper–East Side Manhattanite, an academic political neophyte who had never run for anything before the Republican power brokers picked her to give their statewide ticket a feminine touch and address the party's problem with women. She was so naïve that she bristled when Republican campaign veterans started asking her about her party registration and whether she had any "skeletons in the closet."

By then U.S. Senator Alfonse D'Amato and his allies had already decided that she would be the nominee. GOP state chair Bill Powers:

> What I really wanted to do was get at least one, maybe two women on the ticket, to get away from that gender gap. I originally wanted Bernadette Castro for lieutenant governor and Betsy for Senate, but Bernadette's husband didn't want her to run for lieutenant governor. The governor didn't really have a chance to dance with her [McCaughey Ross] very much.

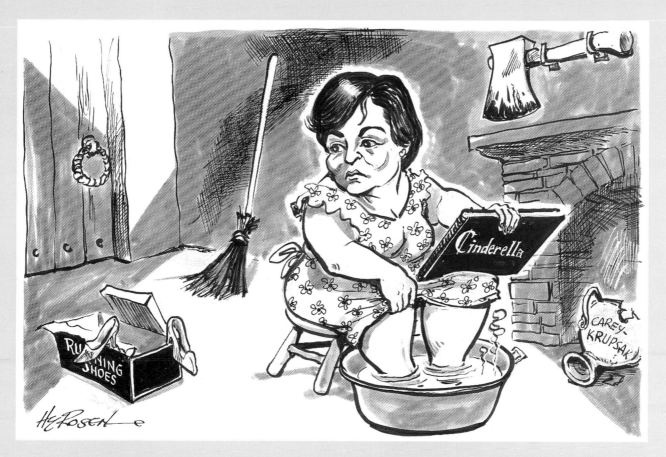

Lieutenant Governor Mary Anne Krupsak was a pioneer, the first woman elected statewide in New York, in 1974. She won her way onto the Democratic ticket in a three-way primary, but then felt left out of the Carey administration. She got out her running shoes and challenged Carey for the gubernatorial nomination in 1978, but she lost badly, and did not hold public office again.

McCaughey Ross came to top-level Republican attention because of her success in attacking President Clinton's universal health care proposal, most notably in a lengthy *New Republic* article. She was giving a health care speech to a national GOP Senate gathering in Philadelphia when fate stepped in:

> I looked over in the corner and there was this small man, who was very busy scribbling down everything I said. And I said to someone at the podium, "Who is that man?" And they said, "That's Senator D'Amato." I'd never met him before. And then a couple of weeks later, he came to the University Club where I was giving a talk about health care.
>
> Senator D'Amato said to me, "You know, you really ought to think about politics."

Krupsak, by contrast, came out of Amsterdam, a fading industrial city in the Mohawk Valley. She was one of the women political pioneers of the late sixties and early seventies, winning an Assembly seat in 1968, surviving a 1970 reelection challenge built around her vote in favor of legalizing abortion, and then jumping to the Senate in 1972 when her Assembly district was carved into four pieces during reapportionment. In 1972, she was one of only three women in the whole Legislature, which had 205 members, and she was the only Democratic woman.

Ten years later, 10 percent of the seats were held by women, and most of those women were Democrats; that was the party where women made their greatest impact. By the time McCaughey Ross came to Albany in 1994, there were three dozen women in office.

Krupsak's run for lieutenant governor, in the Democratic primary, wasn't about winning. What base did she have, coming from Amsterdam? Krupsak remembered:

> It was the first opportunity for a statewide primary. I got swept up in the enthusiasm. A lot of the women's rights groups were coming on strong. I got to be friendly with people in New York City. They said, "Maybe it's time to make a statement. Maybe you won't win, but you'll open the door a crack."

She opened the door more than a crack. She blew the door off its hinges, winning a three-way primary against two men—Antonio Olivieri from Manhattan and Mario Cuomo (yes, the same one) from Queens. Hugh Carey won the gubernatorial primary, and Carey-Krupsak was the winning Democratic ticket that fall, although they did not become a true governing team.

Carey and his team never reached to include Krupsak in the government, a common problem for lieutenant governors of both sexes, and vice presidents, too. In this case, Carey had had no role in choosing Krupsak; they were pushed together by chance. Probably if only one man had run against Krupsak in that primary, she'd have lost.

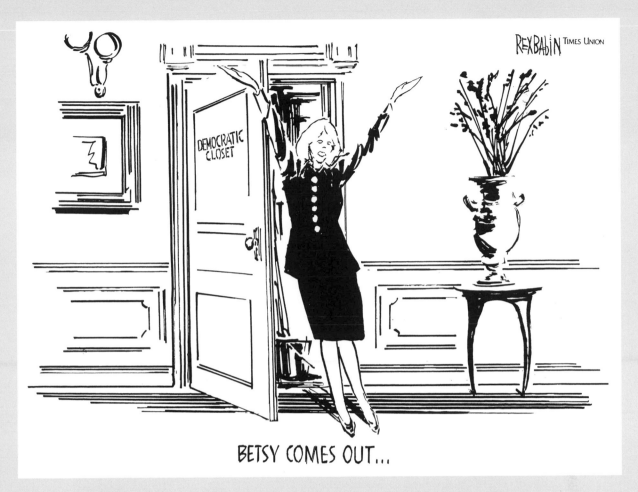

BETSY COMES OUT...

Plucked from a conservative think tank to lend feminine appeal to George Pataki's 1994 Republican ticket, Betsy McCaughey Ross did not find her new GOP friends a good fit. She chaffed at the limits of her role as lieutenant governor, and Pataki dumped her from the 1998 ticket, well ahead of time. McCaughey Ross switched parties and then decided to run against Pataki as a Democrat. (Rex Babin in the *Albany Times Union*.)

Eventually, she got fed up. In mid-June 1978, on the eve of the Democratic convention, Krupsak announced that she was not running with Carey again, but against him, for governor. It was a strange scene, the erstwhile running mate flying around the state behind Carey on announcement day, holding counter news conferences. Krupsak got crushed in the Democratic primary, and that was the end for her:

> My only regret is in terms of losing my opportunity to be in public service. I look back at it, and have for a long time. Perhaps if I wasn't so hotheaded, and if he had been more willing to talk, and discuss things. I was never trying to be co-governor, or anything like that. But I felt I was elected in my own right, as lieutenant governor, and I might have been more helpful to Governor Carey politically. But there develops a kind of palace guard around the governor, and it is hard to get through.

McCaughey Ross's route to the top echelon was quite different, but the result was similar. The Republicans portrayed her during the 1994 campaign as a policy expert who would have a big role in education and health care. The new governor assigned her to work on both. That was when the trouble became public. His people said she wasn't a team player, and she said they didn't pay attention to any of her ideas.

She got typed in Albany as a flake, as not knowing how to play in the big leagues of politics. She fed this impression, doing things like standing up behind Pataki during the governor's entire 1996 State of the State message. And she couldn't hold onto staff.

Pataki announced in mid-1997 that he was dumping her from the 1998 reelection ticket. She switched parties in October, attacking the Republicans as tools of special interests, beholden to the insurance companies and managed care corporations that gave to their campaign war chests. Wilbur Ross, the wealthy Wall Street executive she had married in 1995, was already a prominent Democratic fund-raiser. In December she announced plans to run for governor herself, and she launched her campaign in March 1998.

Ready or not, she was in the big leagues now. Highly photogenic and well-known thanks to her battles with Pataki, the Republican-turned-Democrat was leading the pack of Democratic hopefuls in the early political polls. That made her a target for Democrats as well as Republicans, and she was attacked by leaders in both parties as a disloyal, overly ambitious turncoat.

Krupsak, who does not know her successor, had some sympathy for McCaughey Ross: "There's more to her that she has a reputation for. She has a lot of depth, much more than the image of being a flake. It is so easy just to call a woman emotional. You've got to overcome that." As a young woman legislator, Krupsak was concerned about being typecast. The Republican assemblyman she beat in 1968, Donald Campbell, wound up as clerk of the Assembly:

I had to live with him sitting there and changing my vote half the time. The scuttle-butt was that he said, "You watch, we'll fix her." I never said anything about it, this is the first time I've told anybody publicly. I would have been perceived as paranoid, the way Betsy has been. I just went into the engrossing office and corrected the record, after the day's session.

McCaughey Ross did have some of her ideas adopted by Pataki and the Legislature, although not right away and not in her name.

For example, her big education report recommended that pre-kindergarten classes be available statewide, to give kids a better start in school and in life. Pataki said he didn't read the report, but Democrats jumped on it and passed the plan into law. In January 1998, Pataki proposed a serious state effort to finance that plan.

The lieutenant governor of the nineties was trying to get out from under that flake image that her predecessor had struggled to avoid. "From Rocky to Pataki? Well, it's been rocky," she said.

8

George E. Pataki and the Republican Rebirth

I always believed that if the policies are successful, the politics will take care of itself.

 —Governor George Pataki

There's no second place in our business. You either win or you lose.

 —New York State Republican Chairman William Powers

THE TWO MEN GO HAND-IN-GLOVE. Powers might be described as the iron fist inside Pataki's velvet glove. Powers is the former marine who loves the rough-and-tumble side of politics, who rebuilt the Republican Party with a street-fighting style and relentless fund-raising. Pataki is the ambitious but mild-mannered Yale educated lawyer who is so quiet about it that people don't realize the power of his ambition, or drive, until he has beaten them and is pulling away.

Ask former senator Mary B. Goodhue, whom Pataki served as an aide and a junior assemblyman until he decided it was time to move up to the Senate seat. He took out Goodhue in a Republican primary to position himself for the governor's race.

There is nearly universal bipartisan agreement that Mario Cuomo was ripe for the taking in 1994: he'd stayed too long, his abrasive (some say arrogant) personality was wearing on the voters, the state was still in a bad recession, and the country was tired of the liberal Democratic approach he seemed to exemplify.

"With all due respect to George Pataki, he ran against a governor who wasn't exactly well respected at the time," said Perry Duryea, GOP ally of Pataki's. Many others hold similar opinions. That may be, but Powers and Pataki didn't (couldn't) just show up in November and open the champagne—they worked at it, for years.

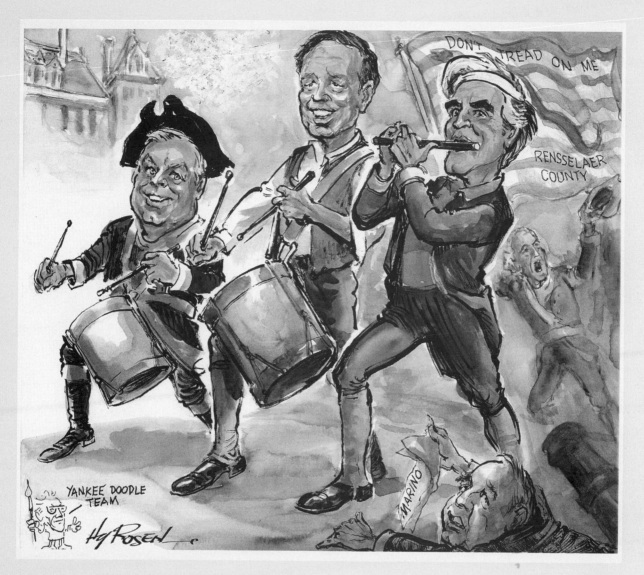

From left to right, state GOP chair Bill Powers, Governor Pataki, and new Senate majority leader Joe Bruno are taking over the State Capitol in January 1995. Powers was the architect of the Republican revival after years in the doldrums, and he helped Pataki get the nomination for governor and beat Cuomo. Then Powers helped to install his fellow Rensselaer County Republican Joe Bruno as leader of the Senate, dumping old guard leader Ralph Marino (foreground) in the process. The Revolutionary War tune "Yankee Doodle" was written in Rensselaer. (Hy Rosen, free lance in the *Troy Record*, 1995.)

Outside New York, the political world was shocked when the famous Mario Cuomo lost to George Pataki, an unknown. David Letterman did a "What's a Pataki?" skit on his late night television comedy show. Actually, the situation wasn't a lot different throughout much of New York.

A native of Peekskill in northern Westchester County, Pataki is the son of a postman and farmer. He grew up in modest circumstances. His life wasn't poor, but *his* Westchester was not at all like the grand estate enjoyed by his Republican predecessor, Nelson Rockefeller.

Pataki was accepted at Yale, but couldn't afford to go until his father went over and talked with Yale officials. They agreed to contact wealthy alumni about funding George's education, which they did. The future governor did his benefactors proud at New Haven and went on to Columbia Law School, also on scholarship, from which he graduated in 1970. His first job out of law school was with a fellow Columbia Law graduate, then a wealthy Wall Streeter, former governor Thomas E. Dewey. Pataki: "I've been involved with governors going back as far as Dewey. I got out of law school and went to work directly for Governor Dewey. Not just with his firm, I was working with him, in New York City. He was long out of politics, but it was interesting."

The young lawyer got into politics himself rather quickly, working for Republican legislators in Albany and then unseating an incumbent Democratic mayor in his hometown in 1982. This was the first in a string of upsets that Pataki pulled off in his rise up the political ladder. If it wasn't exactly prophetic, it certainly showed that he had the guts to pick a fight and the political smarts to know which ones he could win.

As the youngest-ever mayor of Peekskill, a struggling Hudson River city of just over 25,000, Pataki used state and federal programs to attract new housing and other developments, and attracted the attention of GOP leaders beyond his immediate horizon. Clarence Rappleyea, who was appointed head of the state Power Authority by Governor Pataki, recruited this ambitious young man to state office:

> He was the mayor of Peekskill, and at that point I was the Republican Assembly leader. I heard a lot about him and went down personally and got him involved. He became one of my raiders. And he was ambitious. He wanted to keep moving, and he in fact did. We talked about the Assembly minority being the farm club. And indeed it turned out that way. Look at the New York congressional delegation. Most of those people came out of the Assembly. Over half of the Senate majority came out of our operation.

James Natoli, Rappleyea's chief of staff in those days, remembered Pataki's first Assembly race in 1984:

We had the mayor of Peekskill running for Assembly against the Democratic incumbent. We took a poll, and it didn't look good. It wasn't a double-digit gap, it wasn't out of reach, but it was getting that way. He was out of money. We said, "Okay, we need to get him on the radio and we need to do two mailings," one mailing from Al D'Amato and one mailing from George's mother, to Italian women in the district. Billy was the guy who raised the last-minute money when George was running the first time.

He needed $15,000 to do the mailings and the radio. Billy Powers and I sat down at the phones and we raised $15,000 for George.

So there, ten years ahead of time, were the same people and elements that made Pataki a winner in 1994: Powers and D'Amato, careful attention to polling, and identifying and targeting blocks of voters, particularly ethnic voting blocks. Natoli, a moderate Republican who fondly shows off a letter he once got from Nelson Rockefeller, thanking him for working in one of Rocky's presidential campaigns, remained close to Pataki and became director of state operations under the new governor, in charge of major administrative areas, including trimming the state workforce.

Pataki spent eight years in the Assembly, rather quietly. He rarely spoke on the floor and didn't get noticed a lot, except for his height; at a lanky six-feet-four-inches, he stuck out in any crowd short of a pro basketball camp. Whereas his idol, Theodore Roosevelt, made a fuss and bluster the moment he arrived in Albany as a freshman assemblyman with no power, challenging his elders, championing idealist reforms, and making himself a pest, Pataki's style was different. Those who knew him well, like Rappleyea, were aware of this quiet man's long-range ambition, but he didn't broadcast it. He did stick out on environmental issues, though, was senior Republican on that committee, and earned himself an "Environmental Legislator of the Year" award.

In 1992, Pataki started his move up, surprising long-time mentor Senator Mary Goodhue with a primary challenge for her Senate seat. She took her grandchildren on a long-planned trip to Disneyland during protracted budget negotiations in Albany, and his campaign took advantage of the story. The whole affair left a bad taste in some mouths (Pataki had worked for her, relaxed with his feet on her desk when she was in the Senate Chamber), but he won; he'd climbed up a step and was positioned for the next move. James Featherstonhaugh, the well-connected lobbyist who has been an Albany operative since the days of Rockefeller, saw that as a key moment:

I think his decision to run against Mary Goodhue was a very courageous political move. That was not a task that the faint of heart would take on. You had to take on Ralph Marino [State Senate majority leader] and the Senate Republican Campaign Committee. He was virtually alone, but he knew then that he had to get to the Sen-

ate if he was going to position himself to run for governor, which is what he was interested in doing. You know, there are many people who aren't governor. There's no Governor Fink, because he was scared of Ed Koch. But there was a Governor Cuomo because he wasn't. If George Pataki had been scared of Ralph Marino, and the Republican establishment, there wouldn't be a Governor Pataki. By and large you don't get to be governor unless you've got some starch in your spine.

Featherstonhaugh was a friend of Cuomo's and even helped run Cuomo campaigns. In January 1998 he chaired a major Albany fund-raising dinner for Pataki and other top Republicans. Successful lobbyists work both sides of the political street.

Right Man, Right Time

George Pataki's timing was perfect. The Republican Party was rebounding, finally, after years of statewide defeats that drained morale and money out of the once-proud party. The old Rockefeller moderate party had faded away, and it took a long time to build anything back, partly because the primary source of money had dried up. Said Clarence Rappleyea:

> It's like a church that inherits a lot of money. All of a sudden they forget what they have to do from week to week to keep going. And I think because of Rockefeller's personal wealth, we became dysfunctional as a state committee. So very early on, I could see it slipping away. When I came to the Legislature, as a member, we [Republicans] controlled both houses, had the executive. Of course the cost of campaigns has grown so much, too. I watched the state committee kind of wither up with the departure of Rockefeller. The state committee lost its effectiveness. The county structure seemed to break down. Now that may have happened elsewhere, too. But it was aided and abetted by the fact that Nelson Rockefeller was the governor and really the shaker and mover of the party.

Rappleyea and the other Legislative leaders found they had to go out and raise money on their own because the state party wasn't underwriting everything anymore. The state party operation found itself it bad shape as well. It had little money to bankroll statewide candidates. Bill Powers recalls, "Rockefeller's checkbook took us a long time to recover from. They just wrote checks, and funded the state committee."

By 1990, the Republicans sank so low as to nominate a strange but wealthy political neophyte named Pierre Rinfret to run against Cuomo. Only a small cluster of Republicans had even heard of this financier before the party convention, but Rinfret brought his own money to the table. And for a party with no cash, that was a heck of a credential. He got beaten badly by Cuomo, so badly that the Republicans came within a whisker of losing major party status to the Conservatives. If only 19,168 people had switched their votes from the Republican line to the Conservative line, the Re-

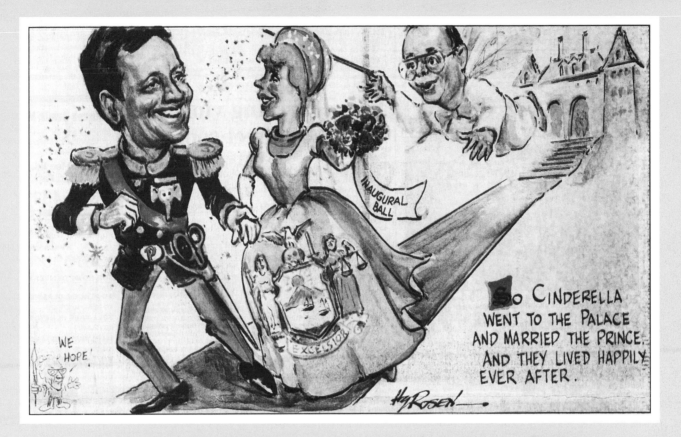

WE
HOPE!

INAUGURAL
BALL

EXCELSIOR

So CINDERELLA
WENT TO THE PALACE
AND MARRIED THE PRINCE.
AND THEY LIVED HAPPILY
EVER AFTER.

Hy Rosen

This Inauguration Day cartoon shows Prince Pataki arriving to take charge, with U.S. Senator Alfonse D'Amato hovering over the scene as the happy fairy godmother. D'Amato used his considerable political muscle to unify the party behind candidate Pataki. He also loaned his campaign brain trust and shook the money tree for the little-known Hudson Valley state senator. D'Amato had helped in Pataki's first campaign for the Legislature ten years earlier, too. Those big shears are to cut government spending. (Hy Rosen, free lance for the *Troy Record,* 1995.)

publicans would have dropped to Row C on the ballot, and lost not only status but enormous power and influence in the politics-laden New York government. Republican leaders were so desperate in that last month of the 1990 campaign that they took out ads urging Republican voters to "hold their noses" and vote for Rinfret to save the party. Upstate the message didn't work, and the GOP finished third almost everywhere; it was Long Island loyalists who rescued the Republicans. This shouldn't come as a surprise: the Nassau County Republican operation on Long Island is the GOP equivalent of Chicago's famous Democratic organization. It is U.S. Senator Alfonse D'Amato's home base. Both Chicago and Nassau produce votes and patronage like machines.

Enter Bill Powers. The former legislative aide, who was then serving as Rensselaer County chairman and working for D'Amato, staged a coup of sorts by grasping the GOP chairmanship in 1991, though he said D'Amato tried to talk him out of it. According to Powers:

> I was $1.6 million in debt, but to whittle away at that I had to win, because nothing raises money in politics faster than winning. Starting in 1992, I wanted one boogie man, one. Mario Cuomo. On that nail I had his picture [Powers pointed to the fireplace mantle in his Albany office]. I looked at him all day long. We ran all our races against Cuomo.
>
> I always knew we could beat him. I knew when I ran for chairman we could beat him. He was too arrogant.

Powers and his Republican comrades focused campaign attention on Cuomo no matter what the local race. They blamed him for everything—the recession made that easy, as did the long, drawn-out budget fights at the Capitol that left the government, and the governor, looking ineffectual in the face of economic difficulties facing the state. There was no decisive action coming out of Albany.

The Republicans pounded Cuomo relentlessly, on taxes and on crime, on anything they could find. They even called a news conference and blamed Cuomo when Powers's car got stolen in Albany. They got some coverage. In retrospect, Powers has fun telling this comeback story; it's all a victory tale. But it wasn't always so easy. Featherstonhaugh said:

> What saved the Republican Party wasn't Al D'Amato; he was busy being senator, most of the time. It was really Bill Powers and he did it with organization. No one would compare Bill to Mother Teresa in any other way, but I think her view of poverty and his view of how you raise a party were identical: you do it one person at a time. I have never seen anything like Powers when it comes to the organization he built.
>
> So George Pataki was the culmination of the process that Powers put in place, as he began methodically to take over every county and city and village in this state, just one at a time. When Pataki got ready to run, the state party was ready for him.

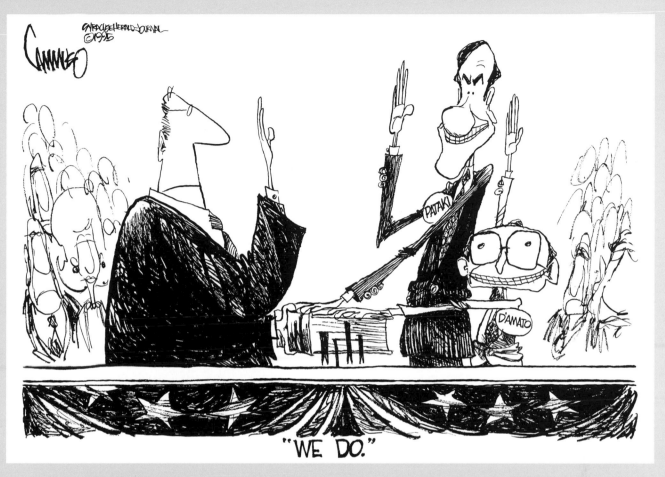

"WE DO."

The worst-kept secret in New York politics was the influence that U.S. Senator Alfonse D'Amato had in the rise of George Pataki. He was portrayed as Pataki's "sponsor"—the power behind the throne. Once the new man took office, D'Amato stepped into the background, publicly, but still exerted a major impact on some policy issues and on patronage. (Frank Cammuso in the *Syracuse Herald Journal,* 1995.)

The foundation for the 1994 GOP victory was really laid back in the early 1990s, when the Republicans began to win a series of races. First it was the Suffolk, Monroe, and Albany county executives in 1991. In 1992, Senator D'Amato won reelection against all odds and could turn his awesome fund-raising and political muscle to the state scene. Then came a huge breakthrough—Republican Rudy Giuliani won the New York City's mayoral race in 1993, unseating incumbent David Dinkins. If the Republicans could win in New York City, where they were overwhelmingly outnumbered, they could win anywhere. And they *were* winning everywhere. The numbers show a big turnaround. In early 1991, only three of sixteen county executives and none of mayors of the six biggest cities in the state were Republicans. By 1997, the GOP controlled fourteen county executive seats and four mayoral slots. The Republican tide was running in New York, and the big givers could see it.

Maggie Boepple, the veteran lobbyist with at least as many Democratic connections as Republican, says admiringly: "I think that initially what Bill Powers was very good at, as chairman of the Republican Party, was he saw the opportunity, saw the anti-Cuomo feeling, that there was this huge opportunity. And business started to contribute in vast numbers."

One unique way that Republicans used their money was to wage the equivalent of political street warfare in New York City Democratic strongholds. Powers believed that the Democrats were literally stealing thousands of votes in the poorest minority sections of the city, where no Republicans had dared to challenge them for years. On election night in 1992, when D'Amato was reelected, Powers suddenly was confronted with 160,000 paper ballots weighing in against him, prompting him to call for a "school bus full of lawyers" from the GOP organization in Nassau County.

> I realized then, the reason we hadn't been able to win is that they're stealing elections.
>
> Now, we have a whole program that we do, we rent a load of rental cars. When they start taking buses [full of illegal voters] from polling place to polling place, we pull up, put a rental car in front of them, the buses are bumper to bumper, we put a rental car behind 'em, lock 'em up, and go. Eight or ten buses. We get in another car and go. . . .
>
> There's no second place in our business. You either win or you lose. My father died of injuries in WWII. I spent five years in the Marine Corps. I've buried my friends. The Constitution of the United States gives everybody in America the right to vote once. And I'll be an s.o.b. if I'm going to allow somebody to steal a f———ing vote, because you know what you're saying to every one of those veterans? "It didn't matter." If you're going to beat me, beat me fair. How do you say to all those white crosses, "It didn't f———ing matter."

In 1993 for the Giuliani race, and in 1994 for the Pataki race, Powers and his operatives (his two sons included) identified the areas where they thought Democratic cheating might take place (they called them "red zones"), and organized their "rapid

response teams," ready for nearly anything. They won both those races, although it is not clear what difference they made. In fact, the Democratic vote totals increased city-wide in 1994.

In 1994, not all the brawling was with the Democrats. There were some Republicans—"white shoe Republicans," in Powers's derisive terminology—who weren't sure Cuomo could be beaten, and who didn't want to risk their positions and power by throwing in with Powers and Pataki. The GOP convention was a near-brawl: people were bodily thrown off the floor and wrestled away from the stage. Conservative maverick Herb London, a New York University professor, barely missed getting enough convention votes to force a primary contest for the GOP nomination. London came up a few votes short amid mass confusion and angry challenges. There were allegations that Pataki forces cheated London at the convention.

How close did London come to getting the 25 percent of the vote needed to force a primary? Bill Powers smiled but didn't answer directly: "He was close, pretty close." The moment of truth came when one man, the head of the Niagara County delegation, failed to show up and cast that county's four votes for London. With those votes, London could have forced a primary, and he already had the Conservative Party line sewn up. Without them, he dropped out and agreed to run for comptroller instead. Pataki was in the clear.

Ralph Marino, the dour GOP leader of the Senate, number one elected Republican at the state level, was not in the Powers-Pataki camp. As Powers recalled:

> That convention almost erupted into a war a couple of times. The convention was about a lot of things, not just about nominating a ticket. It was cleansing our soul as a party. What that did was it surfaced those with their own agendas in our party, and we shot 'em. And we should have done that a long time ago, and got rid of them. They were the reason we were losing all the time, because they were making their own side deals.
>
> In the process we got rid of the people in our party who were too quick to make deals for their own personal agendas, and egos.

Did Powers mean Senator Marino? "Absolutely. I thought he would hurt George. Some people thought that there was peace and we should leave him alone. My attitude was that we couldn't afford to have peace with him."

The complaint was that as guardian of the Senate majority, the last statewide power base the GOP held, Marino was too willing to compromise with Cuomo and other Democrats. Politicians who are in power and are looking to protect what they've got—the status quo—often find common ground with each other against challengers, no matter which party is involved.

As a freshman senator back in 1993, Pataki had made his mark by refusing to vote for the budget deal that Marino had negotiated with Cuomo. He took a terrible pounding from his GOP colleagues for refusing to play by the house rules, but he held

out, establishing credentials as a fiscal conservative with guts. His friends point to that battle as a "make or break week" when Pataki didn't fold. It brought him to the attention of party people looking for a change, which is just what Pataki planned.

Election Campaign

Of course, the main tenet of the campaign was making Mario Cuomo, a heavy presence, an overbearing presence, go away. The death penalty and tax cuts were the issues Republicans would ride to drive Cuomo out.

"Too liberal, too long," was the main theme of the Pataki attack ads, repeated again and again and again, in TV commercials paid for by the GOP's re-energized fund-raising machine.

The 1994 Republican ticket was carefully structured to attack Democratic weaknesses. The advance polling intelligence showed that a moderate, pro-choice, pro–death penalty Republican from the New York City suburbs, with European ethnic roots, stood the best chance of beating Cuomo. George Pataki, with Hungarian and Italian grandparents, filled that bill almost perfectly. He did change his stance on abortion to be somewhat more pro-choice, but otherwise he was an exact fit.

The Republicans were worried about the "gender gap" problem, a national one, which finds them less popular with women than with men. So they put two women on the ticket, Long Island businesswoman Bernadette Castro running for U.S. Senate and Betsy McCaughey Ross as candidate for lieutenant governor. Castro lost to Senator Daniel Patrick Moynihan but got a seat in Pataki's cabinet. Lieutenant Governor Betsy McCaughey Ross, a total political neophyte when selected to run, developed an independent streak and broke with the leaders who put her in place. But meantime, she helped win the election.

Herb London, the conservative who had wanted to run for governor, was placated with the comptroller's nomination but lost. And for attorney general, the Republicans tapped Dennis Vacco, a young federal prosecutor from Buffalo, who didn't have any name recognition outside his home town but would draw lots of votes in that heavily Democratic area. Vacco won and helped Pataki carry normally Democratic Erie County by a healthy 10 percent margin. (Italian Americans are the biggest single voting block in New York.)

For all the planning and party-building, the 1994 election may have turned on the last minute behavior of Republican New York City mayor Rudolph Giuliani, the man whom Powers had helped elect just a year earlier. Suddenly, just a week before the vote, Giuliani turned on the Republicans and endorsed Cuomo. He argued that Cuomo would be better for the city, would provide more aid, and that the big tax cut Pataki planned would hurt the city.

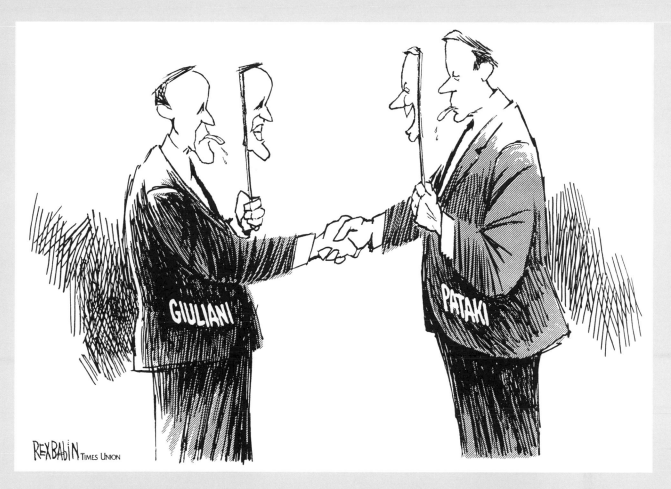

New York City mayors and New York State governors always have a troubled relationship. Pataki and Rudolph Giuliani were no different, but they did get off to a very bad start when Giuliani crossed party lines to endorse Cuomo for reelection. The forced official smiles, depicted in this 1995 cartoon, actually turned more sincere as time wore on, and they developed a mutual interdependence, if not love affair. As two Republicans outnumbered by Democrats, they discovered how valuable it was to cooperate and backed each other for reelection. (Rex Babin in the *Albany Times Union,* 1995.)

At first, it looked like Giuliani's endorsement might rescue Cuomo. After trailing badly, Cuomo surged ahead in the polls that came out almost every day. But in reality, according to both sides, the polls being reported by the media were lagging behind the real movement taking place among the voters; Cuomo had been gaining and Giuliani's announcement came in the middle of that rise. Then came the crucial Democratic misstep.

Manhattan Democratic leader Herman "Denny" Farrell was a Cuomo confidant as well as chair of the powerful Assembly Ways and Means Committee and one of the two or three most powerful black politicians in the state. Cuomo was a habitual early morning telephone caller—he'd start calling around 6:30, after an aide read him highlights of the papers, also by phone—and Farrell was one of his telephone partners. Farrell remembered:

> Cuomo talked to me on Thursday—Giuliani had endorsed on Tuesday—and said, "They're thinking of sending him [Giuliani] upstate. What do you think of the idea?" I said, "okay."
>
> If he had said to me he was thinking of sending David Dinkins [former NYC mayor, an African American] up there, I'd say, "Are you out of your mind?" But I saw Giuliani not as a New Yorker but as a Republican. Well, that was the biggest mistake we made. . . . What you got was the worst. You reinforced what upstaters all believe, that everything is for downstate. Nobody knows that the money comes from downstate. They will always tell you that the money goes downstate, rather than coming from downstate.

Pataki's campaign turned Giuliani's upstate trip to Republican advantage, highlighting an alleged "deal" between Cuomo and Giuliani for more state aid to the big city. Pataki aide James Natoli said, "If Giuliani had done it a week later, we probably couldn't have had the time to recover. Upstate, in Utica, we had people who mobbed Giuliani's plane. The problem was in managing our supporters, as opposed to motivating them to come out."

As it was, Cuomo won New York City by about 640,000 votes, the biggest Democratic margin since 1974, but got absolutely crushed elsewhere, particularly in the more rural areas upstate and on the eastern end of Long Island. New York City contributes 30 percent or less of the statewide gubernatorial vote, even though it has almost half the state's population. Pataki won by approximately 175,000 votes, statewide.

Keeping the Promises

George Pataki, mild mannered as he was, meant to bring about change in a big way. He started quickly, negotiating a death penalty bill with the Legislature and then signing it after only two months in office. He also submitted a 25 percent income tax cut plan with his first budget. And although it was modified in talks with the Legisla-

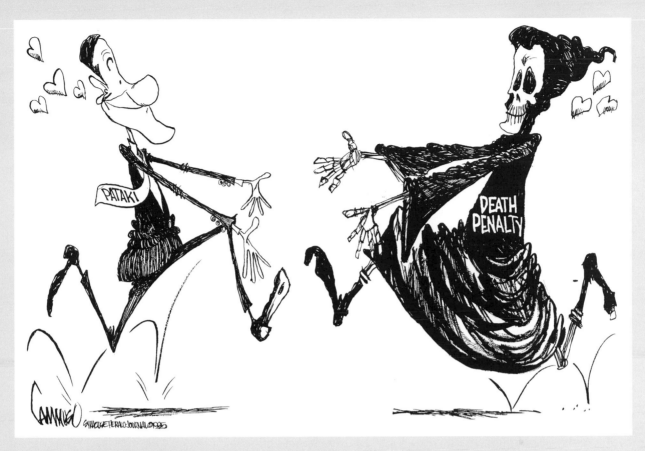

Pataki moved almost immediately to fulfill one important campaign pledge, to bring back the death penalty. He shipped convicted murderer Thomas Grasso back to Oklahoma to be executed just ten days after taking office—Cuomo had held Grasso in New York—and signed a new capital punishment statute into law sixty-six days into his first year. Pataki was reversing a trend that began with Rockefeller, who signed an abolition of the death penalty back in 1965. Then Carey and Cuomo vetoed all attempts to reinstate capital punishment, even as public fear about crime mounted. (Frank Cammuso in the *Syracuse Herald Journal,* 1995.)

ture—to shift more benefits to the middle class and away from the wealthy—the basic plan survived. As political topics, those changes were the cornerstones of the 1994 Pataki campaign. He had promised to sign the death penalty, after years of Democratic vetoes, and he had promised to cut taxes to make the state more business friendly and generate jobs.

It is ironic that Pataki was really undoing the work of Rockefeller, the last elected Republican, not Cuomo, when he signed the death penalty and cut taxes. It was Rockefeller who signed the repeal of New York's death penalty law, back in 1965, and it was Rockefeller who raised taxes way beyond the level of most other states to pay for his major investments and program expansions. By the time Pataki took office, voters associated high taxes and the crime problem with Democrats, and the fact that legislative Democrats went along so quickly attested to Pataki's reading of the politics of the time.

Senate Democratic Leader Martin Connor reflected on this phenomenon:

> I moved to New York right out of college, and I remember thinking, "Gee this is great, they've got free tuition" I also remember thinking, "I wonder how they pay for all this." The truth is, if we didn't kill the goose that laid the golden egg, we certainly clipped its wings. The amazing thing is that all of these taxes were raised by Governor Rockefeller and a Republican legislature, and yet the Democrats got tagged for it. We got blamed!

Spending for social services went from one-quarter of Albany's outlays to one-third in the ten years beginning in 1988. That meant less money for other things, and education funding—both local schools and higher education—suffered.

Pataki recruited a new budget director named Patricia Woodworth from outside New York. A tough-minded hawk on spending who had trained under David Stockman, Ronald Reagan's budget chief, Woodworth became the point person for the administration's early years. She came prepared to do battle with what she saw as an encrusted establishment:

> My observation in coming here, was that New York was truly out of step with the rest of the country, that literally every other part of the country had already been moving toward managed care in the health care system, toward a more aggressive approach to welfare and putting people back to work. And I really felt that it was just a matter of time before New York would also have to engage in the same kind of activity.
>
> The myth had been perpetuated that New York was a leader in all things. But in reality, New York had become a follower, or had just been left out. People were not looking to New York in the area of government any longer to see how things should be done, how government could be improved. I think that was a major difference from earlier periods, when New York was a leader in building social programs and other states followed. The tide had kind of turned, and New York had not kept up with that tide.

And it looked to me that the time was ripe for that kind of change. That was not just because other states were doing it, and were more economically viable than New York, but also because of what we saw happening at the national level, in Congress. And the president's own words, about "Changing welfare as we know it." It was just clear that the time had come for major change, and I wanted to be part of it.

Woodworth came to New York after four bruising years as budget chief in Michigan, where she had helped another Republican governor chop away at the budget.

I had already been budget director in two other states [Florida before Michigan]. So I had a pretty good idea of what state finances looked like, and how states operated. And I was amazed. Not just at the immediate problem, which was about a $5 billion gap in the budget, but I was also amazed by the way in which the state approached the problem. Which is to say I walked into a staff of about four hundred people who were used to operating in a way that to me was very different from what I was used to. That is, they were used to being told that they had to find ways to pay for things, and the more creative the better.

There had not been any real effort to cut back on the size of government for many, many years. There was kind of an entrenched belief within the budget office that you found ways to finance things rather than looking for opportunities to perhaps no longer do some activities or do them with less. So one of the biggest challenges we faced in turning things around was getting people to think about the problems, and the solutions to the problems, in new ways.

Woodworth was asked if, when she took the job, she had any idea of what awaited her. She replied:

Yes, I did and that was part of the reason why I came, a big part of the reason I came, the magnitude of the challenge, both in terms of the dollar gap we were facing as well as the entrenched big government mentality of New York that the governor clearly wanted to change.

From my point of view they would not have been recruiting me had the governor not wanted someone who was going to change things. Because that's kind of what I am, a change agent.

So they were buying trouble when they brought her in? "Which is what they wanted."

They got trouble. A huge brawl erupted with the Legislature—and the education and health care industries—over the significant budget cuts Pataki wanted to make, to help pay for his tax cuts and to help close an inherited deficit of some $5 billion. The battle raged on, and the Legislature missed its April 1 budget deadline for a tenth straight year. Pataki the candidate had promised to end this perennial symbol of dysfunction in Albany, and as governor he moved to withhold the pay of legislators and their staffs when the deadline passed. The move backfired, however, when low-paid secretaries became the focus of debate and made Pataki look mean-spirited. He lost a court fight over the issue and had to back down.

But he did not back down on his basic approach, and he got the spending cuts he needed to balance the budget and still pay for his tax cuts, which took the income tax rate down to below 7 percent for the first time since 1967. In fact, spending from state revenues actually dropped in Pataki's first full year and stayed flat the next year. That had not happened in a long time. Pataki said, "We had a brutal budget fight in 1995, with a lot of partisan bickering back and forth. But no one ever disputed that the $5 billion deficit was there. And instead of raising taxes, we closed the deficit and cut taxes by restructuring the government, because we knew we had to change this state's economic climate. We were hemorrhaging jobs."

In retrospect, Pataki was probably lucky that the deficit was so large. Like the looming default of the New York City fiscal crisis during Carey's time, the mammoth deficit had the effect of focusing people's attention, and allowing Pataki to take tough steps that otherwise were politically unacceptable to legislators of both parties. As Natoli pointed out, "We were racing toward a cliff that was a $5 billion dropoff. It's just not something you're going to solve all by yourself; you need the Legislature. Talk about hitting a wall! If it was a $1 billion deficit, it could have been the 'same old, same old.' But when you're talking $5 billion, well, that's different."

The Providers

One discovery Woodworth made in New York was the strength of the providers—the doctors, hospitals, clinics, and nursing homes—when it came to the battle over health care costs. Health care costs—and particularly Medicaid costs—were a prime target for the new administration, because they kept eating up more and more of the budget, growing more than 12 percent a year. Woodworth asserts:

> I think that New York entitlement systems are far more provider-driven than they are in other states. Which is to say that there are people out there who are making money out of providing government services who are then involved in the political process, who have influences in the political process, and that's certainly true to a much larger degree in New York than anywhere else.
>
> In terms of health care, we've done battle with the providers. It's kind of a difficult road, because you need them to provide services, but in order to be fair to the taxpayers, you need to hold down the costs. The providers clearly had a pretty good thing going here in New York, where, by every measure, they have been receiving more business and more money for that business than any place else in the country. We have curtailed the growth of Medicaid spending, putting in managed care.
>
> We've brought down the level of growth from probably the 11 to 12 percent range to 6 or 7 percent. That's still faster than the rate of inflation, but we're making progress.

"...TOLD YOU I'D PUT WELFARE RECIPIENTS TO WORK..."

Requiring welfare recipients to work was a Pataki mantra and a popular theme all around the country. The Pataki welfare cuts were also part of his overall budget strategy. (Matt Davies in the Gannett Suburban Newspapers, 1996.)

In some ways, Hugh Carey fought the same battle that twenty years earlier. Carey got temporary control of health spending, with aggressive government regulation. He put in controls on reimbursement rates, on construction of hospitals, and on what doctors could charge some patients. New York saved more federal health care dollars than any other state as a result.

Eventually the providers gained the political upper hand and took control. For example, Cuomo health commissioner David Axelrod was able to convince the governor to veto a very expensive hospital reimbursement bill in 1987 and negotiate a more moderate alternative. But when Commissioner Axelrod tried to promote another veto in 1990, for the same reason, he got nowhere. Why? Because the hospital lobby went out and did some political organizing at the local level to make itself veto-proof. The governor and legislators didn't dare stand up to them, or to the hospital workers' union. Axelrod's proposal to begin weaning hospitals gradually off government rates and toward a market-driven system went nowhere. Legislators always called Axelrod's office demanding more money for their local hospitals.

When Pataki took office, the debate suddenly changed. Managed care was sweeping the nation—in the wake of President Clinton's failed health care reform proposals of 1993—and was the great new hope for holding down costs. Pataki convinced the Legislature to decontrol the system and let the market take over, something that Cuomo couldn't even broach. Woodworth reflected on the change:

> And I think in fact we have made huge changes in the way New York thinks about these entitlement programs over the last two years. The conversation when I first came here was so very different from the conversation that we have now with the Legislature.
>
> Now [laughter], how profoundly it has made its way into the depths of the political system or the bureaucracy remains to be seen.

Actually, less than a year after the big deregulation reform of 1996, the Legislature and Pataki reacted to public complaints about HMO cost-cutting by passing new laws—to block hospitals from discharging new mothers and breast cancer patients too fast—thereby beginning to re-regulate the health system a little bit at a time, procedure by procedure.

Good Results

Pataki was able to claim good results for his work very quickly. Taxes, crime, and welfare rolls went down, while jobs went up. Pataki explained:

> I think we have accomplished more in three years now than our predecessor did in twelve. And it's because we had a clear agenda of the change that was necessary to bring this state back to where it should be.

A huge Albany fight erupted over rent control in 1997, with Republicans trying to end most limits on landlords, and Democrats championing the cause of tenants. Accused here of milking the issue, Assembly Speaker Sheldon Silver defended rent control and rallied scared tenants against Pataki and Senate GOP leader Joseph Bruno. Ultimately, Silver and Pataki reached a compromise that Bruno was forced to accept. (Matt Davies in the Gannett Suburban Newspapers, 1997.)

There are 400,000 fewer people on welfare than when I took office. And it didn't just happen. It happened because we changed the laws to reflect a very clear principle, that is, that able-bodied people should take the consequences of their own acts. And it's in their interest to be required to work in exchange for a check, instead of being told the government will take care of them.

Just look at these numbers. [The governor, sitting in an armchair under a portrait of Theodore Roosevelt, got up and went back to his desk to get a report with welfare caseload numbers.] It's just fantastic. And you look at the numbers on jobs and it's the exact opposite. They're not going up as fast as I'd like but it's going much faster than it was. We are seeing the investment and we are seeing the expansion that we didn't have in the past.

I'll bore you with one other figure. In 1994, we had 73 expanded or new corporate plant locations in New York State. Nowhere in the top twenty states, whatever. Last year [1996] we had 511, seven times as many. Because these policies are working, having a positive impact.

Of course, Pataki claims credit for these developments, as would any governor or mayor or other politician, Republican or Democrat. To be fair, it is not clear that his policies really have cut crime and cut welfare and boosted jobs. Crime and welfare rolls were going down all over the United States in the late 1990s, in some places faster than in New York. The national economy has been in good shape, and that moves people off welfare and into jobs everywhere. Crime was dropping mostly in New York City during Pataki's first term, thanks in part to more aggressive community policing under Mayor Giuliani and more police officers on the street. (Prior Democratic administrations at the state and city levels enacted a tax to pay for those police.) But crime was also going down in places like Los Angeles, where police presence was reduced.

The economic growth argument is complicated. There was no question that New York in the late 1990s is a friendlier place for business: state agencies have been retrained to be helpful, rather than to get in the way. Lobbyist James Featherstonhaugh, who represented some big business clients, said:

New York literally used to dare you to come in and do business here. The attitude permeating the regulatory agencies was that government did you a favor by allowing you to do business. And you had to earn that favor. I am actually stunned at the extent to which this administration has changed that attitude, and I mean way down in the agencies. The change is unbelievable.

Despite Pataki's claim, the job numbers did not take off—there were as many new jobs in Cuomo's last two years as in Pataki's first two—and the economic recovery was spotty. Long Island and parts of New York City came back in a big way with the high tech revolution and Wall Street's boom in the late nineties. Upstate, however, the

economy continues to lag, and in poorer sections of New York City the unemployment rate remains over 10 percent, more than twice the national average.

As an economic unit, the Empire State is still not exactly the object of envy. H. Carl McCall, the Democratic comptroller, was asked if he thinks that Pataki has turned the state's economy around. In response, he offered this caution:

> No. No. I think he has been lucky, in that he was here when the economy turned around. First of all, there is a perception that the economy's been turned around. What has been turned around is Wall Street. Wall Street, the financial services sector, has produced incredible revenues and that has given us the perception that everything's fine. But underneath that we have serious economic dislocation. We are forty-eighth in the country in terms of job creation. We have one of the highest unemployment rates. So *that* he hasn't done anything about. But there is this perception that the economy is better because of what Wall Street is producing.
>
> The business climate? The business community was very turned off by Cuomo. They felt that he did not listen to them. That he was not responsive to them, that he didn't care about them. Right or wrong, that's how they felt.
>
> What Pataki's been able to do is to simply change the rhetoric, and has made it clear to them, in his rhetoric, that things are different, that he's listening to them, that he's prepared to be supportive. That has such a tremendous impact. Just the fact that symbolically he's said, "New York is going to be a business-friendly state, I'm with you," has meant a great deal in contrast with what they perceived as the Cuomo attitude.

Democratic Tilt

Pataki was elected the same year conservative Georgia congressman Newt Gingrich's troops took control of the House of Representatives away from the Democrats for the first time in forty-six years. They both benefited from the antigovernment mood in the country, the clear frustration of the public with an expensive, sometimes intrusive, and ineffective operation.

In his first State of the State message, Pataki attacked the government he had just taken over. He poked fun at a whole series of silly sounding bureaucratic rules and regulations, with vintage antigovernment rhetoric. But in fact, after his bruising first year, when he achieved the big spending cuts and tax changes he wanted, Pataki took pains to distance himself from the Gingrich model. He is the first Conservative-Republican governor in New York history, and he has a unique record to establish. He describes his philosophy as pro-government, at least in part:

> I am very much a fiscal conservative. I don't think it is right that we spend ourselves into the tax mess and that we don't exercise the fiscal discipline to look to tomor-

row and not just what we can buy today. But at the same time, I am not one of those that hates government. I am in government because I think there is a very important role for an activist government, an activist government in the environment, an activist government in helping to work with local schools, an activist government in areas like mass transit. So very often there are those who not only are fiscal conservatives, but dislike government. I believe in the private sector and the importance of individual initiative, but there's a very important role for government to play in working with the private sector, and working to help individuals achieve their goals. So I think it's a little bit different from some others in my party.

This may indeed be the real George Pataki, who once worked in Rockefeller campaigns. He was also doing lots of polling to see what worked with the public. Although he always denied that polling told him what to do, he spent a lot of money on Arthur Finkelstein, the political advisor and negative advertising guru who came to him from Al D'Amato. Pataki kept this architect of hard-hitting campaigns on his payroll while in office, with an $8,000-a-month basic retainer, and paid him more for focus groups and polling. This perpetual campaign mode was criticized by Democrats, but it was standard late-twentieth-century politics, not at all unique to Pataki. President Clinton went so far as to test public reaction to different vacation spots he was considering. In New York, Assembly Democrats never launch a major initiative without polling first.

A $1.75 billion Environmental Bond Act was the centerpiece of Pataki's second year. He not only got it through the Legislature with ease, he went on to campaign for the massive borrowing plan, with television commercials and in person, and he climbed noticeably in stature when voters approved it by a healthy margin. (Cuomo had failed with a similar proposal just five years earlier.) The Bond Act also provided Pataki an opportunity to travel around the state before the 1998 election, announcing popular local projects and promising construction jobs for new sewage and water treatment plants. This sounded more like Rocky than Newt.

Despite his early work on—and success with—the death penalty, tax cuts, getting tough on welfare, and cutting government spending, it was only with the passage of that bond act that his statewide approval ratings made it up to the magic 50 percent threshold, according to published polling results. Then he proposed a budget with major hikes in school aid, a school tax rebate/cutting plan, and expansion of Cuomo's Child Health Plus insurance program to cover more children by spending more money.

In other words, he was getting popular, on some fronts anyway, by looking more like a Democrat. Pataki maintains it's because he'd achieved savings first:

You know what amazes me? We were taxing much more, and spending more. But we were spending less on education, less on the arts, less on the environment. We're investing more on the environment than ever before, we're doing more in the Coun-

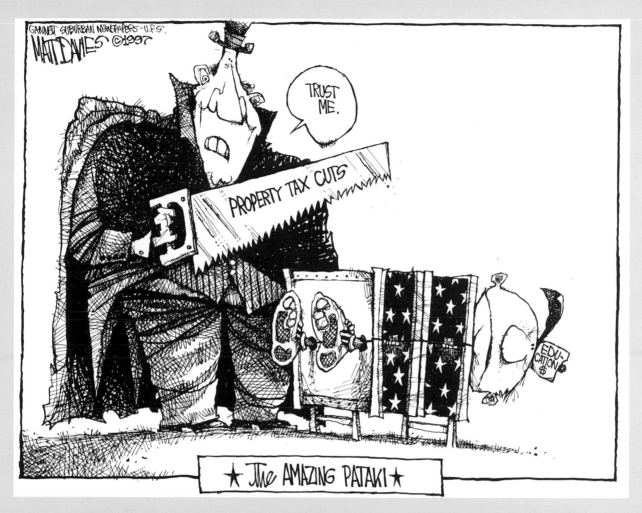

Property taxes were the major tax complaint of New Yorkers, and Pataki figured out a way to lighten that burden by having Albany pay a portion of each homeowner's bill to the local school district. Thanks in part to the Wall Street boom, which stuffed the state treasury with unexpected windfalls, Pataki was also able to afford a big increase in aid to schools just before he ran for reelection. That was Pataki's first-term political magic, making big cuts early and then buying into popular spending programs later. (Matt Davies in the Gannett Suburban Newspapers, 1997.)

cil on the Arts than under the prior administration. We are doing far more in education. And yet because we've been able to reduce the bureaucracy by over 20,000 people, changing the way we run the government, we can do it and cut spending overall. It's just a matter of running the government better.

The 1997 budget was an election-friendly document, with record level increases in school aid, those property tax breaks, and another bond act, this one from Assembly Speaker Sheldon Silver, proposing to borrow $2.4 billion for reconstructing and modernizing aging public school buildings. (Voters rejected the bond act that November.) Pataki proposed, but did not fight for, unpopular cuts to higher education and more tuition increases at the state and city universities (he'd pushed through the biggest tuition hike ever his first year). He also backed off on unpopular welfare cuts to single mothers. He approved a $425 million pork-barrel borrowing fund for popular local projects like sports stadiums, art museums, and the like. In other words, after two years of tough spending cuts, Pataki could afford to be more voter-friendly. The idea of cutbacks sounds great, but when it comes down to November, it is universally understood that the voters like the government to spend money—on *their* favorite projects.

Budget hawk Woodworth, with three budgets behind her, decided to move on at the end of 1997. She took a job as vice president at the University of Chicago. "I have no intention of going upstairs and asking the governor to make major cuts between now and Election Day," she said.

In fact, the budget plan that Pataki unveiled at the beginning of 1998 was roundly criticized by his erstwhile conservative friends as much too expansive. The conservative *New York Post* editorial page and Conservative Party leaders lambasted the man they had helped to elect.

Pataki's friends at the Change New York organization, enthusiastic supporters early on, gave him a D+ for the 1997–98 budget. A heavy reliance on long-term borrowing—81 percent of it without voter approval—was one reason many critics were dubious. With such big surpluses driven by Wall Street, why rely so much on borrowing for capital improvements? The answer lies in the bipartisan demand for tax cuts and popular spending at the same time. Spending money on things that voters want is a lot more popular than raising the money to pay for those projects and programs. Pataki boosted state spending by almost 10 percent in his reelection year.

Will Pataki Win Again?

Of course, in 1998, the big political question is whether Pataki's approach will earn him a second term. Sure, the voters all said they wanted cutbacks, but they were used to big spending and all the evidence from legislative behavior, anyway, testifies to a permanent addiction.

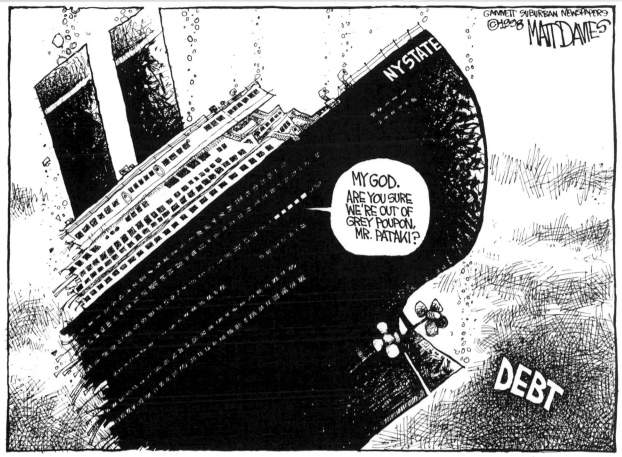

DISASTER *at the* SUMPTUOUS BUDGET-SURPLUS PORK-SPENDING PARTY *in* SUITE 73c.

The movie *Titanic* was the hit of the 1997–98 winter, and Pataki hoped that his election year budget would be as popular. After cutting the budget hard in his first two years, Pataki loosened the reins in 1998, his reelection year. It was a common pattern throughout the period, and he used a lot of borrowing to fund his proposals. This tactic angered critics worried about the state's long-term economic prospects. (Matt Davies in the Gannett Suburban Newspapers, 1998.)

Perry Duryea, the former GOP Assembly Speaker who lost the 1978 race for governor to Hugh Carey and has since helped Pataki, reflected on the risk of Pataki's early cutbacks:

It is a difficult turn, because we are taking things away from people. We've limited certain access to education. The state university is going through a struggle now, because the costs are being increased, and maybe the growth is being somewhat restricted. There's no question it's difficult. On the other hand, I think it was necessary. I candidly think he's to be respected for how he campaigned. He said, "I'm going to do one, two, three, four" and now I think he's doing one, two, three, four. He may be paying a political price. We'll never know, until the general election. But he's sticking by his political pledges and his platform. I happen to think that he can do it, and be re-elected. I believe that thinking New Yorkers realize that what worked in the sixties doesn't work in the nineties.

As Pataki's first term draws to a close, the pain from those cuts doesn't seem so great. The strategy of taking the hard, politically dangerous cuts early, and then easing up later, seems to be working.

Even the ever-combative Cuomo agrees that Pataki will probably get a second term: "The Democrats have seen to that. They agreed with him on the death penalty. They agreed with him on the tax cut. And they agreed with him on welfare. What's left?" The welfare reference in Cuomo's remark is to the 1996 decision by President Clinton to sign the welfare reform bill drafted by the Republican Congress. The debate was largely over; Pataki was in tune with the national consensus.

Comptroller McCall, the only Democrat elected statewide, decided not to challenge Pataki. Here is his assessment:

Pataki? The jury is still out on him. People kind of feel, "he's not a bad guy." But I think the jury's out in terms of solid accomplishments whether there will be any that we can attribute to him.

There is a perception that the economy is doing well, that the state's moving in the right direction, the business community's on board. It is very difficult to beat somebody when they've got those things going for them. People don't like to change when things are going well. I believe Bill Clinton was reelected because nationally people thought that the economy is doing well, so therefore why change. And I think Pataki is going to have the same kind of effect here. People are going to say, "Look, all this money from Wall Street, you're going to have a $1.9 billion [or more] surplus in the budget, you're cutting taxes, the business community says New York is really great." How do you get people to walk away from the guy who's in charge?

Alan Hevesi, the long-time Democratic legislator currently serving as New York City comptroller and widely expected to be among the Democratic front-runners for mayor in 2001, believes Pataki is lucky the economy is going so well: "If Mario Cuomo

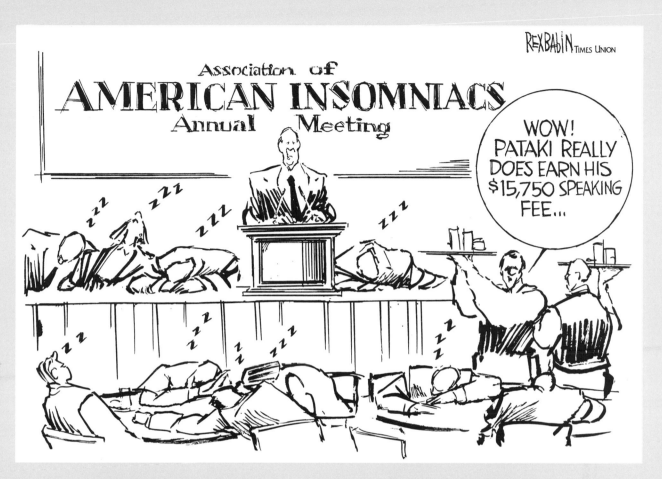

Pataki suffers by comparison with his predecessor when it comes to public speaking. Mario Cuomo was a riveting orator, capable of moving a crowd to tears or to great excitement. Pataki is not that way; he is more average. When he, like Cuomo, started hitting the rubber chicken circuit to raise money, critics were surprised that people would pay big money to listen. (Rex Babin in the *Albany Times Union*, 1997.)

or David Dinkins had the current economy going for them, they would have been re-elected. Bill Clinton proved that." Does he think that Pataki stumbled into good luck? "Yeah, but Pataki promised things and he delivered. The death penalty, the tax cut. A booming economy? I don't know whether he did it, but he enjoys it. So he delivered, and then, you're lucky."

Pataki has recovered from early political mistakes—hiding the private corporate money raised to fund his inaugural parties, for instance, and blocking an open Republican presidential primary in order to protect D'Amato's friend U.S. Senator Bob Dole's candidacy for the GOP presidential nomination—and he has things going his way. He has developed a talent for simply abandoning an unpopular position when it isn't working and then moving on, without making a big deal about it, without trying to justify his switch in public. His harsh attacks on judges for being too easy on criminals stopped abruptly in 1996, when the polls showed that it was a loser. In the rent control battle of 1997, Pataki started out with a strong stance in favor of decontrol, but then flipped when his position proved unpopular, and he went on to cut a deal with the Democrats. He then sent out brochures to all rent-controlled tenants asserting that he had saved their apartments and paved the way to a better future.

The art of compromise, some might call it. Pataki has an ability to stay on message, to focus on a limited and specific agenda. He does not try to do everything all at once.

Pataki has concentrated on a few primary areas: the budget, crime, the environment, women's issues. Women's issues are important because of the GOP gender-gap problem. Environmental issues are important to Pataki personally, and his successful bond act campaign, combined with the landmark Catskills watershed agreement with New York City to protect the drinking water supplies, effectively cut away any platform that Robert F. Kennedy, Jr., might have had to challenge Pataki in 1998. An articulate environmental lawyer based in White Plains, just north of New York City, Kennedy is a potential opponent whom Pataki's team had greatly feared.

James Featherstonhaugh, lobbyist and one-time Cuomo campaign operative, said:

> I think Pataki has been good, and fortunate. He's had a good economy, he hasn't been quite as tested as some of his predecessors. He's by far, I mean by far, more focused than any of the other three governors [Rockefeller, Carey, and Cuomo]. His view of the role of the chief executive is a little different than the other three. They were all inveterate meddlers in the details of government. George sees his role as a chairman of the board, setting the tone, setting policy. He is by far the most disciplined of any of them.

Pataki has also learned to focus on his major budget victories, rather than on the messy process. If the polling data are right, he has largely succeeded, avoiding the public disdain for Albany in which Cuomo always shared, by being so obviously involved in the budget battles.

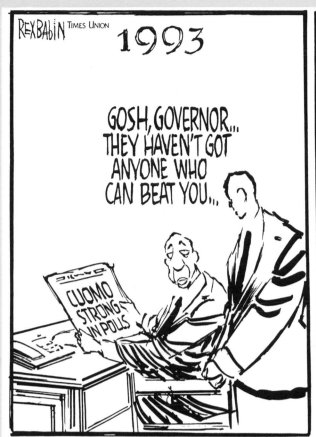
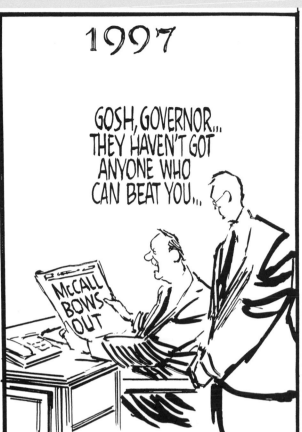

After a slow start, Pataki's popularity rose in political polls to such heights that his prospects looked very strong as 1997 came to a close and his reelection year dawned. Comptroller Carl McCall, the only Democratic statewide office-holder, decided not to run. This cartoon recalls that Cuomo looked good, too, four years earlier. But Pataki beat him. (Rex Babin in the *Albany Times Union,* 1997.)

Pataki has accomplished this distance partly by spending less time around the State Capitol. Pataki doesn't even live in Albany; he and his wife, Libby, stay with their four children at their twenty-two-room home near the Hudson River in Garrison, Putnam County. The governor spends at least as much time there and at his New York City office as he does at the State Capitol, where the Legislature and the media feast off partisan squabbles.

Actually, Pataki had a suprisingly weak 1998 legislative session, for an incumbent governor riding so high in the polls. He failed to gain approval for a number of major initiatives—casino gambling, charter schools, and no parole for violent felons. Pataki also lost control of the budget negotiations, and the Legislature started experimenting with independent conference committees. The governor recovered somewhat with major vetoes, but this experiment could be another major step in the growth of legislative power.

Another reason Pataki looks good for reelection is money. He has piled up record amounts of campaign cash, enough to fund a television advertising blitz that would do Coca-Cola proud. Powers boasts, "If you look at all the campaigns, you're probably talking about $50 million [for 1998]. Think about that. The governor's race will probably be $20 million, and Senator D'Amato's will be close to $15 million." The fund-raising has been extremely aggressive, and many organizations and interest groups doing business with the state felt it was a good idea for them to contribute. The same kind of practices go on in Washington, but the top political leaders in neither capital are inclined to change the system that has gained them power and kept them there.

However, the Pataki fund-raising machine did attract attention from federal prosecutors when the *New York Times* revealed that a wealthy Long Island contractor had set up a special political action committee that gave $100,000 to the state GOP just before getting a major state contract. A grand jury investigation began.

Pataki for President?

The question is inescapable. True enough, as New York went from Rocky to Pataki, it fell from number one to number three in population. And the economy remains weaker than in other parts of the country. But every governor of New York gets touted for the presidency at some point, if he doesn't screw up altogether, and Pataki started in 1997 going around the country giving speeches for money and raising campaign cash. A strong reelection could put him on the national GOP radar for 2000 or 2004, for vice president, certainly, if not for the top slot. How does he feel about being measured for the presidency, as governor of New York State?

My goal right now is to do the best that I can for the people of this state. And there's a lot more to do. There's an enormous amount that has to be done. And I think that in the past, the flirting of some of my predecessors, the speculation, and the "will he or won't he," I think that detracted from the attention and the ability to govern the state. I want to govern the state just as well as I can. I've always believed that if the policies are successful, the politics will take care of itself. And my goal right now is to work on the policy and the future needs of the state, and we'll see what happens with the politics.

He certainly is not ruling out a try for national office.

9

From Rocky to Pataki

You're talking about from Rocky to Pataki, and I think that is an important time frame.

 —Governor George Pataki

Dᴜʀɪɴɢ ᴛʜᴇ ʟᴀsᴛ ғᴏʀᴛʏ ʏᴇᴀʀs, New York State and the world around it changed dramatically. Empire State politics and politicians steered the state through turbulent times, and were tossed around a bit themselves.

One overriding trend is apparent: the era of incredible, creative spending and problem-solving ushered in by Nelson Rockefeller in 1958 ended for good with the election of another Republican governor, George Pataki, in the mid-1990s. Symbolically, it was during Pataki's first years in office that the top income tax rate dropped back below 7 percent for the first time since it had jumped up to 17 percent, at the end of the Rockefeller era.

When Nelson Rockefeller was elected New York's governor in 1958, the treasury was stuffed full, the economy was flowering, and the possibilities seemed limitless. Activist government was good government, and New York showed the rest of the country what that meant.

When George E. Pataki was elected, thirty-six years later, the gardens were no longer in bloom. The state treasury was coming up short year after year, the state's economy was clearly lagging behind the rest of the nation, and the very idea of an activist government was no longer popular.

As the late Assembly Speaker Stanley Fink put it in an interview shortly before he died:

> With a Republican governor and a Republican Legislature, New York repealed the death penalty, passed the most liberal abortion law in the country, and after the assassination of Martin Luther King, Jr., created the Urban Development Corporation to override discriminatory local zoning laws. They created Medicaid and finished building the largest university system in the country.

This was with a Republican Legislature and governor. Nowadays, you couldn't even get the Democrats to support that stuff. New York is nothing but a microcosm of what happened across the nation. It happened here first.

During this period, the Empire State arguably lost the natural right to its nickname. New York slid from number one to number three in population, and ended up with one quarter of its children living in poverty.

Rockefeller himself said when Democrat Hugh Carey took over in 1975, "Poor Hugh. I drank the champagne and Hugh Carey got the hangover." In fact, all the governors suffered the Rockefeller hangover, his high tax rates and the expensive health care programs that he put in place. But they—and the people—also profited from the amazing investments Rockefeller made in the future of New York, the public and private universities, the environment, and the mass transit system that allows New York City's modern economy to function.

Carey began the climb-down in the mid-1970s, fashioning a less ambitious but deeply compassionate government out of the remains of the fiscal crisis that brought the Big Apple to near disaster and the state to fiscal sobriety. He also confronted the beginnings of New York's economic dislocation, as the Northeast sank and the Sunbelt rose. Ronald Reagan was elected president during Carey's last term and began the downsizing at the national level that Carey had already started in New York.

Mario Cuomo governed for twelve tumultuous years, desperately struggling to maintain balanced budgets in the face of two serious recessions and a politically potent collection of institutions that resisted cutbacks in education, health care, and other major spending programs. Rather like New York's old steel factories, which didn't invest in new technology and eventually got blown away by updated competition from Asia and Europe, Cuomo's Democratic Party did not change fast enough to ward off the challenge from a new breed of Republicans.

Pataki's state government held down spending (for a couple of years, anyway) and continued to cut taxes. Pataki has also broadcast a business-friendly signal to the private sector, trying to spur economic growth again. But he didn't break at least one Albany habit—he keeps turning to massive back-door borrowing for politically popular projects.

Much like an adolescent growing into maturity, with awkward limbs, acned skin, and embarrassing behavior along the way, the Legislature came of age during this time. Gone is the old rural domination, swept away by the "one-man, one-vote" court rulings that helped bring about a democratizing of the institution and an infusion of women and minorities. The Legislature developed the intellectual power to challenge the governor, and it manufactured the political muscle to back up that brain power.

Sadly, the ugly, expensive, nonstop political warfare of the nineties has tarnished

government's standing with the public. Understandably. The atmosphere in Albany lacks the excitement of accomplishment and the bipartisan spirit of the earlier days, when men and women of good will and dedication—from both parties—served in government and enjoyed it.

Also missing from the scene is the sense of fun, the sense of human joy and sadness that once was a part of our politics. Hugh Carey, sometimes heard singing with his friends at a tavern down the hill from the Mansion, was a man who celebrated that human side of government.

Who knows where New York State will go in the next century. The economic base is not great, but it is improving. The school systems need help, and there is a vast population of young people who face an uncertain social and economic future. Thousands of new immigrants represent great hope and a great challenge. Governor Pataki gets the last word:

> You're talking about from Rocky to Pataki, and I think that is an important time frame. When you start out with Rocky, you start out with the beginnings of the state university system, and you needed someone who had the vision to create a statewide university system. You started with the beginnings of the Thruway [which Dewey initiated], and we didn't have the interstate highway system. You started from one or two sewage treatment plants, and yet Rockefeller had the vision of a clean water, clear air program. And you need that vision of an expansion and commitment, to create the infrastructure, whether it was the SUNY system or the sewers, so this state could thrive. But it's always a question of balance. And that was a capital investment in the future of the state, which I think in large part was appropriate.
>
> What we did was we switched from a capital investment in the future of the state to an ongoing expensive running of the state, a huge bureaucracy that was unresponsive to the needs of the people of the state and ineffective in the implementation of the programs for the state. If you don't manage government very closely, it's like anything else, the tendency is to stagnate, and the strongest force is inertia. But circumstances change, and needs change. And priorities should change.

The road from Rocky to Pataki wasn't always smooth, but it sure was entertaining.

The caricatures are fun, but in all seriousness, a cast of dedicated public figures did indeed romp across the stage from Rocky to Pataki. Winston Churchill captured the idea in a 1947 speech: "Many forms of government have been tried and will be tried in this world of sin and woe. No one pretends that democracy is perfect or all-wise. Indeed, it has been said that democracy is the worst form of government except all those other forms that have been tried from time to time."

Index

Abortion, 107–9, 172–75, 192

Adirondacks, 9

Agnew, Spiro, 56

AIDS and HIV, 116, 128, 130

Albany Times Union, 107, 123, 154, 157

Anderson, Warren A.: on Carey, 76; on the Legislature, 139, 143, 169–71; and NYC fiscal crisis, 65–66, 66–68; and Rockefeller Drug law, 30; on special interests, 78

Associated Industries of New York, 58. *See also* Business Council of New York State

Attica prison riot, 27–28, 96

Axelrod, David, 110, 127–28, 200

Beame, Abraham, 54, 70–71, 73–75, 100

Biggane, James, 23

Boepple, Maggie, 150, 153, 190

Breslin, Jimmy, 90

Brown, Richard, 137, 160

Bruno, Joseph L., 138, 140, 142, 148, 168, 183, 201

Budget, Division of, 22, 32, 50–52, 78, 197

Burke, David, 62

Bush, George, 122–23

Business Council of New York State, 83–84, 131. *See also* Associated Industries

Carey, Helen, 61–63

Carey, Hugh L.: on abortion, 108; Army experience of, 61; budget battles of, 215; business relations of, 83–84, 131; with Cuomo, 89, 92, 100–101; death penalty, 87, 132; environmental policy, 84–86, 88–90; family, 61–63; and Evangeline Gouletas, 90–92; health care costs, 200; and I Love NY campaign, 80–82; on Lt. Gov. Krupsak, 178, 180; legislative relations, 74, 76–80, 139, 142, 149, 153; Love Canal, 84–86, 88, 90; NYC fiscal crisis, 64–74; personality traits, 62, 74, 88–92, 216; on Rockefeller, 32, 34, 164; on Shoreham nuclear plant, 120

Carlino, Joseph, 12

Carter, Jimmy, 70, 90

Casey, Albert, 68

Castro, Bernadette, 176, 192

Catholic Church, 106–9, 172–75

Cavanagh, James, 54

City University of New York (CUNY), 73–74

Clinton, Bill, 152, 178, 200, 204, 208

Connor, Martin, 162, 196

Corning, Erastus, II, 17, 20

Coughlin, Thomas, 94

Cuomo, Andrew, 94, 126, 134, 136

Cuomo, Matilda, 94, 107

Cuomo, Mario M.: on abortion, 107–9; business relations of, 16–17, 203; campaigns for governor of, 92, 182, 131–32, 134; campaigns for mayor of NYC of, 92, 100; and conflicts with Koch, 100–102; and death penalty, 87, 100, 132, 135, 195; early life of, 97–98; family of, 94; GOP attacks on, 188–90; governing of, 31, 108, 110–12, 115, 129, 215; as lieutenant governor, 89, 92; on Pataki, 208; personality of, 98–100; philosophy of, 102–6, 112–14, 128–31; Presidential prospects of, 96–97, 102–6, 115, 120, 122–26; as public speaker, 102–6, 126, 209; on Rockefeller, 1; and Shoreham nuclear plant, 119–21; Sing-Sing prison riot, 94–96; and taxes, 118–19; on welfare, 112–14

Daley, Richard, 73

D'Amato, Alfonse: influence in Republican party 185–90, 204; recruiting Mc-Caughey Ross, 176, 178; on teachers, 154

Death penalty, 100, 132, 135, 192, 195

Debt, state, 14–21, 22, 36, 52

Hy Rosen was born in Albany in 1923 and started his career as an artist and then editorial cartoonist with the *Albany Times Union* in 1945, after serving in the U.S. Army during World War II. He began political cartooning in the mid-1950s, and his work was syndicated nationally. He was a Professional Journalism Fellow at Stanford University in 1966, served as president of the Association of American Editorial Cartoonists in 1972, and has won a number of national awards for his work. His work is represented in the presidential libraries of Presidents Truman, Johnson, Kennedy, and Nixon. He retired from full-time editorial cartooning in 1989. Mr. Rosen continues to draw, but has concentrated on his outdoor sculpture work, including commissions for the Gray Rider statue at the New York State Police headquarters and the Tricentennial Statue for the City of Albany's 300th anniversary celebration. He lives outside Albany with his wife, Elaine. They have three children and three grandchildren.

Peter Slocum began his newspaper career in 1972. He wrote for the *Middletown Times-Herald Record*, the *Washington Park Spirit*, the *Troy Record*, the Associated Press, and the New York Daily News, covering government and politics for a decade. In 1982, he joined the New York State Department of Health as a public affairs official and senior advisor, and in 1995 took a similar position with the New York Senate Minority Leader. He is also an adjunct professor at the State University of New York at Albany School of Public Health. Mr. Slocum lives in Albany with his wife, Ann Sayers. They have two daughters, Emily and Molly.